Into
the
Forest

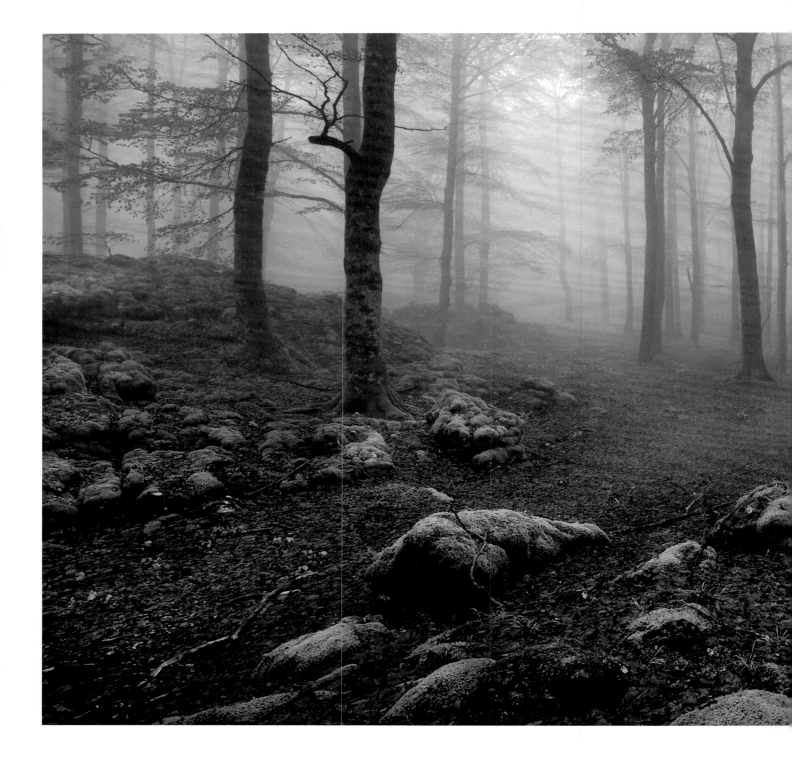

Into the Forest

THE SECRET LANGUAGE OF TREES

SUSAN TYLER HITCHCOCK

FOREWORD BY **SUZANNE SIMARD**

NATIONAL GEOGRAPHIC

WASHINGTON, D.C.

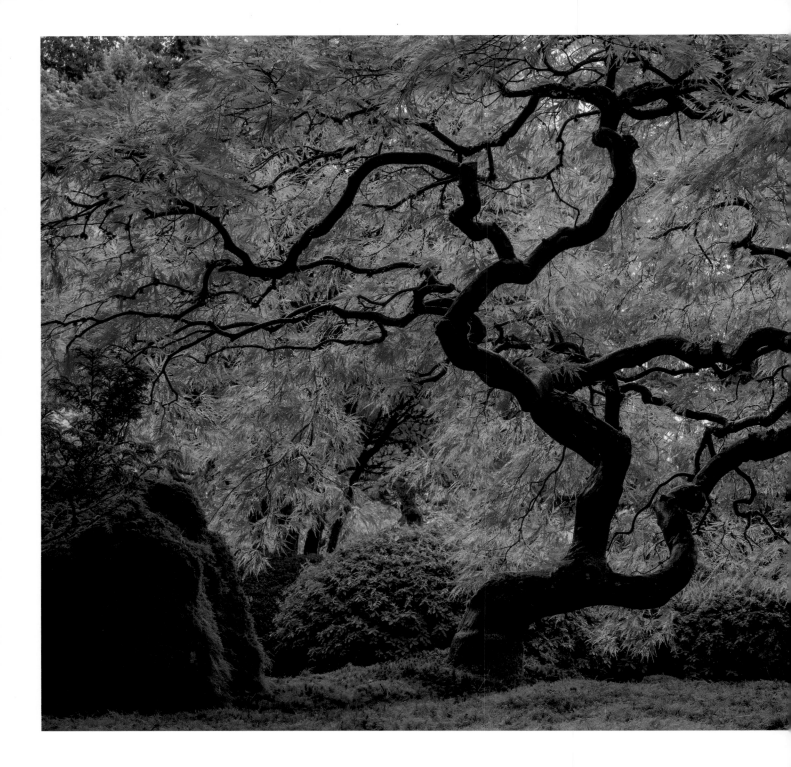

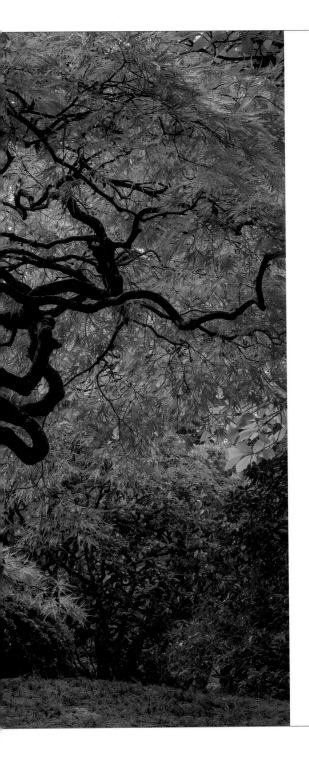

CONTENTS

The twisting boughs of a Japanese maple support a crown of glowing red.
PREVIOUS PAGES: Fog sifts through a forest in Spain's Basque Mountains.

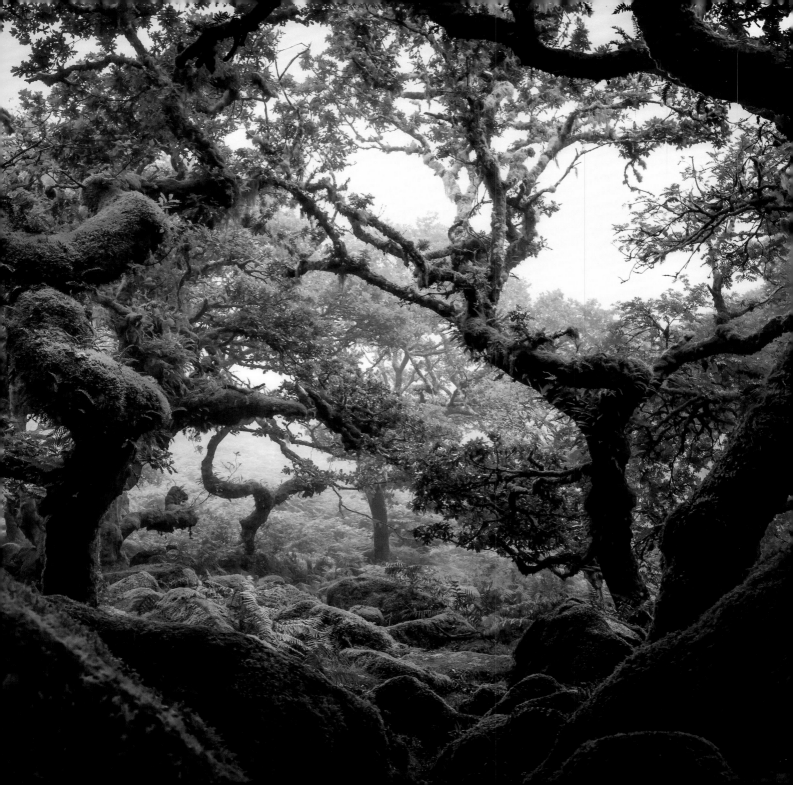

Seeing the Forest for the Trees

Welcome to the world's forests. Here, in this enlightening book, Susan Tyler Hitchcock shows us that a forest is much more than an assembly of trees. In rich, poetic prose, Hitchcock brings the forest to life—and invites you to participate. Within moments of diving into the book you will begin to see that the forest is not just a green canvas of trees and plants but a complex system that also includes mammals, birds, amphibians, fungi, microbes, and more. These creatures work together to make the forest whole, and in so doing provide us clean air to breathe, cool water to drink, nutritious food to eat, medicines to heal, and a place to soothe spirits. Our health, and our world, depend on the forest.

Trees and plants constitute 99 percent of terrestrial biomass on a global scale, with the rest of us creatures making up the balance. The work this biomass achieves is titanic. Scientists have found that even though forests contain only 31 percent of terrestrial ecosystems, they store more than 80 percent of terrestrial carbon, deliver the vast majority of clean drinking water, and are home to three-quarters of the world's land species, including many that are rare and endangered. Forests also modulate our climates, providing shade and regulating temperature, creating clouds and keeping the soil moist, and soaking up 20 percent of all greenhouse gas emissions. Forests benefit us directly, too, by supplying

Dwarf oaks and mossy boulders animate Wistman's Wood in Dartmoor, U.K.

us with resources to clothe, house, and feed ourselves; to make art, music, and poetry. Forests inspire and calm our souls—as this book will do as well.

Hitchcock also explores the complex and enduring relationship people have had with forests, from reverence of the tree of life by the Aboriginal people on the west coast of North America to the worship echoing through Cambodia's Ta Prohm temple, entangled with fig and ceiba trees, from the development of a new city around a central shade tree in West Africa to the building of bridges with the roots of rubber figs for crossing monsoon-swollen rivers in India. These stories from history illustrate how the lives of people are intersected, interwoven, and interdependent with the lives of forests.

But today, our forests—our very life-support systems—are suffering under the weight of global change. As our population rockets toward eight billion people, we are creating a multitude of eco-sociological crises. While our worship of forests remains deep in our psyche, humans are also responsible for the loss and degradation of primary forests worldwide.

The damage is already significant. Most global deforestation has occurred in the tropics, but humanity is also denuding temperate and boreal forests at a rapid rate; savannas and woodlands are also threatened. Primary forests—those advanced in succession and not significantly altered by humans—have been reduced to a fraction of the size that they once were.

Ten thousand years ago, at the end of the last ice age, just over half of the habitable terrestrial ecosystems were covered with forest. But during the last five millennia we have lost one-third of Earth's forests, with over half of that loss occurring in the last century. This deforestation is traced to agriculture and forestry, industrial development, transportation, and the migration and urbanization of people. Since humans began felling forests, including illegal logging, we have cut down almost half the world's trees. This book details

their fate, whether lost in swamps, turned into short-lived paper products, or sold for tropical wood furniture to developed nations at paltry prices.

Forests worldwide are all under threat, and the consequences are profound. Deforestation is the primary cause of species extinctions, contributing to what scientists are calling Earth's sixth mass extinction. Removal of canopy cover destroys the habitat of forest-dependent species and increases temperature and precipitation extremes that are harmful to plants and animals. The mountain caribou of Canada, the mangrove hummingbirds of Panama, and the tigers of Sumatra are all at risk of disappearing because of deforestation. Removing forests also disrupts hydrological cycles: We are seeing flooding in communities of Canada from the loss of headwater woodlands, farmland desiccation in Brazil from the loss of tropical rainforests, and soil erosion in the United States from the cumulative effects of logging and wildfires.

With respect to climate change, deforestation presents a double whammy because logging adds carbon dioxide to the air by converting trees to short-lived products and at the same time removes the ability of the denuded land to absorb existing carbon dioxide. It is estimated that between 10 and 20 percent of greenhouse gas emissions come directly from logging, and those emissions are expected to increase as wildfires consume increasing amounts of global forests. As this book astutely notes, logging old trees makes our forests even more vulnerable to burning up. In recent years, these pressures have shifted the boreal, temperate, and tropical forests from being net sinks for greenhouse gases to net sources. Loss of forest translates directly to loss of human life.

We have agency in our life on this planet, and there is much we can do to protect our forests. While weaning ourselves away from dependence on fossil fuels is

essential for mitigating global change, there is more we can do to reduce emissions and loss of biodiversity by caring for our forests. Happily, this book offers concrete actions that can be taken by individuals and governments to protect forests while still maintaining livelihoods. As Hitchcock notes, "everyone can participate."

The primary message of this book is to "step into the forest." Hitchcock points out that as we return to and relearn to honor the forests deeply, we will recognize the complexity and interconnection of life. This will inspire us to not take more than we need and to fulfill our obligations to care for the trees and creatures of the forest. Akin to wisdom already known by Aboriginal people the world over, we are asked in these pages to recognize that "many are one, and the one comprises many." Also crucial is the need to take immediate action to protect and restore old-growth ecosystems for their value in storing carbon, providing habitat for species, and maintaining life-sustaining ecosystem functions and services. We must act now.

Hitchcock also calls on us to use science to restore denuded and degraded land back to thriving forests. She lauds governments and nonprofit ventures that are organizing to plant a trillion trees. But she tempers these accounts with caution, writing that planting more trees is not as simple a solution as it might seem: "Species selection and diversity, the need for long-term tending, even the vagaries of weather present challenges."

For the future of the planet, we need governments to properly regulate and monitor the activity of logging companies as conditions of the right to harvest trees, so they can protect the integrity of ecosystems and their functions. "Replanting trees for the purpose of future logging can only go part of the way in reestablishing the natural balance," Hitchcock observes. "Governments and nonprofits have established standards and monitoring practices to enforce an ethic of environmental stewardship in the logging industry." I would add that

those companies that are profiting from logging and responsible for damages because of unethical practices should bear the costs.

In asking us to go into the forest—to open our hearts, minds, and senses to them—Susan Tyler Hitchcock shows us how they function, their importance in our lives, and our obligations to care for them. She reminds us of our deep human history, our ability and responsibility to properly care for Earth's forests. By learning to better love the green world all around us, we will change our attitudes, behaviors, and actions and leave the world in a better place for the coming generations.

So, turn the pages slowly, absorb her wisdom, widen your lens, and be prepared to change your view of forests forever.

SUZANNE SIMARD
Professor of Forest Ecology
University of British Columbia
Vancouver, Canada

CHAPTER ONE

TREE

To understand the forest,
let us first get to know the tree.

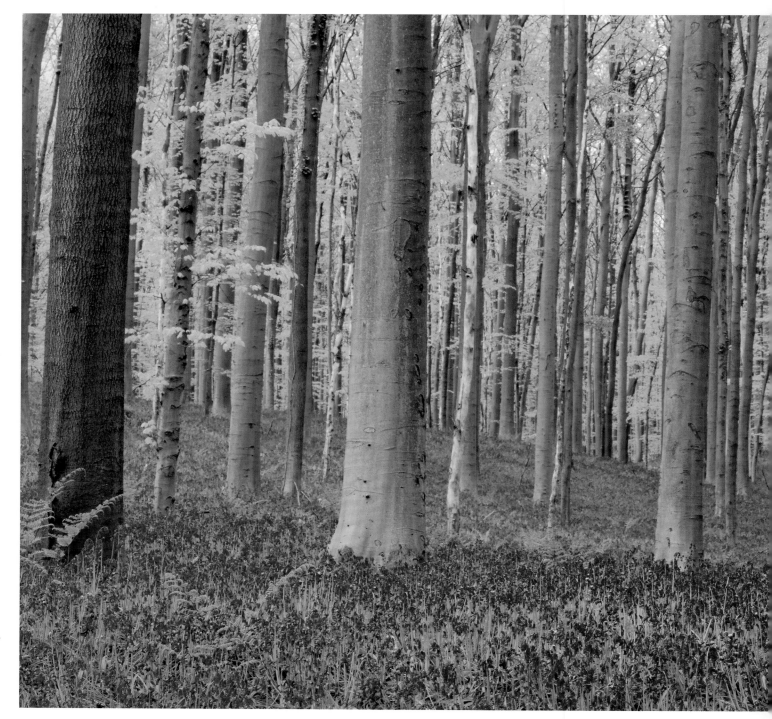

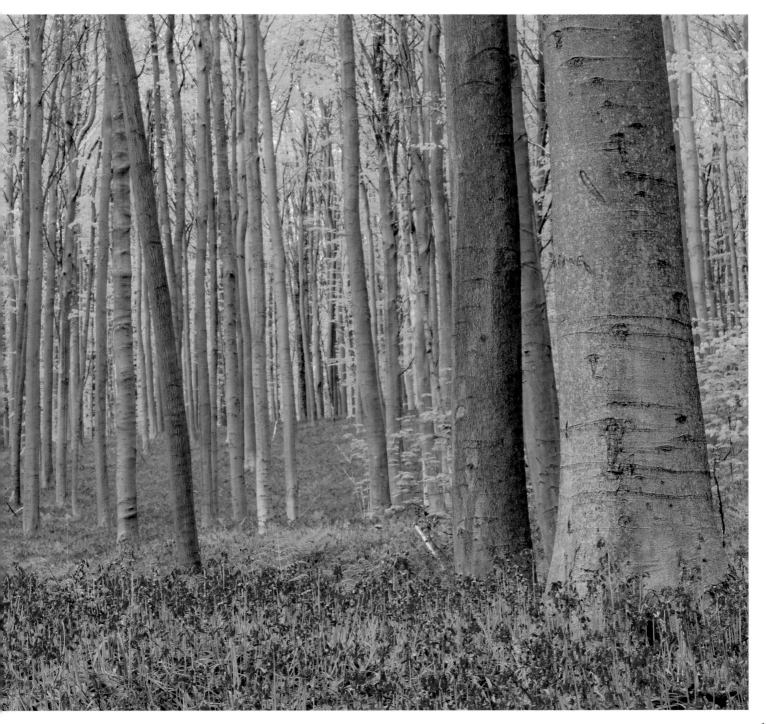

The Tree of Life

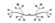

At the center of the world there stands a tree. It has been growing through millennia. Its roots plunge deep into the soil; its branches spread out and up to the sky. Its leaves shimmer in the sunlight; its flowers bloom eternally. It casts its seeds far and wide. Like most of its kind, this tree has lived longer than any one of us now alive, and it will far outlive every one of us.

This tree stands at the mythic center of origin stories told around the world. In the Babylonian *Epic of Gilgamesh,* when life began, a single tree, the *huluppu,* grew on the banks of the Euphrates. Norse mythology evokes the great tree Yggdrasil, whose roots and branches hold the world together. Among the ancient Maya, a sacred tree connected three realms: The roots reached into the underworld, the trunk embraced the world of human existence, the branches stretched into heaven. In the Maori tradition, the great tree god Tāne separated his parents, Papatūānuku and Ranginui—earth and sky—and brought light into the human realm between them. And the Shinto religion of Japan tells of gods and goddesses descending from heaven and dwelling in the pine trees. In that tradition, every tree is divine.

Now science is confirming what humans have intuited all along: The trees and the forest have wisdom to share, grace to impart, and a profound healing effect on the human body, mind, and spirit. A greener world is a better world. Time spent in nature feels good.

The Angel Oak near Charleston, South Carolina, spreads muscular limbs. Some date it back 500 years.

PREVIOUS PAGES: Bluebells and beech trees paint a vernal scene in Brussels, Belgium.

Yet our modern lives veer in the other direction. Around the world, more people live in the city than in the country, and the number just keeps growing. As we shift toward urban living, we yearn for ways to dwell in nature—whether that means a weekend campout, a hike in the woods, a stroll through the park, mindful acknowledgment of a magnificent tree in the neighborhood, or a simple green plant nurtured in a pot on the windowsill.

For millennia, a tree has flourished at the center of our universe, speaking wisdom to us. It is time to listen again. ▪

ABOVE: Royals pay homage to the tree of life in a relief from Dur-Sharrukin, an Assyrian palace built in the eighth century B.C.

OPPOSITE: Native to South America and beloved for their showy blooms, jacaranda trees now grow around the world. This one graces an Australian paddock.

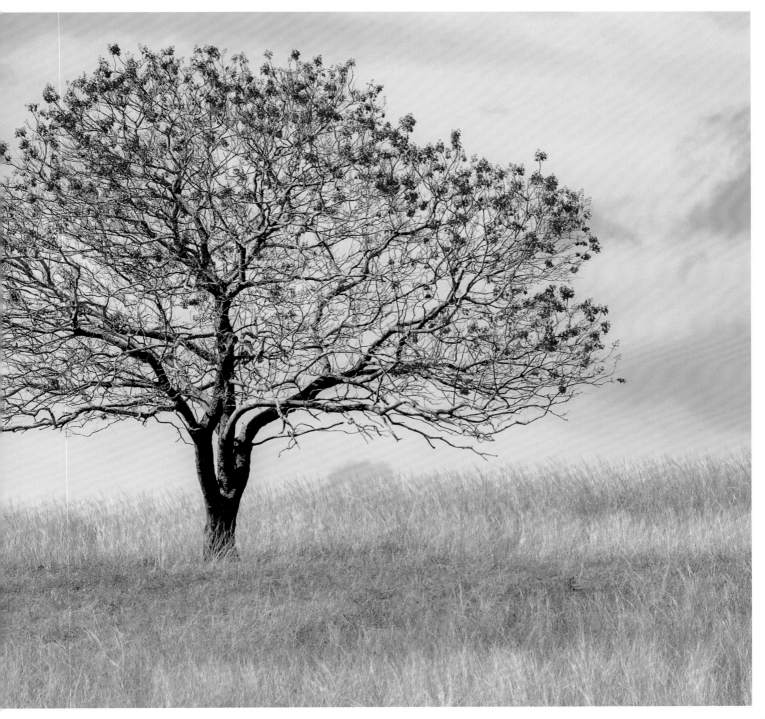

We Are Plant-Blind

We live in a world of green. Trees, lawns, weeds, gardens surround us. And yet, say botanists James Wandersee and Elisabeth Schussler, our culture suffers from *plant blindness:* the inability to appreciate plants in the biosphere and the inclination to consider plants less important than animals. Children are fascinated with lions and tigers, dogs and cats, snakes and frogs; more kids clamor for a pet animal than a pet plant. Few of us can distinguish one type of tree from another, let alone different species of grass or garden weeds. It's only when plants flower—the bright yellow dandelion, the cheerful cherry blossoms—that we notice the plants around us.

Why this cultural bias, Wandersee and Schussler have asked. Starting with the psychology of perception, they have teased out a few explanations. We view plants as a backdrop: not only a context for the action and behavior of animals, but also a homogenized wall of green from which we tend not to single out individuals. In psychology-speak, plants have "low signal value." Plants don't move, talk, eat, fight, or sleep; they don't have eyes that stare back at us—all reasons we find animals interesting and plants less so. And our educational system perpetuates plant blindness. Children learn less about plants than animals, and botany is less often studied in college than zoology.

The irony is that plants represent more than half of the world's endangered species—16,460 out of 31,030, according to 2020 numbers from the International

From the ground up in Rio de Janeiro, Brazil, the forest canopy presents a kaleidoscopic view of green.

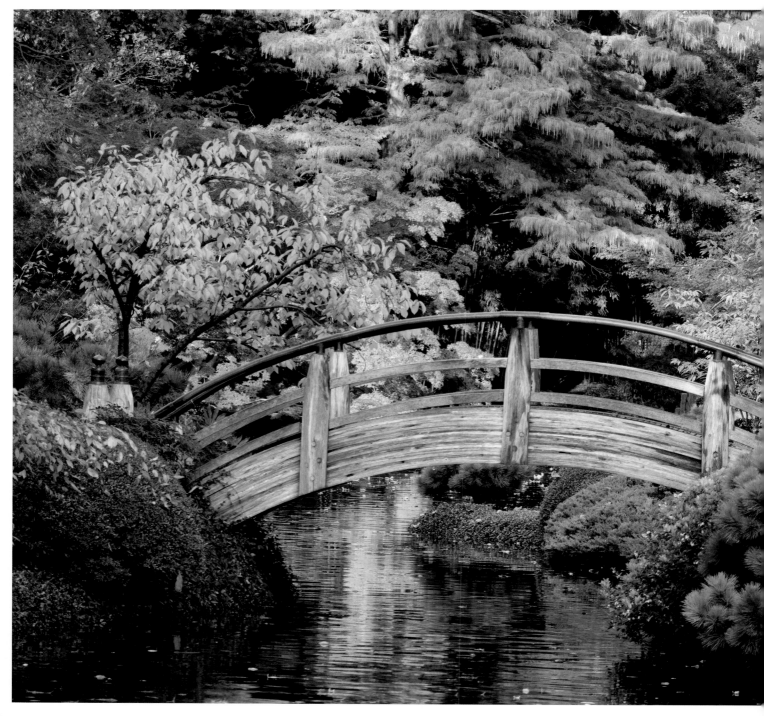

> ## "We need hours of aimless wandering or spates of time sitting on park benches, observing the mysterious world of ants and the canopy of treetops."

—MAYA ANGELOU,
Wouldn't Take Nothing for My Journey Now

Union for Conservation of Nature (IUCN). Another 2,500 plant species are considered near threatened. Plants form the substrate of every animal habitat on Earth. By honoring, preserving, and even just noticing the plants in our world and the trees in our forest, we support our beloved animals—and the entire natural world.

They do not speak our language, but there are conversations going on among the trees. Transcending plant blindness, we improve our own lives, too. Might the forest offer comfort, healing, and awareness? Let us learn to pay attention. ■

Sometimes we can't see the forest for the human constructs that obscure it. Here, the graceful curve of a worn wooden bridge complements autumn colors.

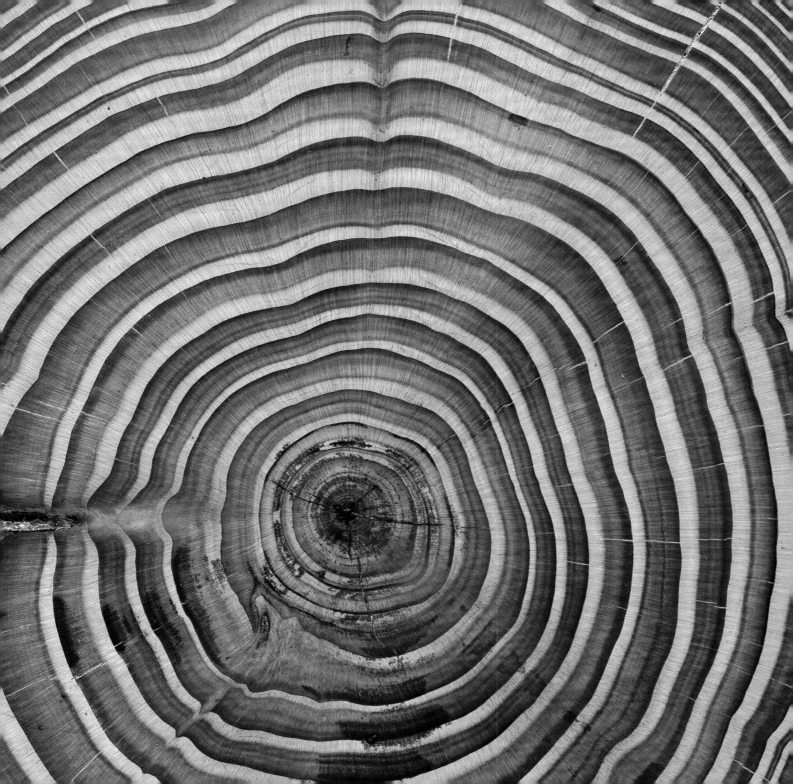

History in Tree Rings

Children learn to count the rings of a tree's trunk in order to figure out its age: one stripe for every year. But what's happening *inside* the tree that creates a distinguishable ring each year?

Nourishing sap flows up and down channels—the veins and arteries of a tree's circulatory system—that run from roots to twig ends and back. Just beneath the protective bark, xylem cells carry the sap up, phloem down—a transport system that provides the juices that keep the tree alive and growing. In places where conditions swing from hot summers to freezing winters, xylem and phloem movement changes with the temperature: free flow in summer, little to no flow in winter.

Meanwhile, as a tree grows, it gains in girth. This intersection of outward growth with the seasonal pulsing of sap creates the color differences visible as concentric rings in the trunk's cross section; a thick, light-colored band reflects summer abundance, while a darker, tighter line shows limited winter growth or drier conditions. A full year's growth adds one of each, which we tend to consider a single ring, counting only the dark ones. Summers with more rain generate broader spaces between the lines. It's not an exact science, but it's a way to read the history written into the trees.

Since neighboring trees experience the same weather, they lay down similar ring patterns over the years—something like a shared fingerprint for time. The outer 100 rings in a 300-year-old tree will closely match the pattern of thick and thin in the full set of rings in a nearby 100-year-old tree.

A tree's cross section tells its life story in rings.

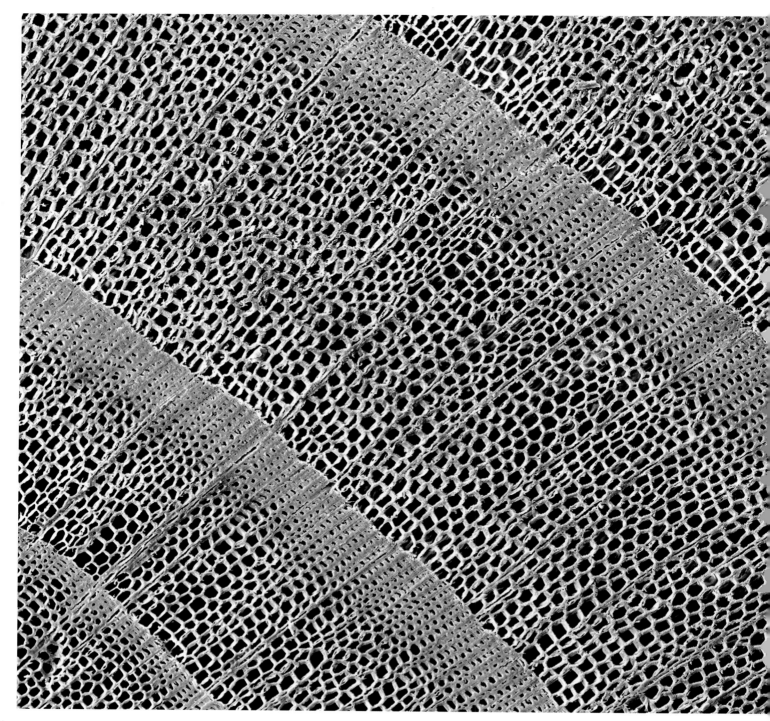

"I have a soft spot in my heart for tree houses, which have always imparted certain magic and practical knowledge."

—RICHARD LOUV,
Last Child in the Woods

Thus, tree rings reveal history—and fortunately, scientists called dendrologists have developed tools and techniques to bore into trunks without damaging them, extricating a section with the ring pattern intact. They can even reconstruct the past using the ring patterns of timber used in construction. One famous example is the Sweet Track, an ancient wooden walkway built through peat bogs in Somerset, England: Rings in its logs date the track back to 3806 B.C., making it a thousand years older than Stonehenge.

Tree rings have ancient stories to tell, if only we pause to listen. ▪

The rings of a larch tree cross section, here magnified, show the tightly packed cells of winter and the larger, looser cells of warmer weather.

THE MAORI CREATION MYTH

It all began as a long, dark night in which Ranginui, the sky father, and Papatūānuku, the earth mother, dwelled with their children. The children wanted to break free of their parents' all-encompassing embrace to see the light, but they argued about how to make that happen. One said they should kill their parents; another said they should let them be. Finally one brother, Tāne, lay on his back with his feet in the air. He pushed and pushed and pushed until he finally separated Rangi and Papa, creating the world we know today. Tāne is now honored as the God of the Forest.

Native tree ferns dominate the New Zealand bush, here near Rotorua.

FOLLOWING PAGES: A Vancouver botanical garden turns a riot of colors: Allium and bluebell flowers pop up as laburnum tree blossoms dangle down.

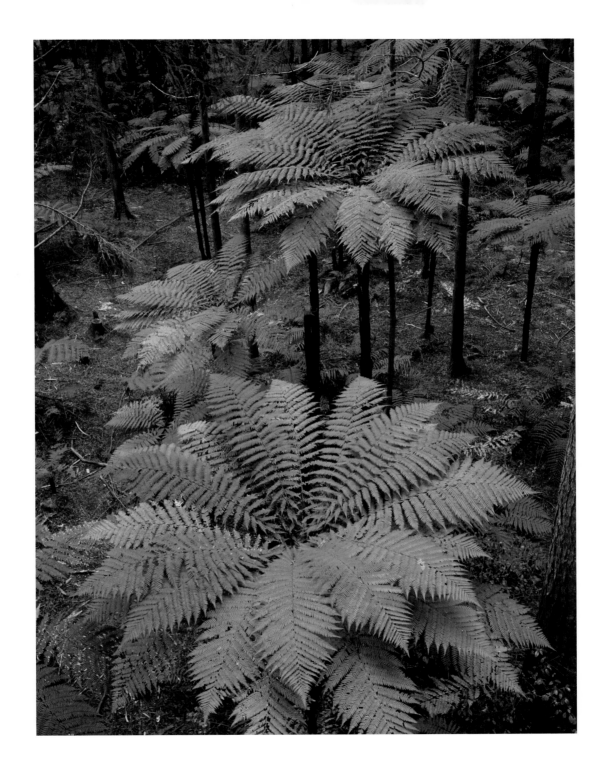

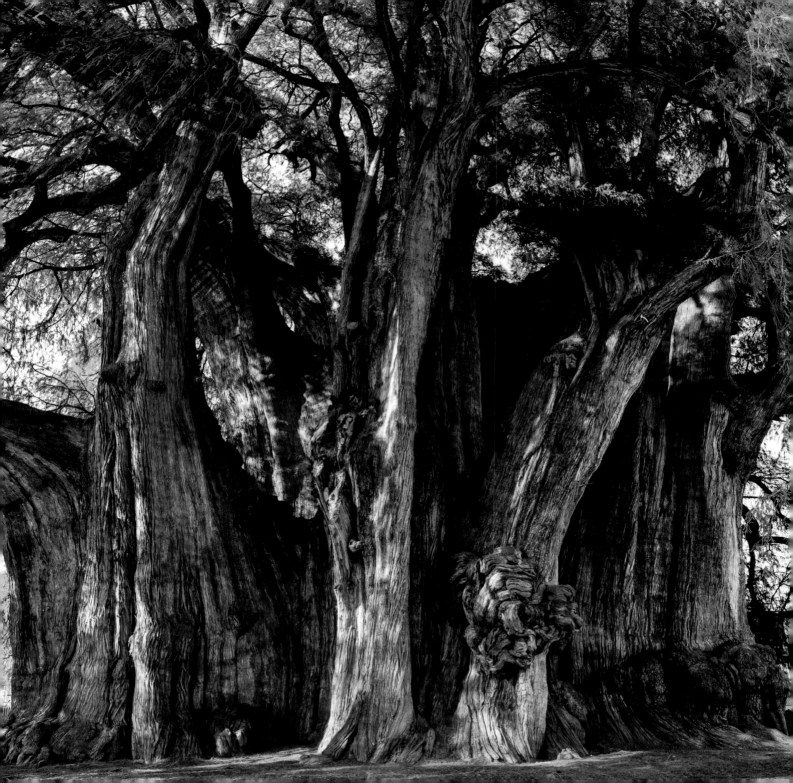

Extreme Trees

Among the world's trees, which is the biggest, the tallest, the oldest? It's a game we play, conducted by both adventurers—always out there finding more—and scientists, who take measurements to learn how and why certain specimens attain such colossal characteristics.

Part of the game is setting the parameters. So what constitutes "big tree" in this scenario? Most conclude that the prize goes to Pando, a multitrunk, single-rooted grove of aspen spreading over more than 100 acres in Utah. The combined mass of these tens of thousands of related upstarts is estimated at 13 million pounds.

But let's limit the contenders to single-trunk trees. Now which is biggest?

First, there's the massive sequoia named General Sherman in California's Sequoia National Park, towering at 275 feet tall, its trunk at the ground some 36 feet across. But that one's bested in height by Hyperion, a 380-foot-tall coast redwood discovered in 2006 deep in California's Redwood National Park. Its location is kept secret to preserve it from the harm that comes when a tree gets too famous—the most outrageous example being Yosemite's famous Wawona tree, one of the sequoias through which roads were cut in the late 19th century, pictured in many an early tourist photograph. Down came the tree during the winter of 1969, surely weakened by the tunnel dug through it.

Still, those tree trunks couldn't compare in width with El Árbol del Tule, a Montezuma cypress growing in Oaxaca, Mexico. Its gnarled and knotted trunk is

El Árbol del Tule, a Montezuma cypress in Oaxaca, Mexico,
claims the prize for broadest trunk: about 38 feet across.

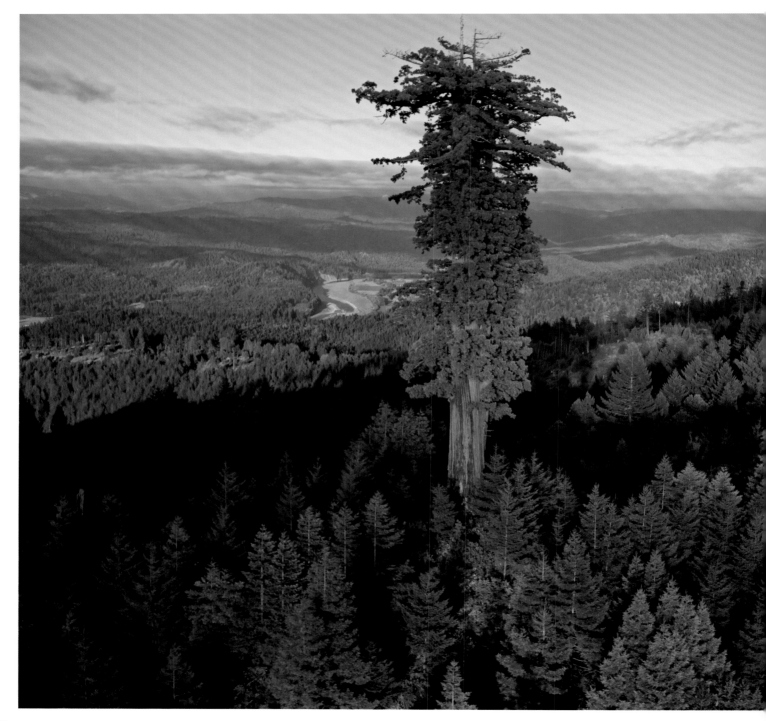

> "Among the scenes which are deeply impressed on my mind, none exceed in sublimity the primeval forests undefaced by the hand of man."

—CHARLES DARWIN,
The Voyage of the Beagle

difficult to measure, but one estimate of its circumference puts it at nearly 120 feet.

As to age, we return to Pando. Not only is the enormous grove of tree clones the biggest in the world; it's also the oldest organism known, its gene stock estimated at 80,000 years old or more. But if the measure is a single tree, the Great Basin bristlecone pines of California, Nevada, and Utah may win the prize. Native to bleak, cold, and arid mountaintop conditions, 10,000 feet above sea

A solitary redwood towers over neighboring evergreens
in California's Humboldt Redwoods State Park.

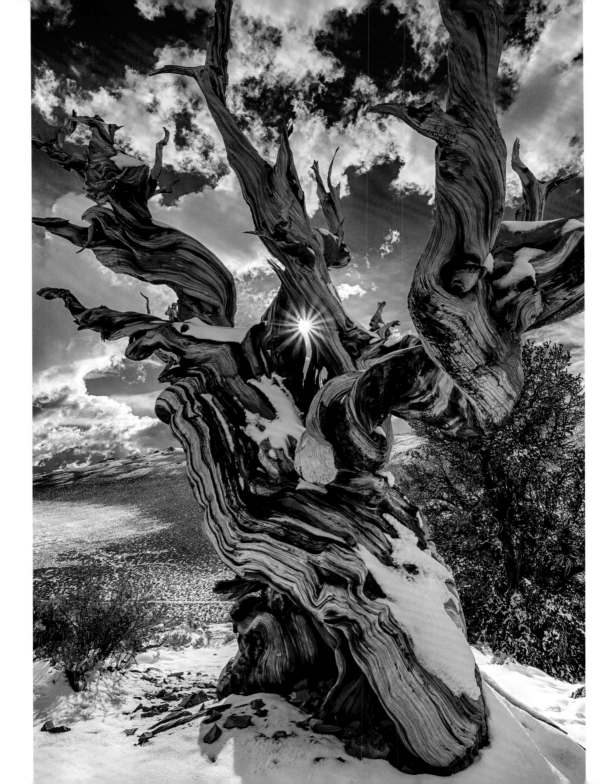

level, these trees brave the high timberline, where some have been weathering the storm for nearly 5,000 years.

One of these is Methuselah, most famous among the bristlecone pines, which has made it through 4,850 years. But a recently discovered bristlecone (as yet unnamed) tops that record, its age estimated to be an astounding 5,060 or 5,070 years. Like that of the giant California redwood Hyperion, its location is kept secret for its own safety. Another bristlecone pine of similar age, dubbed Prometheus, toppled in 1964 when the coring tool of researcher Donald Rusk Currey broke off inside its trunk. The U.S. Forest Service gave him permission to cut the ancient tree down, making it easier to count its rings: 4,844! That means Prometheus had already taken root when construction began on the first pyramids in Egypt.

Bristlecone pines have long fascinated many researchers. Ring pattern comparisons from ancient trees at high elevations throughout the Northern Hemisphere provide paleotemperature evidence that correlates with geological findings, allowing climate scientists to plot temperature change through time.

These ancient trees may also hold secrets about human aging. All chromosomes—plant and animal—end in structures called telomeres. Gerontologists have focused on telomeres in humans as a key to learning more about aging; some believe studying those of bristlecone pines may yield clues on how we can live longer (though likely not to the age of 4,000).

But wait—there's one more contender for oldest tree on the planet. A Norway spruce, scraggly and solitary, stands on a rocky mountaintop in Sweden's Fulufjället National Park. Carbon-dating the root system beneath it, scientists estimate that this tree is 9,550 years old. Observations suggest it was once part of a massive clonal stand, just like Utah's Pando. Now it alone remains, a sole survivor, pushing 10,000. ∎

The sun glints through the ancient limbs of
a bristlecone pine in California, long considered Earth's oldest variety of tree.

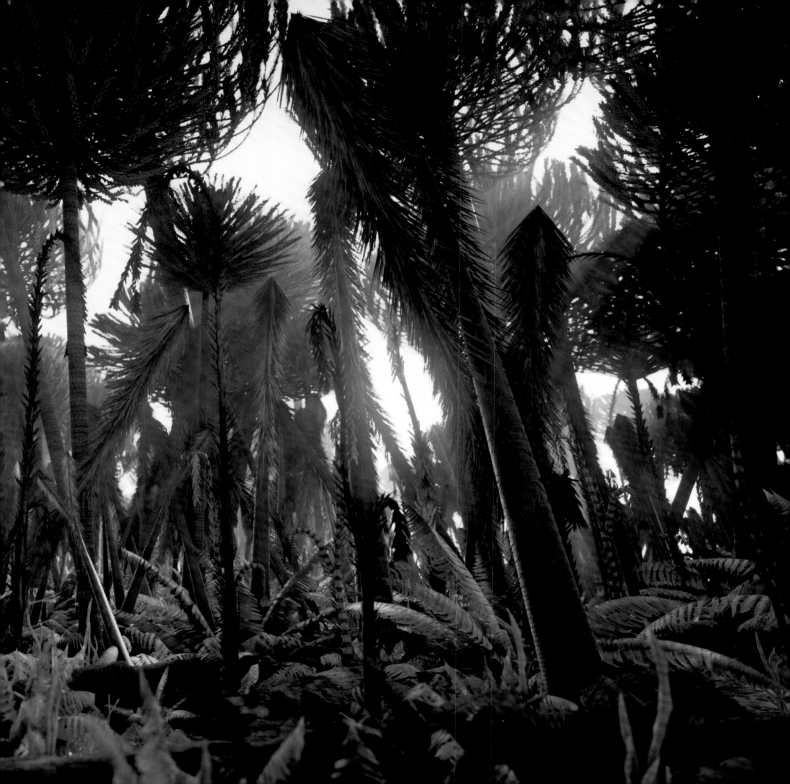

First Forests

In the grand sweep of evolution on Earth, forests came first. Before flowers, before dinosaurs, even before the continents took the shapes we know today, proto-tree communities grew on this planet. Fossils found around the world—in the Americas, Europe, Asia, North Africa—give paleobotanists a glimpse at what trees looked like 385 million years ago.

Imagine a grove replete with growth. Three kinds of plants stand side by side. One stretches its tall trunk up from a thickened base some six feet or more across. Its top splays out into a fan of fingers, like a child's drawing of a tree. Another, shorter, grows alongside, and from its trunk occasional branches jut out here and there, all the way up. A third grows underneath, thick rhizomes spreading snake-like, curling over and under the ground and around its taller neighbors.

We know now that a forest like this once grew in the North American Catskills. The evidence, discovered as sandstone, was chipped out of the Riverside Quarry in Gilboa, New York. As early as the 1850s, people were finding telltale chunks of fossil-filled stone, some the size of church bells, now understood to be castings formed by sediment that had hardened inside hollow prehistoric tree trunks. A dam built in the 1920s submerged the site for decades, but repairs forced it to be temporarily emptied in 2010, revealing the abundant forest that grew there and allowing identification of the three different tree species.

These three species, given the names *Eospermatopteris, Archaeopteris,* and *Tetraxylopteris,* predate dinosaurs by more than 100 million years. The tallest

Prehistoric forests may have looked like this artist's interpretation, inspired by tree fossil finds in China, Germany, and the United States.

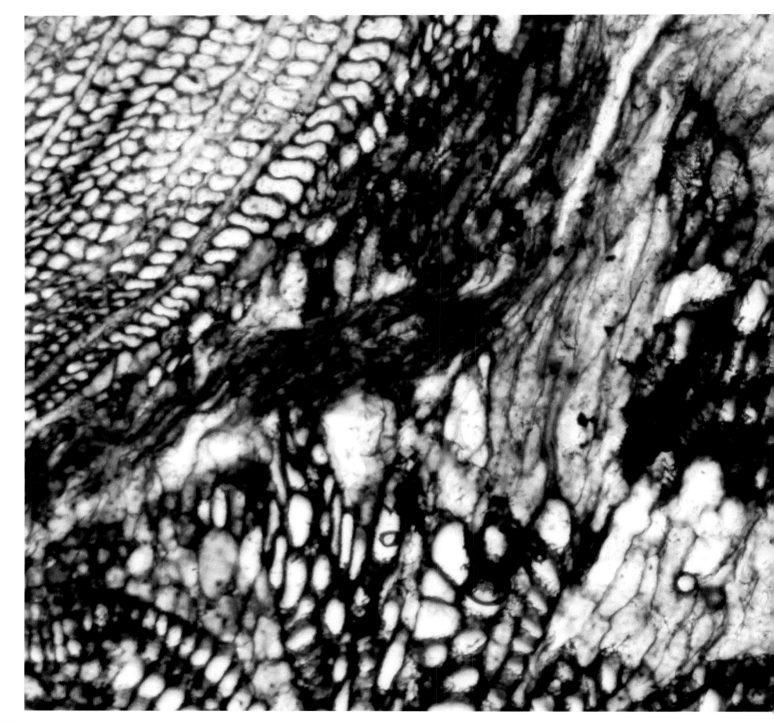

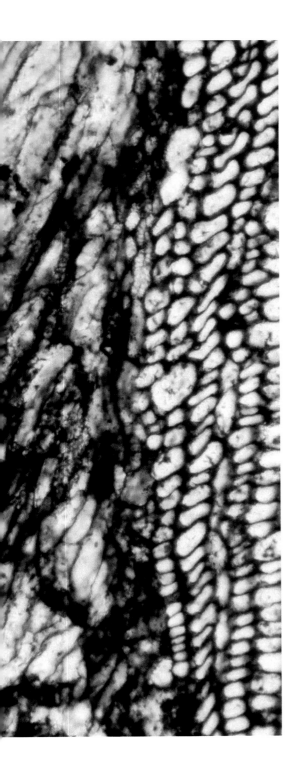

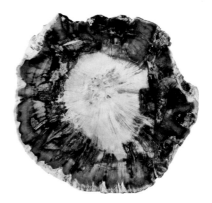

species had fronds somewhat similar to those of ferns of today, but no true leaves—a later evolutionary development that provided even more surface area to capture sunlight for the sake of photosynthesis.

Recent discoveries of intact cross sections of prehistoric tree fossils, found in northwestern China, revealed a primitive system of xylem cells by which water transport and growth occurred. Each new find enhances our understanding of evolution—not just of trees, but of the planet as a whole. As forests evolved, trees began soaking up carbon dioxide and providing oxygen to the atmosphere—essential steps on the path to a planet on which life abounds. ■

OPPOSITE: The tree ring structure of fossilized *Archaeopteris,* here greatly magnified, holds clues to how trees evolved.

ABOVE: A cross section of petrified wood from the Triassic period, 200 million years old or more

FAMOUS TREES

THE TREE WHERE A CITY BEGAN

A magnificent tree spreads its boughs at the center of the noisy, bustling coastal city of Freetown, capital of the West African country of Sierra Leone. It's a *Ceiba pentandra,* commonly called a kapok or cotton tree for the fluff that surrounds its seeds as they take wing. Some say it's 500 years old, some say older. Tradition speaks louder than science here, for all agree this tree gave shade to arrivals at the founding of the city in 1792.

Enslaved Africans who had fought in the American Revolution escaped to Canada, aided by abolitionists who sought ways for them to repatriate to Africa. More than a thousand freed men and women landed here from Nova Scotia, so it is told, establishing "Free Town" on a piece of property sold by tribal chieftains to humanitarian organizers in Britain and Canada. This very cotton tree marked the interior limit of the land. Those who arrived then are known as the Krio, or Creole, people.

The city has grown around the tree; its population now exceeds one million. The tree—and the country—has withstood tribal differences, colonial rule, and civil war. Many cherish the tradition of Freetown's cotton tree, but others scorn it as a symbol of slavery past. That attitude may have sparked two recent attempts to set the tree on fire, in 2018 and 2020. Flames leaped from the hollowed-out trunk, but the tree survived and still stands, a controversial symbol of a complicated past. ◼

Freetown, Sierra Leone, has built up in all directions around its famous cotton tree.

FOLLOWING PAGES: Lily pads mimic a woodland walkway in the Singapore Botanic Gardens.

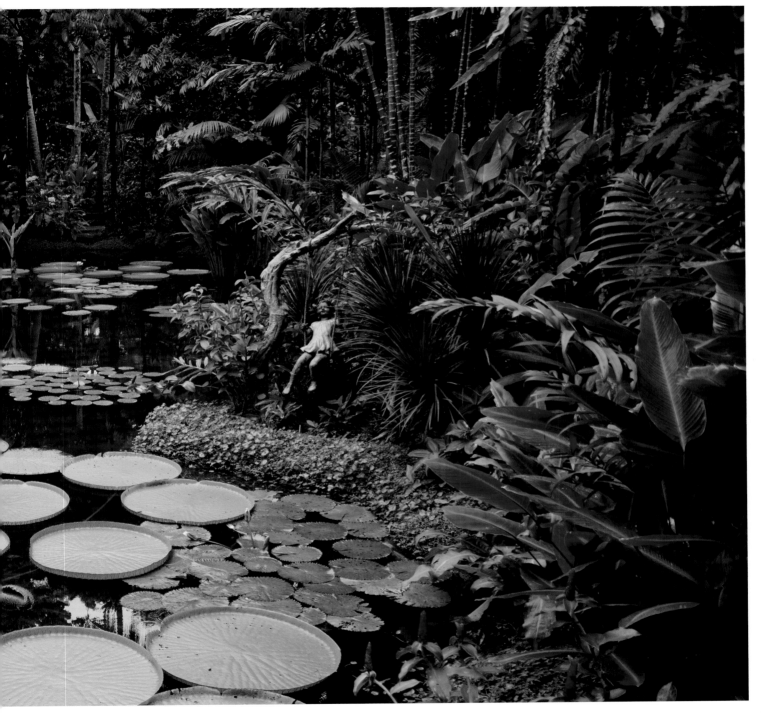

Captured in Amber

Burnished nuggets resembling translucent gold wash up on beaches around the world. Smooth and warm to the touch, pungent and piney, they hold a charge of static electricity, revealed by gentle rubbing. Now and then, one of these treasures encloses a glimpse of prehistory: a flea, a spider, a leaf, a flower, captured forever in amber.

This nugget began as liquid resin, exuded by a tree to cover over a wound. We can see its equivalent today, when pine trees ooze sticky sap where limbs are broken. But amber originates from tree species no longer extant that lived millions of years ago. The resin from them flowed and hardened, occasionally engulfing detritus along the way. Borne by rivers, floods, or glaciers, these hardened bits of life settled underwater, resurfacing on seashores far from where their parent trees stood.

Amber is an archaeological treasure trove. Necklaces of amber beads dating to the Stone Age have been found in Danish bog lands. The ancient Greeks so valued amber that they attributed it to the gods. In one tradition, it was the tears of Apollo, god of the sun; in another, it was the tears of the Heliades, mourning Apollo's son Phaethon, whose attempt at driving the chariot of the sun ended in his death. Amber was prized among the ancients as medicine and incense, as a talisman and an embalming agent.

Today, we honor amber for the life-forms it preserved so well that cells and even DNA can be extracted and analyzed. A flea, a wasp, an ant, a spider: Tiny

Some 40 to 50 million years ago, tree resin hardened
and entrapped this fly in amber.

creatures that lived millions of years ago, captured in fossilized tree resin, can be studied with modern technologies.

These bits of amber contribute to our understanding of evolution. Samples excavated from the shoreline of Grassy Lake in southeastern Alberta, Canada, revealed feathers dating to the Late Cretaceous period, some 100 to 65 million years ago. The details are so exquisitely preserved that paleontologists have been able to determine that some came from dinosaurs and others from birds, linking the reptiles of the past with the birds of today. ■

ABOVE: Stone Age artifacts from Denmark exemplify how long amber has been cherished in human culture.

OPPOSITE: Dinosaur remains captured in Canadian amber reveal their precursor feathers.

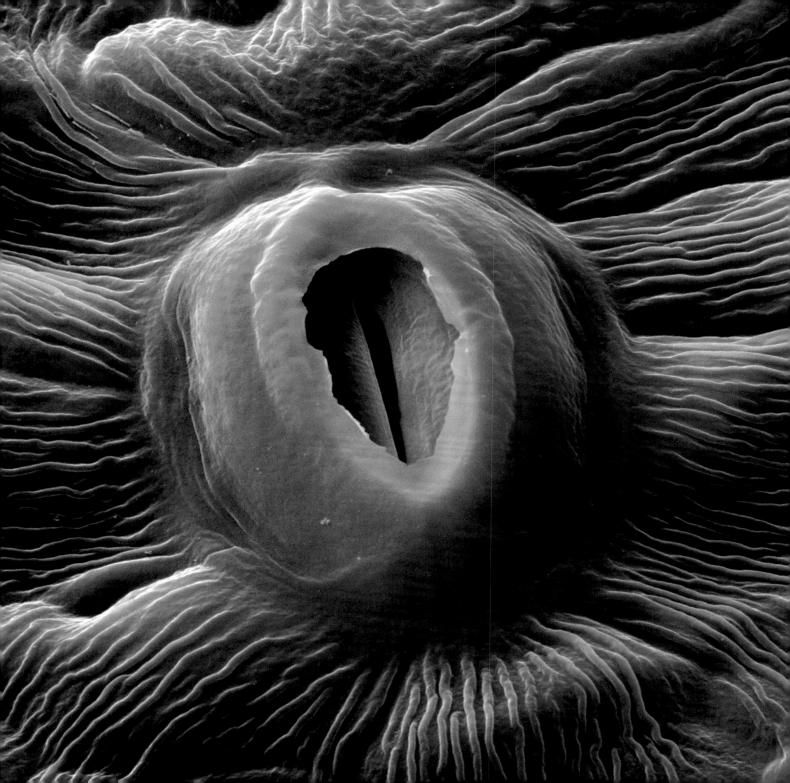

Carbon Copies

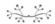

We are told that by preserving Earth's forests and even planting more trees, we can counteract the effects of climate change. But how does that happen? Follow the carbon.

Carbon is one of the basic constituents of the material world. It is an element that exists in the air around us, in our bodies, and in the natural world—rocks and rivers, plants and animals, seas and trees. The livelihood of planet Earth depends on its carbon cycle: the balanced circulation of this key element through land, ocean, and atmosphere.

Because of its atomic structure, carbon bonds with other elements in numerous ways, creating the backbone of many complex organic molecules—the stuff of life. When those molecules are broken down, energy is released. That's what happens when we eat food, and it's what happens when leaves photosynthesize.

Trees play a critical role in Earth's carbon cycle. Just as we breathe in and out, plants also exchange gases, taking in carbon dioxide and water and, through photosynthesis, breaking down those molecules, rebuilding them as sugar for food and releasing oxygen back into the atmosphere. With those carbon-rich sugars, trees develop wood, leaves, flowers, and fruit.

Trees participate in Earth's carbon cycle in other ways as well. As creatures (including us) eat the products of trees, we break down their sugars, using them for energy and leaving behind waste. As plants decompose—as leaves drop and

Through leaf pores called stomata—shown here via a scanning electron microscope—
trees breathe in carbon dioxide and breathe out oxygen.

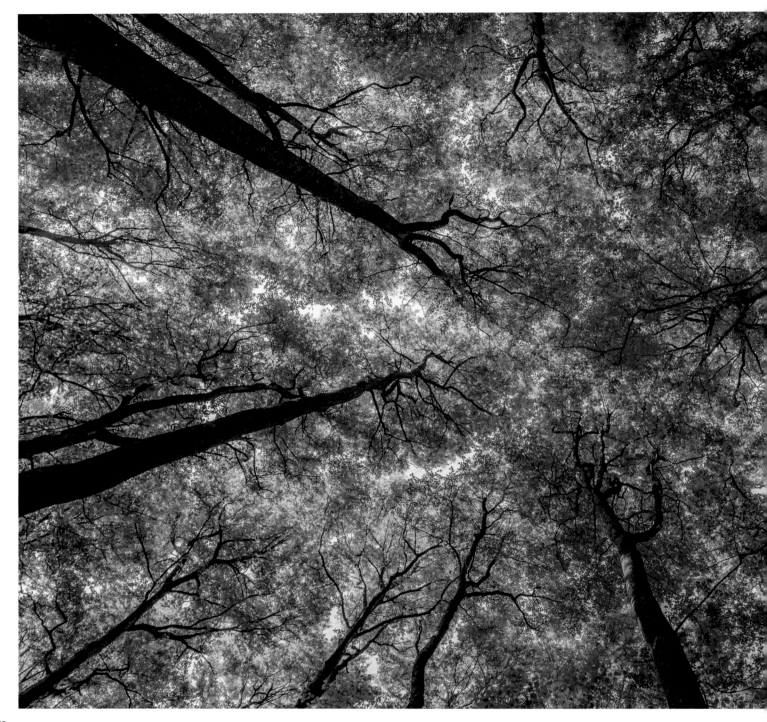

"Trees are sanctuaries. Whoever knows how to speak to them, whoever knows how to listen to them, can learn the truth."

—HERMANN HESSE,
Wandering: Notes and Sketches

trees topple and both decay on the forest floor—the complex sugar molecules break down, causing carbon to return to soil. During a forest fire, as flames consume the wood, carbon reenters the atmosphere in the resulting gases.

All these processes have been happening for millennia. What's different now is that we humans have found more ways to eject carbon into the atmosphere, tipping the cycle off-balance. When we extract coal, oil, and gas for fuel, we are tapping into Earth's ancient carbon reserves. When we

Water and gases move perpetually through the world's trees—a process critical to the nature of Earth's soil and atmosphere.

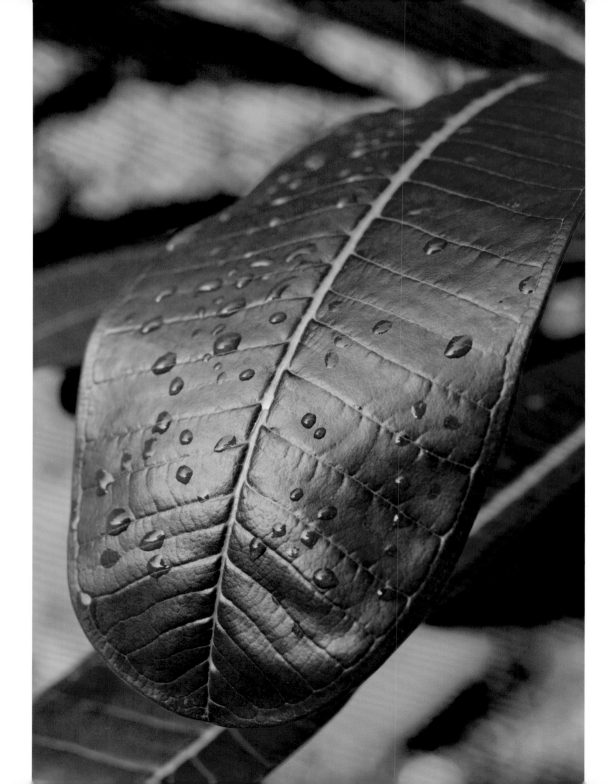

burn that fuel, we release carbon into the atmosphere—more, prematurely, compared with unmitigated planetary processes.

Carbon-based molecules in the atmosphere serve as greenhouse gases—so called because, like a greenhouse, they hold energy, felt as heat, within the atmosphere that blankets Earth. More carbon, more greenhouse gases trap more heat and raise the temperature of Earth and the atmosphere. Forests can modulate that dynamic, but as we cut down trees, fewer remain to absorb carbon from the atmosphere.

Conversely, the more forests that grow, the more carbon trees can absorb by photosynthesis. They become what some call carbon sinks, with the trees pulling carbon from the atmosphere and depositing it in the wood of their trunks, limbs, and twigs, in the detritus of the forest floor—and, ultimately, back into the earth. ∎

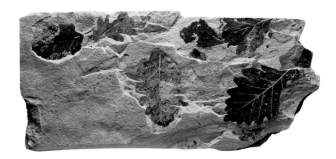

OPPOSITE: Evapotranspiration, or the movement of water in and out of plants, plays a key role in the water cycle of the planet.

ABOVE: These fossil impressions of tree leaves may be two million years old.

Growing Up With Trees

We disseminate the concept in the very word we use for a child's first year in school: "kindergarten"—a children's garden. The term was coined by educator Friedrich Froebel in early 19th-century Germany, in the thick of the Romantic period, when poets and philosophers alike sought inspiration in the natural world. Froebel's ideas set off what educators call the kindergarten movement—based on the theory that guided play in a natural environment starts children on the path to a better life.

More than a century later, as if to refresh the notion, a woman named Ella Flatau inspired what she and fellow Danes called *Naturbørnehavens:* forest schools. Young children, she believed, learned best when allowed the freedom to play and explore in nature. Neighboring Swedes, already convinced of the value of *friluftsliv*—free air life—for their children, established similar *I Ur Och Skur:* rain or shine schools.

The movement has snowballed, and now young children attend forest schools around the world. Known as "bush kindy" in Australia, "enviroschool" in New Zealand, *mori-no-youchien* in Japan, and *Waldkindergarten* in Germany, they present an antidote to the rise in urban lifestyles, screen technologies, and childhood ailments such as attention deficit hyperactivity disorder (ADHD) and obesity.

Research has affirmed the philosophy. When their school setting includes

Gazing up at trees, a child may develop a playful imagination
and a respectful regard for the natural world.

more green, children in countries around the world have been observed to gain in mental acuity, self-confidence, and creativity; they also grow up healthier, both physically and emotionally. Conversely, according to one Danish study, children growing up amid less green space were more than twice as likely to develop psychiatric disorders later in life.

But why? That's harder to assess. Biologist Edward O. Wilson would attribute it to biophilia, our genetic predisposition to find satisfaction through connection with nature. Richard Louv, founder of the Children & Nature Network, has dubbed it Vitamin N—an "elixir in the age of nature-deficit disorder," based on the principle that a heartfelt connection with nature is "fundamental to human health, well-being, spirit, and survival." With the forest our children's classroom and the trees their teachers, we set them on the path to a life in harmony with nature. ∎

Children today delight in climbing trees, as they have through the ages.

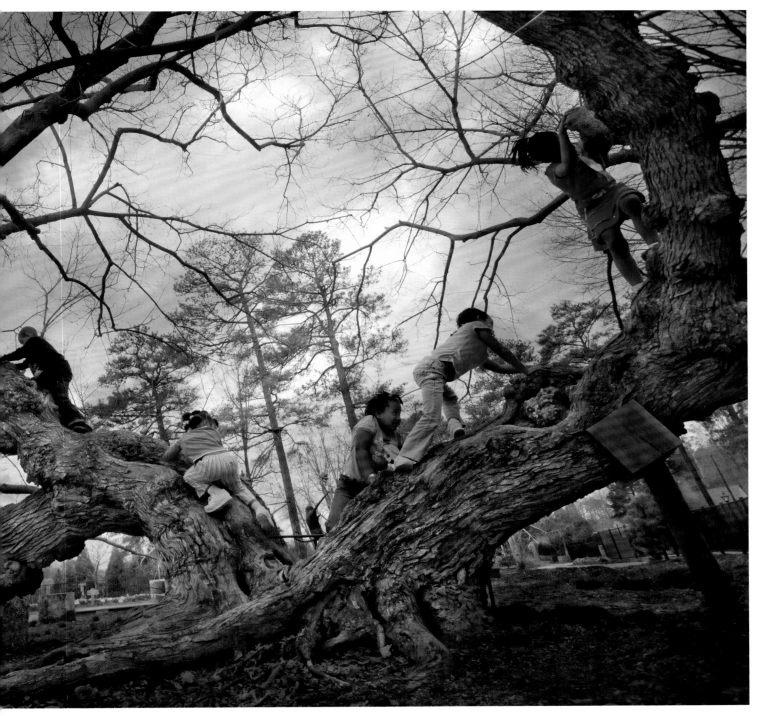

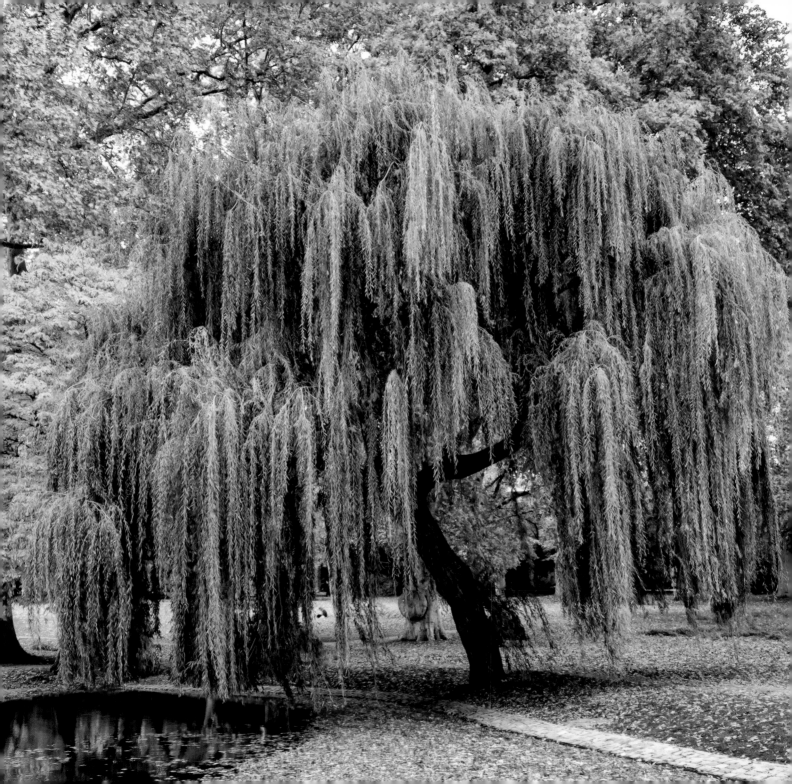

Tree Medicine

The very phrase "herbal medicine" suggests that the plants with curative powers are herbs—leafy greens low to the ground. But for millennia, remedies have also been harvested from trees around the world. Two of the most famous, willow and cinchona, have different stories to tell.

We know that the ancients turned to willow trees to ease pain. The Ebers Papyrus—the oldest known compilation of medical knowledge—references "splinters of the willow tree," as it has been translated, to calm the nerves. Hippocrates eased the pain of childbirth with willow leaf tea. Folk healers in Europe and North America gathered the inner bark of the willow tree, finding it (in the words of an 18th-century clergyman) "very efficacious in curing aguish and intermitting disorders."

In the 19th century, German and French scientists isolated the active ingredient in willow bark, naming it salicin after the tree's botanical name, *Salix*. But it took German chemists working for the Bayer company (and deriving salicin not from willow bark but from meadowsweet, an herb used for centuries by European herbalists) to develop a compound that did not upset the stomach. The result was aspirin. Which chemist actually came up with the winning combination has long been the subject of debate. But those controversies are nothing compared with those that arose over the other world-renowned medicine derived from a tree.

Chemists developed the formula for aspirin from the inner bark of willow trees.
Seen here, a weeping willow in Germany

By the time European conquistadors laid siege on the Americas, malaria was already a well-known and broadly feared disease. Cuneiform tablets, Vedic scriptures, an ancient Chinese canon, and Homer's *Iliad* all mention the ague that came from swampy waters and insect bites. So in 1630, when the Spanish Countess of Chinchon, wife to a nobleman and emissary to Peru, found relief from fever thanks to the dried bark of a native tree, European physicians believed a wonder drug had been discovered.

We now know the tree as cinchona, a name given it by Linnaeus, after the countess. And we now understand that its active ingredient is

OPPOSITE: At a plantation established in the 1940s in India, a woman spreads cinchona bark to dry for processing into quinine.

ABOVE: A wooden bowl holds shavings of willow bark, long revered for its medicinal properties.

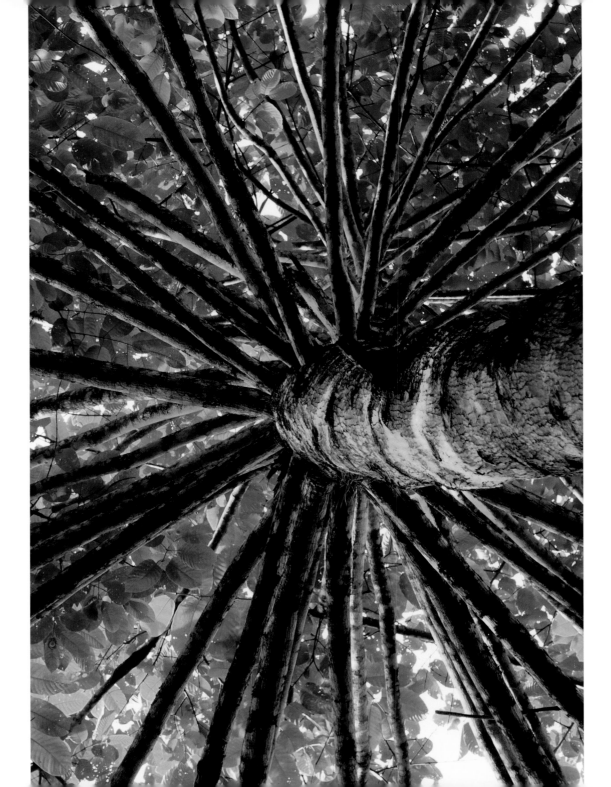

quinine, a chemical component of the tree's inner bark that is indeed effective in killing *Plasmodium,* the parasite spread by mosquitoes that causes malaria. But natives familiar with the tree likely did not know that detail, because malaria did not even exist in the New World until Europeans brought it there.

Word of Peruvian bark, as it was known, and its curative powers swept through Europe. As more tropical lands were colonized, malaria grew as a threat, making cinchona bark essential to empire building. Expeditions drove into South American forests to harvest the bark and gather seeds and saplings to propagate in more convenient locations. By the mid-1800s, cinchona plantations had been established far and wide: on Caribbean and Indo-Pacific islands, as well as in Africa, India, Australia, and New Zealand. Not all proved fruitful producers of quinine.

By the early 20th century, the Dutch and British vied for world domination in the cinchona market, with successful plantations in Java and India, respectively. During World War II, Germany and Japan captured plantation territories and quinine reserves, making the laboratory quest for synthetic quinine all the more urgent. As recently as 2006, a million people around the world died annually of malaria, despite effective antimalarials such as chloroquine, made famous as a putative antidote to COVID-19. To complete the circle, some researchers are now exploring naturally derived quinine as part of a COVID treatment.

In the end, it all comes back to the tree—in these cases, the willow and the cinchona—and to that essential part of the tree, the inner bark. It makes sense that the layer designed to circulate life-giving food to limbs and branches, flowers and fruit, would prove beneficial to humanity.

Happily, what's good for the tree may sometimes prove good for human health as well. ∎

Cinchona trees, native to South America, are the natural source
for quinine—once the only known cure for malaria.

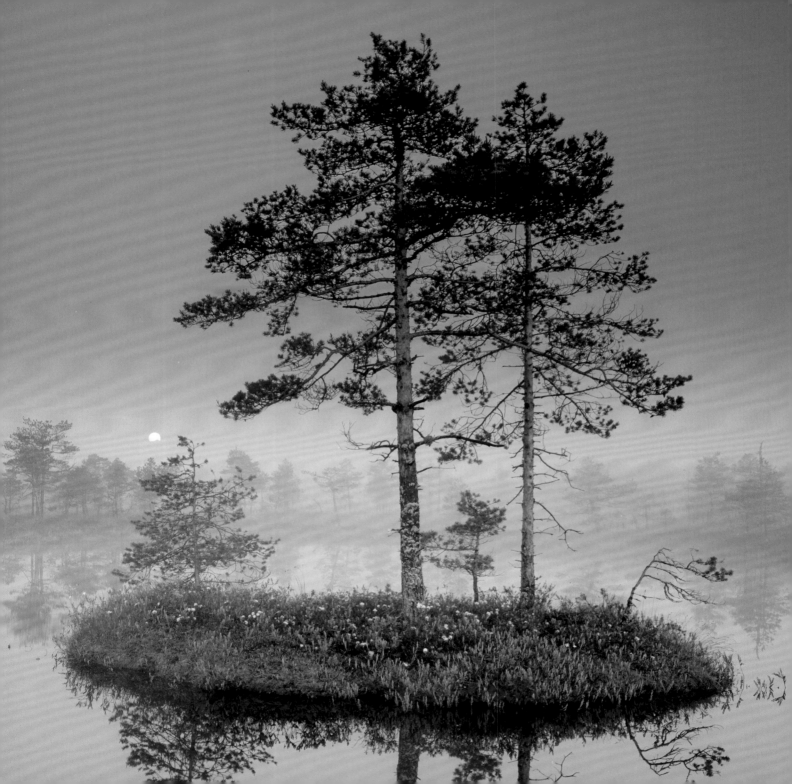

The Loveliest Poem

He may have been a hero in his time, but today, Joyce Kilmer is known for writing just two lines of poetry: "I think that I shall never see / A poem lovely as a tree." It's a concept so clean and universal that it has survived for more than a century in our cultural imagination.

First published in *Poetry: A Magazine of Verse* in August 1913, the simple 12-line poem went on to personify the beloved tree, which "may in Summer wear / A nest of robins in her hair," and ended with an endearing moment of self-deprecation on Kilmer's part: "Poems are made by fools like me / But only God can make a tree."

A devout Catholic, Kilmer worked as a writer and editor, including a stint on the staff of the *New York Times*. But his life was cut short in his early 30s. He enlisted for service during World War I and, deployed as an intelligence officer in Europe, was shot and killed as French and American troops pushed the Germans back along the banks of the Ourcq River. To honor his bravery, his memorial mass took place in New York's magnificent St. Patrick's Cathedral, and he was posthumously awarded the French Croix de Guerre.

His poem, though, was kept alive—in large part because its sentimental lyrics were set to an equally sentimental tune by composer Oscar Rasbach in 1922. It was then included in more than a dozen films and television segments, from '20s-era Vitaphone shorts to *The Muppet Show* in the 1970s. Kilmer's name now graces a 3,800-acre old-growth forest and wilderness area in western

Moonrise, mist, and lonely trees—prelude to poetry

> # "The woods are lovely, dark and deep, But I have promises to keep, And miles to go before I sleep . . ."

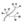

—ROBERT FROST,
"Stopping by Woods on a Snowy Evening"

North Carolina; an elementary school in Chicago; a service plaza on the New Jersey Turnpike; and parks in the Bronx and New Brunswick, New Jersey, his birthplace.

And though he published countless other poems—many about his love of the natural world—Joyce Kilmer will be forever remembered for his two lines commemorating the poetic loveliness of the tree. ◾

Ancient trees reach back to mythic times. This one, in England's Dartmoor Forest, is nicknamed Medusa, after the Gorgon with snakes for hair.

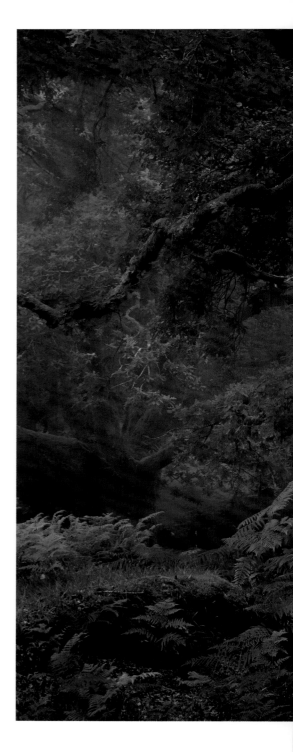

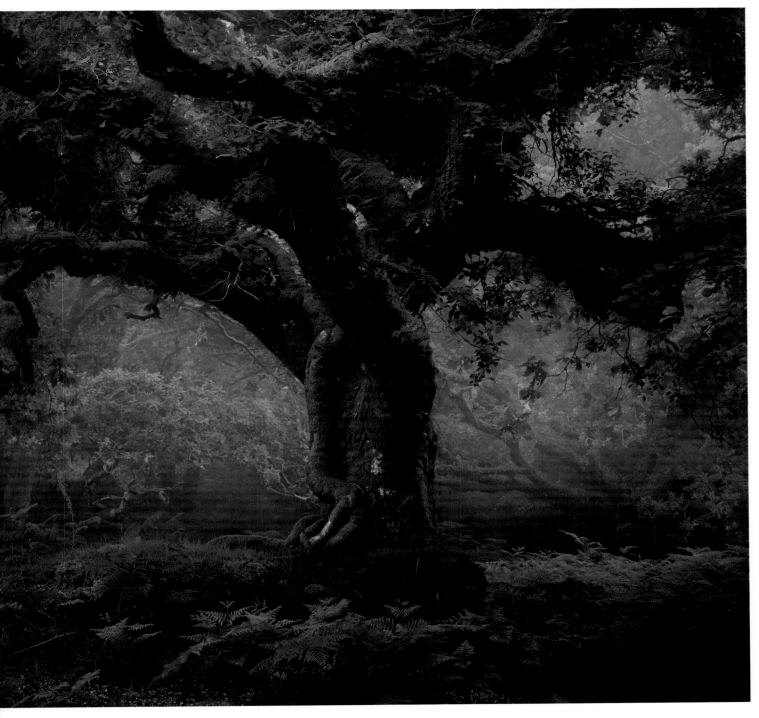

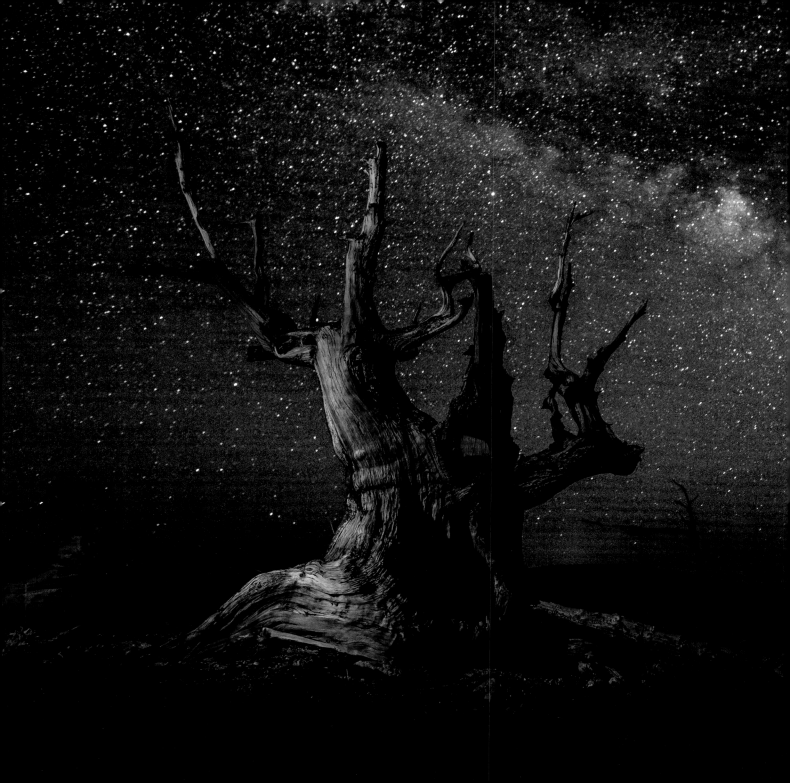

Good Night, Tree

We think of trees as immovable. They may sway in the wind or change shape as they grow. But move with the rhythms of day and night? Yes: According to ancient and current knowledge, a tree undergoes a diurnal cycle, change rippling through its cells, measurable physical swings occurring between sunset and sunrise, even if we do not notice.

Recent experiments have shown these 24-hour cycles. Collaborators in Finland and Austria selected silver birch trees—same species, different conditions—and used laser scanners to plot their positions through time; this way, they could track them all night without artificial light. They took readings only on windless nights, to eliminate wind as the cause of changing shapes.

With this approach, the researchers were able to create a three-dimensional point cloud: animated tree avatars whose shapes they compared through time. They found that the birches drooped at night and perked up in the morning. Branches moved as much as 10 centimeters, changing the most nine to 10 hours after sunset and returning to daytime positions soon after dawn.

Does this mean trees go to sleep? That's the human way of saying it. But country folk who tap maples have long recognized the trees' daily cycle. At a key moment in the year, sugar-rich spring sap flows up as the sun hits opening tree buds and sinks back as the sun goes down. Tap into that diurnal cycle, and you've got the makings of maple syrup. ◾

Edging on eternal: a sky full of stars and a bristlecone pine,
centuries old, in Patriarch Grove in California's White Mountains

FAMOUS TREES

THE TREE THAT IS A FOREST

A brilliant yellow washes through 106 acres in central Utah every autumn, the shimmering leaves atop a stand of some 40,000 to 50,000 aspen trees, all originating from a single root system. Tens of thousands of trunks and treetops, one living organism: Called Pando—Latin for "I spread"—this interconnected arboreal wonder is believed to be the world's largest living being considered by mass. It may weigh some 13 million pounds.

Each individual is genetically identical to the rest. Although aspens can reproduce by sprouting from seed, DNA testing has confirmed that all these trees arose by cloning, new shoots coming up from the same vast underground root system in a process called suckering. In 1976, the number of individual suckers was put at about 47,000—and the age of Pando at 80,000-plus years.

But many worry that Pando's days are numbered. Few new suckers are maturing. Cattle and mule deer graze here, treading and nibbling on new shoots. Juniper and other invasive plants fill in the understory and compete with the young trees. And a fungus called shepherd's crook may be discouraging new growth, too.

Forest rangers and tree lovers alike are seeking ways to rejuvenate Pando. Advocacy groups like the Grand Canyon Trust are putting in hours and dollars to fence in areas, weed out invasives, and support science dedicated to keeping this great organism thriving. ∎

The many quaking aspen tree trunks in Fishlake National Park, Nevada, all emerge from one root system: Pando, the world's largest single organism.

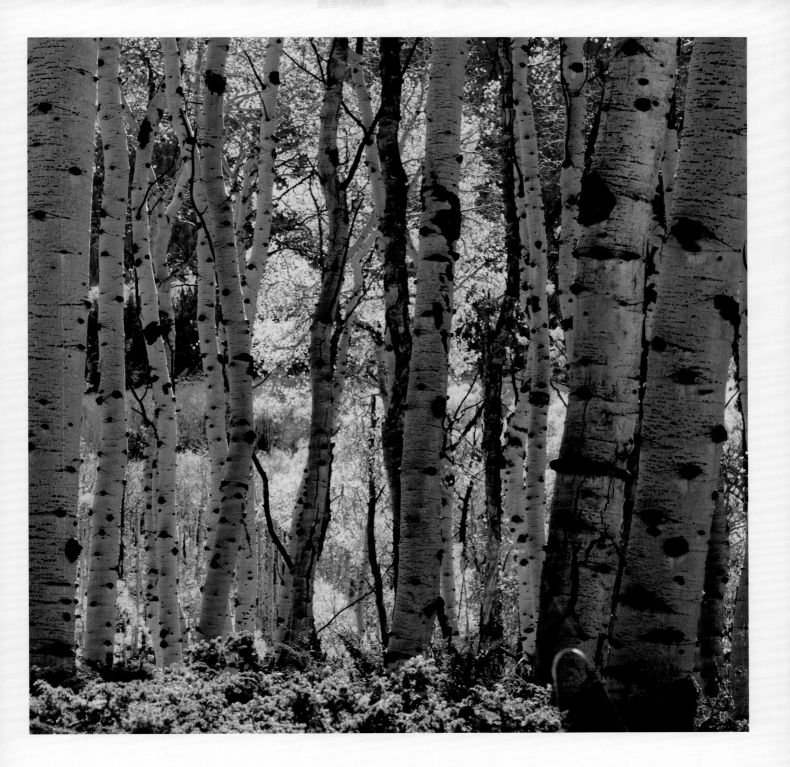

CHAPTER TWO

EARTH

Trees emerge from the soil underneath,
intertwining with the life it cradles.

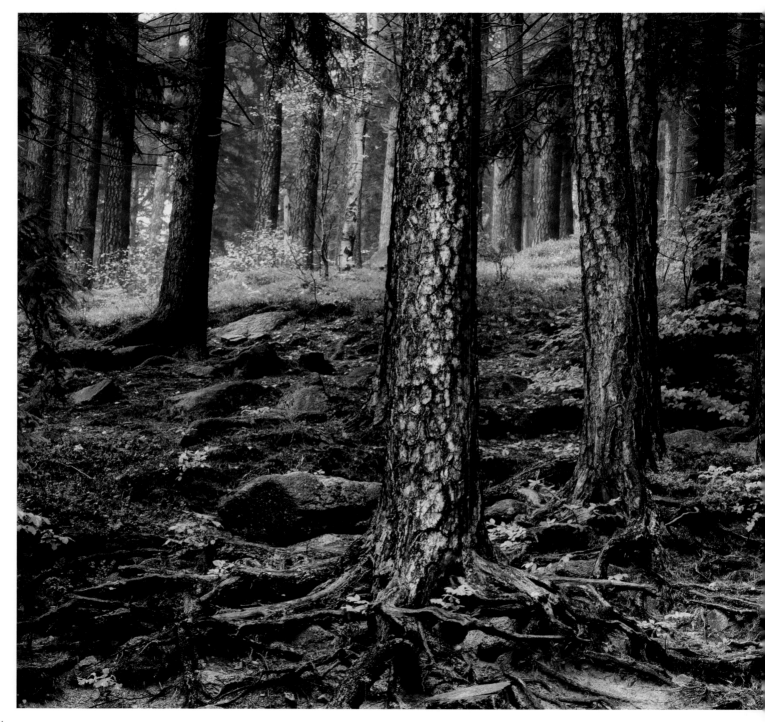

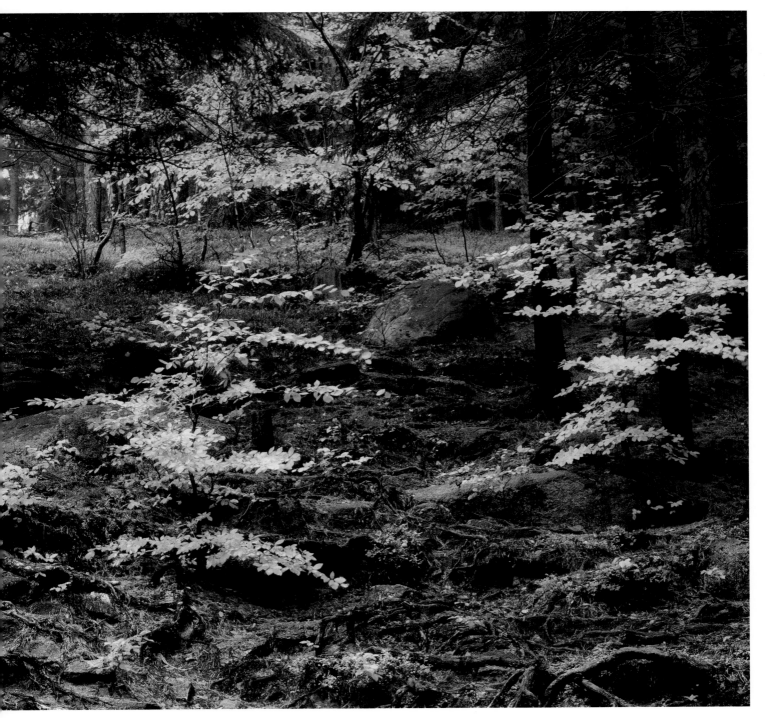

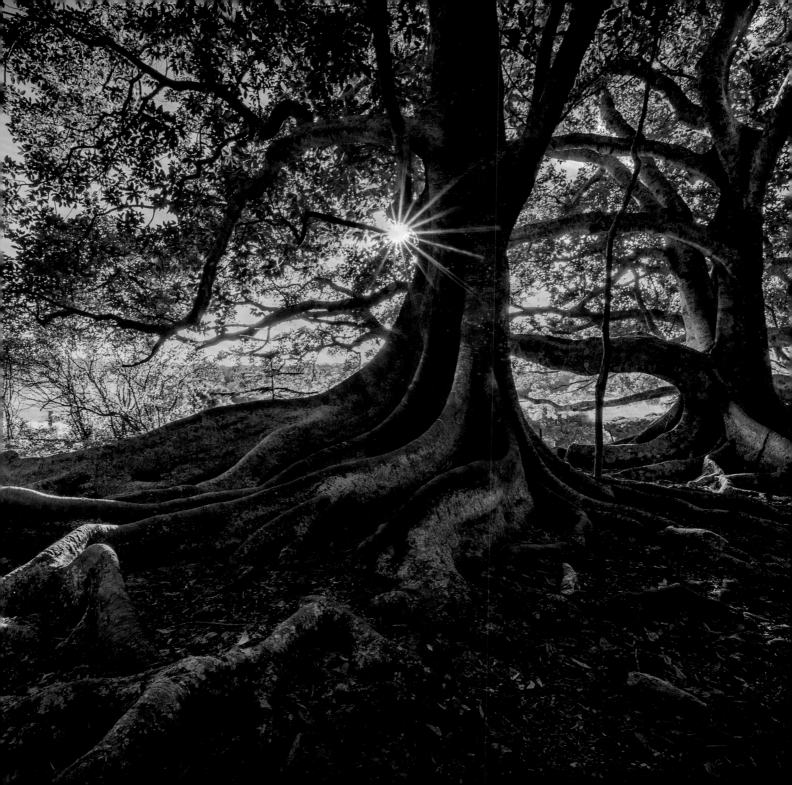

The Underground World

If you ask a child to draw a tree, the result will be a stick standing on flat ground with twigs and leaves branching from it. Fact is, that's the picture most of us hold of a tree: the aboveground portion. Yet a whole world—messages and exchanges, connections and interactions, life-forms galore—dwells underground as well: a context just as vital to the tree as the trunk, limbs, and foliage above.

Welcome to the rhizosphere.

"Rhizosphere," meaning "the world of the root," is a word coined more than a century ago by German biologist Lorenz Hiltner. An expert in the interaction of roots and soil, Hiltner and his research team won notoriety at the 1904 World's Fair for a soybean inoculation method that enhanced the interaction of plant roots and bacteria, improving the health of both plants and soil. More generally, Hiltner recognized that every plant is (in his words, translated from the German) "substantially dependent on the composition of the soil microflora in the rhizosphere."

Little did Hiltner know what a complex world he was unlocking for investigation. Today, we are only beginning to understand the complicated network of plant and animal life that makes up the rhizospheres under the world's trees—from the visible (insects, worms, fungus) to the invisible (nematodes,

Morning light illuminates the rambling roots
of Moreton Bay fig trees on Australia's Norfolk Island.

PREVIOUS PAGES: A forest photograph from Poland's Karkonosze Mountains shimmers
with textures worthy of a painting.

bacteria, even viruses). Entire studies have sought to characterize the rhizosphere of single plant species in particular climates. All amount to the amazing conclusion that for a tree, to a large extent, underground is where the action is.

It's a dynamic world, with trade-offs of nutrients and carbon occurring constantly among species. Outside conditions affect these interactions: too much water or not enough, sweltering heat or frigid cold. The impact of human development ripples through the rhizosphere as well, as we plow up, tamp down, and build on top of the soil.

To truly know the forest, we must delve into the underground world that supports it. And to understand that world, we must go deep, dark, and small. ■

A cliffside collapse reveals the complicated system of roots supporting this precarious tree.

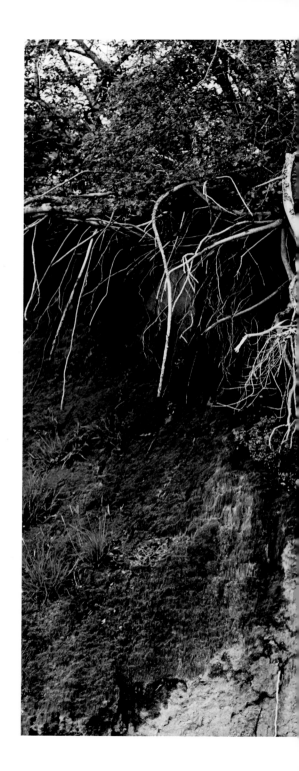

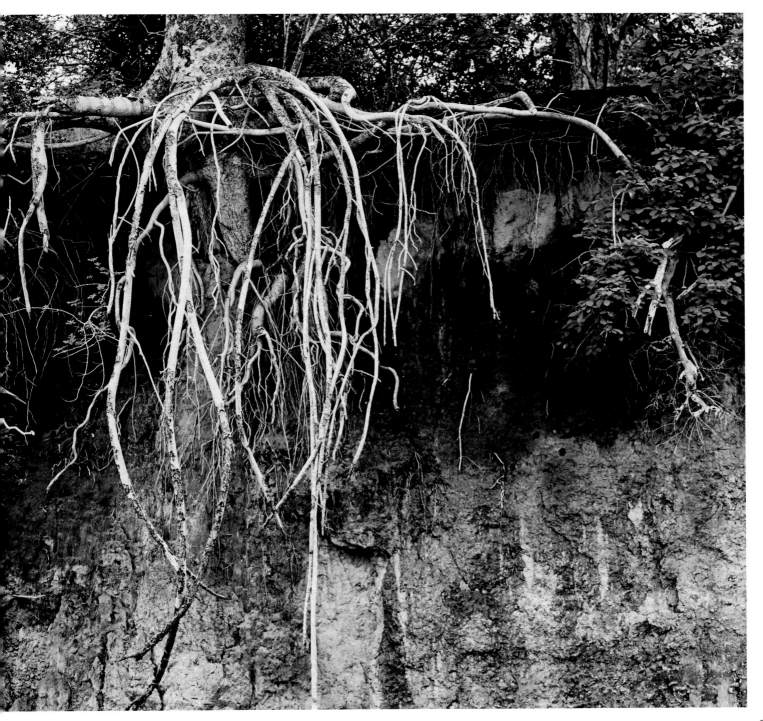

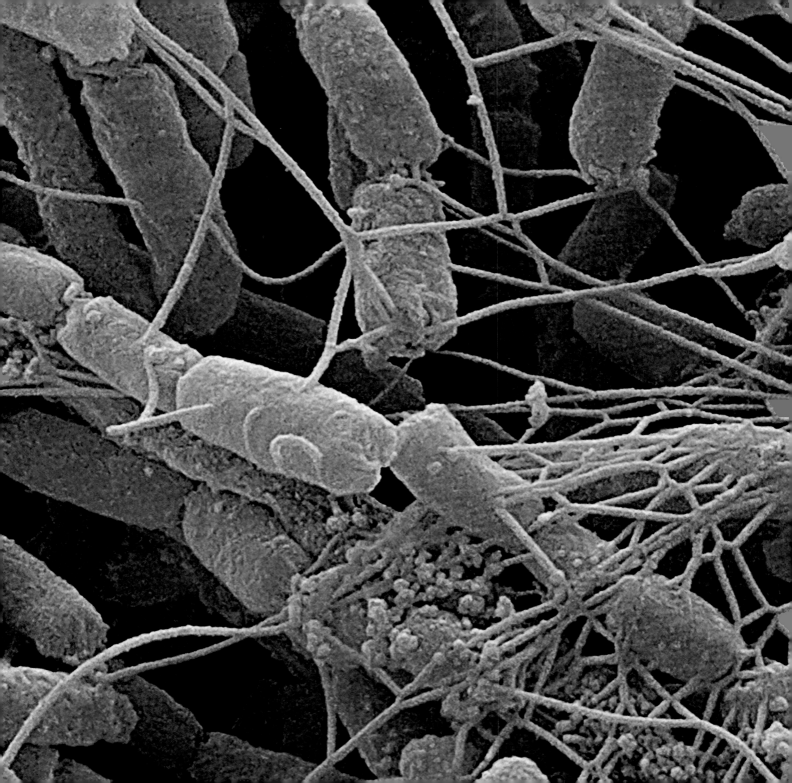

Microbes Down Under

Just as we are only beginning to understand the role of bacteria in human health—the gut microbiome—so are we only coming to recognize the role and abundance of bacteria that keep the forest alive and well. For the forest has a microbiome, too. If only we could peer down into the soil and magnify the image by a thousand or even more, we would see a bustling, interconnected network of participants, with bacteria playing key roles in the community.

Gardeners and farmers have long known that certain soil-dwelling bacteria will boost the growth of their plants. A bacterium called *Rhizobium* has a special relationship to plants in the legume family: peas and beans, but also trees including black locust, honey locust, mimosa, redbud, acacia, and tamarind. Special nodules develop along the roots of these leguminous plants, and bacteria take up residence inside those nodes. The plant provides carbon, generated via photosynthesis, to the bacteria. The bacteria pull available nitrogen from the soil and offer it as food for the plant, in a process called nitrogen fixation.

While the usefulness of *Rhizobium* has been recognized (if not fully understood) since Roman times, scientists have only recently begun to take a census of bacteria living in soil, each with its own way of contributing to the forest's livelihood. One study analyzing 30 grams—that's two tablespoons—of soil from a thriving beech forest in Norway found it to contain thousands of

Color-enhanced and magnified some 16,500 times, this image lets us peer in on the world of a *Streptomyces* bacteria, commonly found in soil.

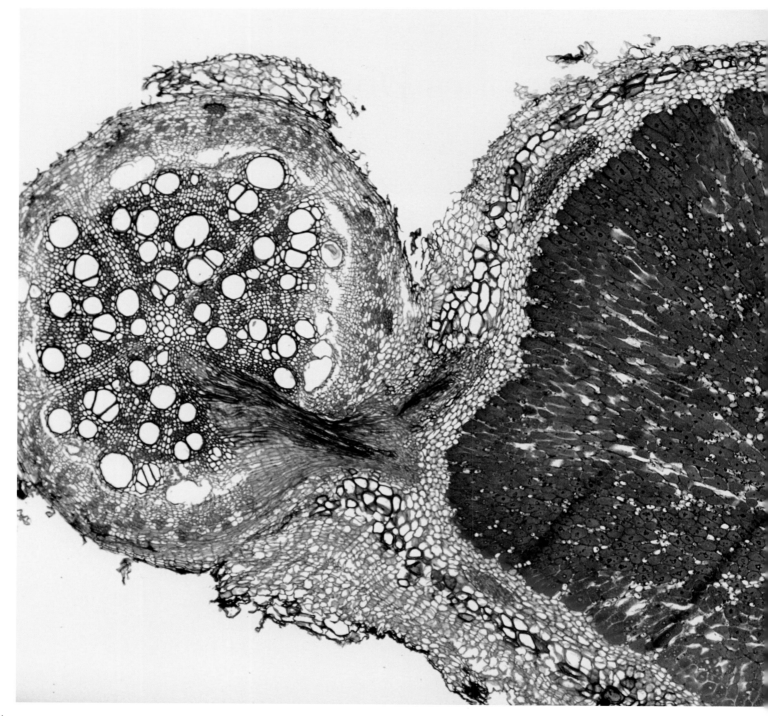

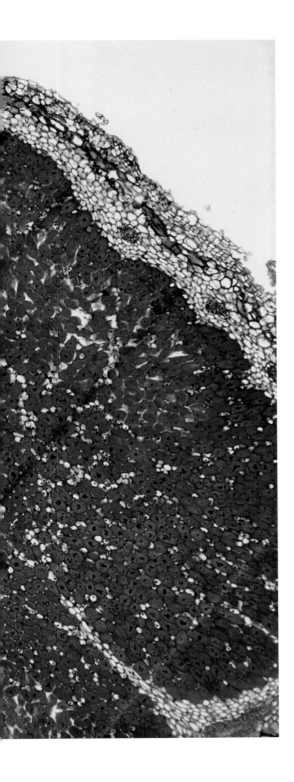

> ## "Wood, earth, mould, etc., exist for joy."
>
> ✳
>
> —HENRY DAVID THOREAU,
> journal entry, January 6, 1857

(maybe even a million) different species of bacteria. The vast range shows how little is understood about these minuscule creatures.

Some bacteria work away at leaves and twigs, even stumps and logs, on the forest floor, contributing to the cycle of decomposition that turns dead stuff into new life. They use enzymes that animals, including humans, do not have—enzymes that allow them to break down cellulose and lignin, key components that give plant cells their strength and rigidity.

Partnerships between bacteria and fungi flourish at the heart of the active community of the forest microbiome. One study singled out two strains of *Streptomyces* bacteria in the lab and watched a particular fungus—fly agaric, or *Amanita muscaria*—intertwine with the roots of pine and spruce seedlings. These researchers observed *Streptomyces* not only supporting the

Legumes, including trees, harbor bacteria that cluster in root nodules.
This magnified nodule, at right, tops the plant's root, left, in size.

growth of a fungus that helped the seedlings grow, but also discouraging the growth of another that would be harmful to the developing trees.

Other bacteria work away, pulverizing rocks and freeing important minerals so that hungry roots can slurp them up in a watery solution. In one experiment, researchers observed the interaction among pine seedlings, a type of mica called biotite, and a bacterium called *Burkholderia glathei*: a three-way symbiosis of tree, rock, and bacteria. The seedlings grew when given either the mica-borne minerals or the bacteria alone—but they grew half again as fast when both were provided in combination.

It's a complex world down there, that microbiome in among the roots of growing trees. Scientists recognize there is still much more to learn. As in our bodies, so in the forest: Sometimes the smallest players assume the biggest role. ∎

Aided by bacteria, fungi thread through rocks, roots, and soil. Recent studies reveal that trees can interact through this underground network.

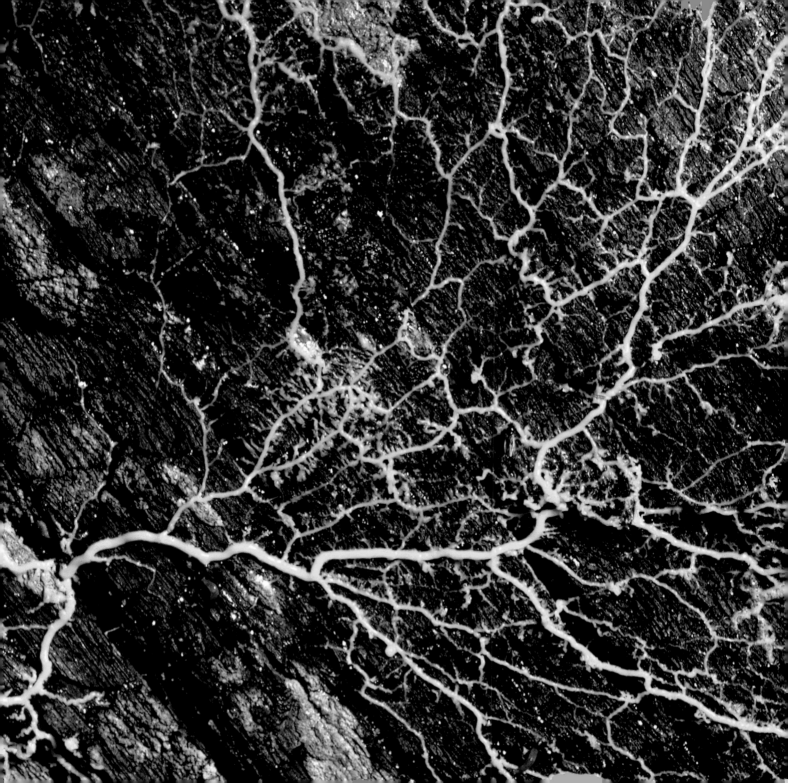

Forest Fungi

The forest could not survive without its fungi. The mushrooms you see—the cartoon toadstools, the little brown fairy rings, the tough shelf fungi jutting out from aging tree trunks or rotten logs—are a tiny part of the story. The real mycological magic happens underground.

Just as we are only beginning to recognize the importance of bacteria in the forest soil, we are only coming to understand the importance of the vast underground mycorrhizal, or fungus-root, network. Minute fungal filaments called mycelia weave in and around, above and under the roots of all trees, maintaining symbiotic relationships with their arboreal kinfolk. The fungus provides nutrients and water in exchange for photosynthetic energy. The mycorrhizal fungi link trees and plants of the same or different species together in a complicated fabric nicknamed the wood-wide web.

The connections are intimate: Fungal tissue bonds with tree root tissue and mutual gifts are exchanged. Microscopic images of a tree root cross section reveal fungal cells in among the rest. The mycelia, which do not photosynthesize, receive life-saving carbon in the deal. They in turn provide the trees with minerals dissolved in water—essential nutrients, especially phosphorus and nitrogen, that the trees cannot access on their own.

Others play roles in the mycorrhizal network as well: microscopic life-forms like bacteria, worms and insects, the roots of other plants. In fact, a vast, largely

Neon yellow fungal strands invade
the crevices of a rotting log in Costa Rica.

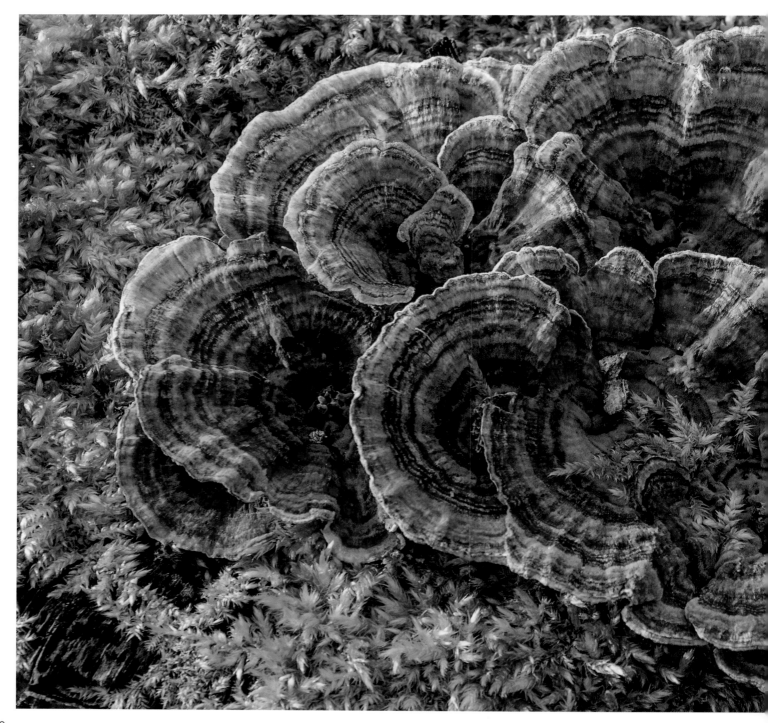

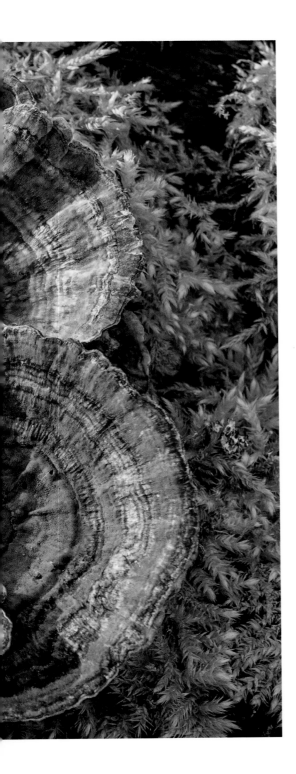

unexplored commonwealth of life exists in just the first few inches underground in a healthy forest. One scientist calls it a "many-to-many relationship."

Research is now suggesting that the mycorrhiza offers a communication network to the forest as well, through which trees share information and resources. Elegant experiments that introduce such dangers as leaf-eating insects or tissue-damaging fungi to one plant have shown that in a matter of hours, nearby plants are mustering defensive enzymes against the onslaught. Other experimental results suggest that the stronger, healthier, or older trees within a mycorrhizal network share resources with their smaller, younger compatriots.

Even trees of different species help each other. Forest ecologist Suzanne Simard's research has shown over and over, for instance, that Douglas fir trees grow bigger and better when they share the soil with birch trees. It is a picture of fitness that includes not only competition for resources but, just as important, cooperation and sharing among all life-forms in the forest, both aboveground but especially below. ■

Shelf fungi, like these on a tree trunk in Germany, represent the fruiting bodies of an organism within the rotting wood.

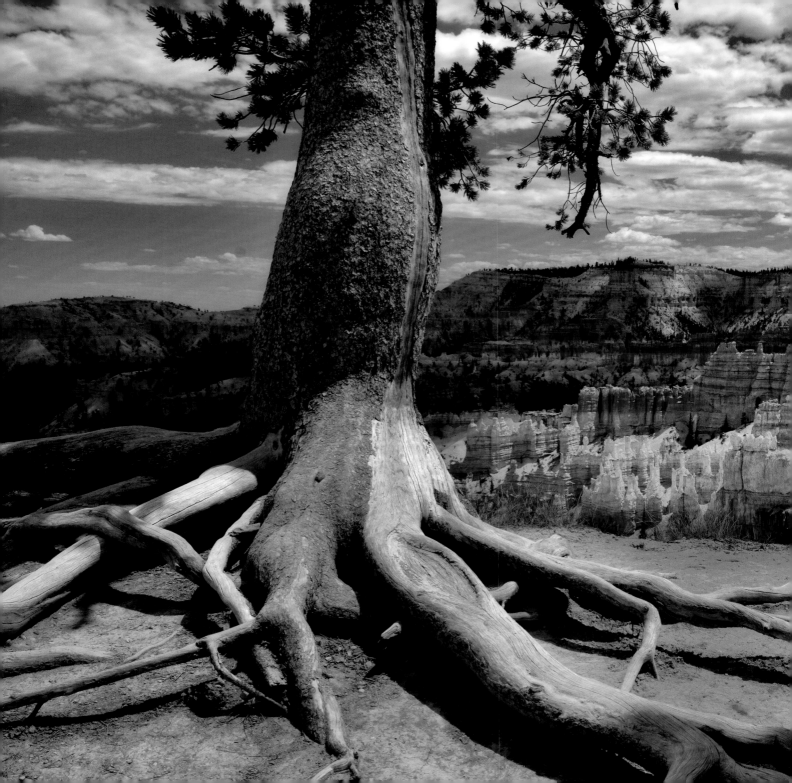

Stay Rooted

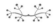

A distinguishing characteristic often cited about plants is that unlike animals, they don't move. After all, a tree has no legs, wings, or fins. A tree stays rooted: the very metaphor for a solid stance in opinion, an unswerving tradition, a deeply held belief. And yet there is constant movement in a tree's root system at all times.

When a tree seed sprouts, it sends a single root, or radicle, downward. But soon enough, new rootlets branch out horizontally. As the root system spreads under the growing tree, an intricate process happens at the cellular level. Specialized cells at the tip of each root hair multiply and push on through the soil. Above them, more receptive root hairs bush out—each a single, relatively short-lived cell that sucks in elements essential for growth.

Thus begins the transport of water and nutrients up the roots, through the trunk, out the branches, and finally into the leaves. Converse transport occurs as well, with carbon taken in from the atmosphere and incorporated into sugars via photosynthesis traveling from the upper realms of the tree down to the roots.

Thicker, older brace roots do the heavy lifting, anchoring the weight and structure of a tree. Mature root systems rarely mirror the tree above in height, but instead spread out in all directions. Few plunge deeper than a yard or meter underground, remaining closer to the surface, where oxygen and moisture are more available. Roots can stretch out two to three times the circumference of the crown of the tree above—as far as the tree is tall.

Set against the hoodoos of Utah's Bryce Canyon National Park, these tree roots stretch out aboveground before plunging under.

As tree roots grow, they interact with the world underground. They dive through air pockets, snake around rocks, and tangle with the forest's vast underground fungal system. This network of successful interweaving results in a dense structural fabric, a dynamic hammock that supports the trees.

We see the trees standing tall. We walk through the forest, occasionally stumbling over a thick root that's made its way above ground level. Occasionally we marvel at the root ball of a fallen tree—how massive, how vulnerable, now revealed. But most of the time we remain unaware of the work, the motion, the strength, the creative energy surging beneath us. From our vantage point, the tree meets the world in its trunk and branches. For the tree, though, the meetings that happen underground are the ones that make all the difference. ■

When a tree falls in the forest—such as this California redwood—it often reveals the massive root system that once held it upright.

A JAPANESE FOLK TALE

A young woman, named after an ancient tree that grew where two rivers meet, was courted by a handsome young man who visited in the night but never revealed his name. When she grew big with child, her parents insisted she learn his name. Once she asked, though, he stopped visiting. Eventually the parents discovered their daughter's beloved was a sacred tree. They reacted with horror, but try as they might, they could not cut it down. Finally the young woman, promising never to leave it, convinced her beloved tree to lie down across the rivers. It has lain there ever since, a symbol of the connection between trees and humans.

Trees shade a Zen moment in Japan's Osaka Castle Park.

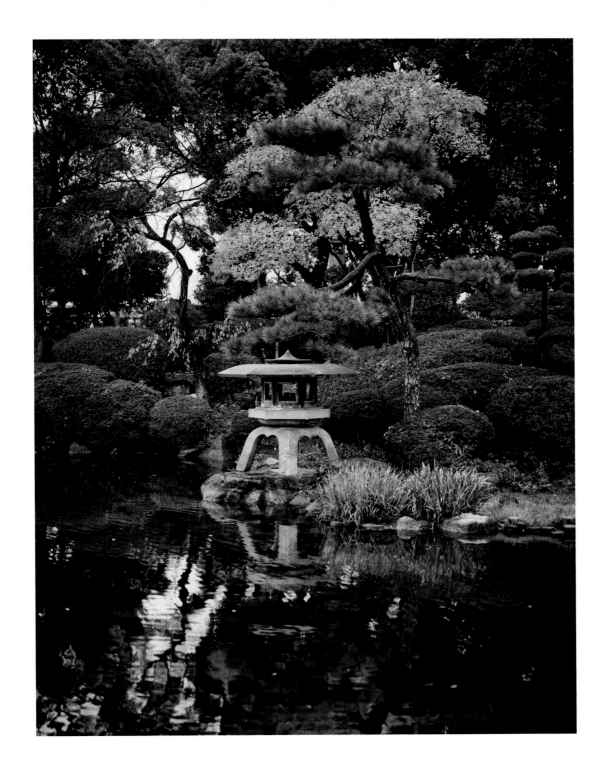

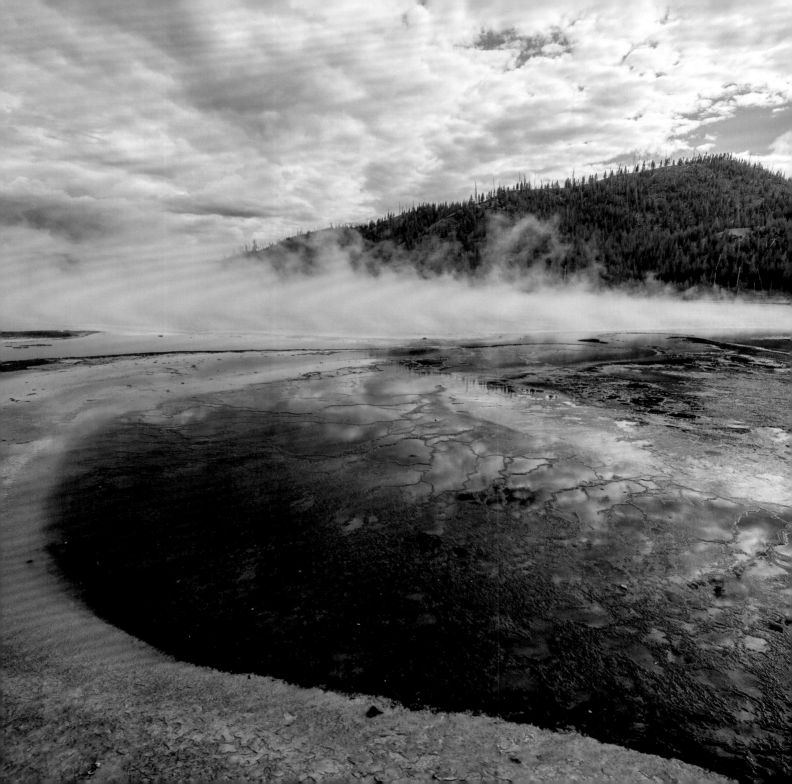

The Evolution of Dirt

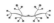

Our planet began as a roiling ball of elements careening through space, incorporating planetary debris as the solar system evolved. Geological components began to differentiate. The heavier materials, such as iron, sank into the red-hot core; the lighter elements bubbled up toward the surface. When the temperature was just right, water remained liquid and covered the planet. Chunks of matter moved around, joining up and splitting apart. Ultimately, this patchwork surface took on the patterns we know today: land and sea, continents and oceans.

Land began as rock. Today, if we drill deep enough—more than half a mile down in some places, just at the surface in others—we reach that bedrock layer, the foundation for all that came after and all that lies above.

Rains washed down, wearing away at the rock. Life shimmered into being, single-celled cyanobacteria that survived on carbon dioxide. These earliest photosynthesizers built up the oxygen in the atmosphere, fixing nitrogen and leaving behind bits of matter—both digested sediment and their own dead remains. Stuff other than rock and water began accumulating on the planet's surface.

As life-forms evolved, many found ways to interact with rock: extracting minerals, scraping against surfaces, boring in, and cracking open. With life comes death, and with death comes more remains that build up on the surface. Some species come to thrive on those leftovers, breaking the matter down even more, then dying and becoming part of it all. Thus over time, matter mounds up.

Weather, topography, and other local conditions influence the nature of soil.
Here, obsidian bits darken the soil of Yellowstone's Black Sand Basin.

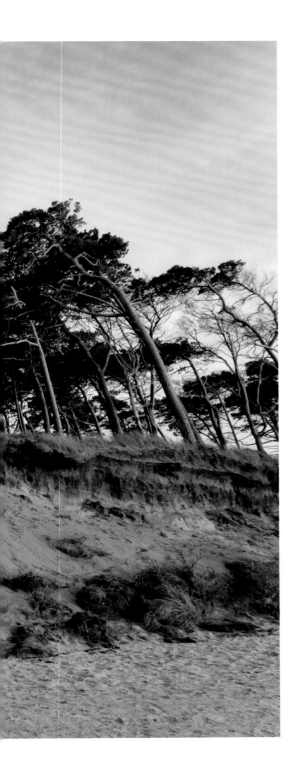

These are the soil horizons: the characteristic layers of matter found in a cross section from forest floor through the mineral soil and down to bedrock. The top, called the O horizon, consists of freshly fallen and rotting residue: a blanket of deep, dark humus in a healthy forest. Just beneath that lies the A horizon, where organic mingles with mineral matter, eroded from the rock below. The roots of a forest tree both seek out and contribute to this layer: the best source of water and nutrients, the region where the mycorrhizae thrive.

The subsoil and substratum, horizons B and C, lie beneath. Each subsequent horizon is more tightly packed, containing more clay, silt, and sand, with fewer pockets for air and water to move through. Finally, the lowest horizon, R: bedrock.

Sift beyond the rotting organic material, dig down in among rocks and roots in the forest floor, and the handful of dirt you bring up will come from the A horizon. The soil of each forest has its own color, texture, and aroma that speak of life and abundance. This stuff has a past that can be reckoned in eons, in centuries, or in seasons. It is the medium and the nutriment, the raw material and the perpetual product of a healthy forest.

Soil is, pure and simple, what makes life. ■

Erosion along the German coastline of the Baltic Sea accentuates the horizontal layers of soil present there.

FAMOUS TREES

TREES THAT CROSS RIVERS

In the Cherrapunji region of eastern India, near the border with Bangladesh, monsoon-swollen rivers plunge through steep rocky ravines. Above, a jungly forest looms. Residents of this mercilessly sodden environment have discovered that live tree roots will bond together to form a bridge more long-lasting than anything they could fabricate out of lumber, metal, or concrete.

The process begins with a seedling of *Ficus elastica,* the same tree cultivated worldwide for rubber. As the tree grows, aerial roots shoot down from its branches for extra stability. Flexible and fast-growing, those roots are stretched out and trained across a ravine, the root tips tucked into the soil on the opposite bank. Cut logs of bamboo may be stretched out to serve as a base for the roots, but that wood quickly rots while the roots keep growing.

Over and under, around and around, the tendrils weave a stronger fabric every year. Roots wrap and graft together. It takes a decade or more of tending, training new growth in with the old. Ultimately a bridge is born.

No one knows the age of India's oldest living root bridges. Some are likely hundreds of years old; some measure more than 100 feet long. They have provided welcome pathways of travel, transport, and escape over boulder-strewn ravines that would otherwise be dangerous, if not impossible, to traverse. Flexible, strong, and rot-resistant, these living root bridges represent botanical architecture that will outlive all who tend them. ∎

Over time, the Khasi people of northeastern India created this double bridge of living *Ficus* roots.

FOLLOWING PAGES: Mangrove roots create a tangle above and a marine nursery below the waterline in northeastern Dominican Republic.

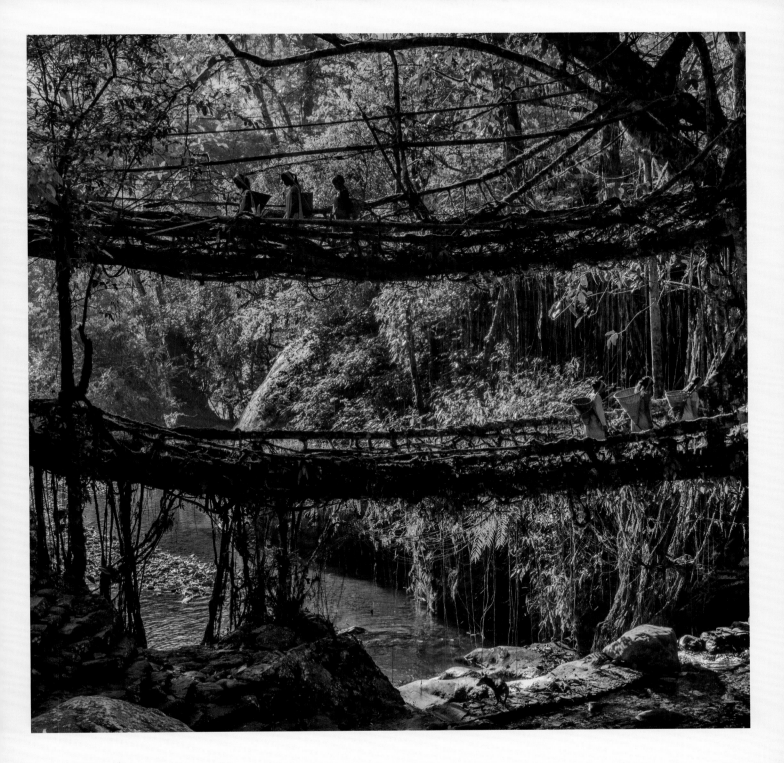

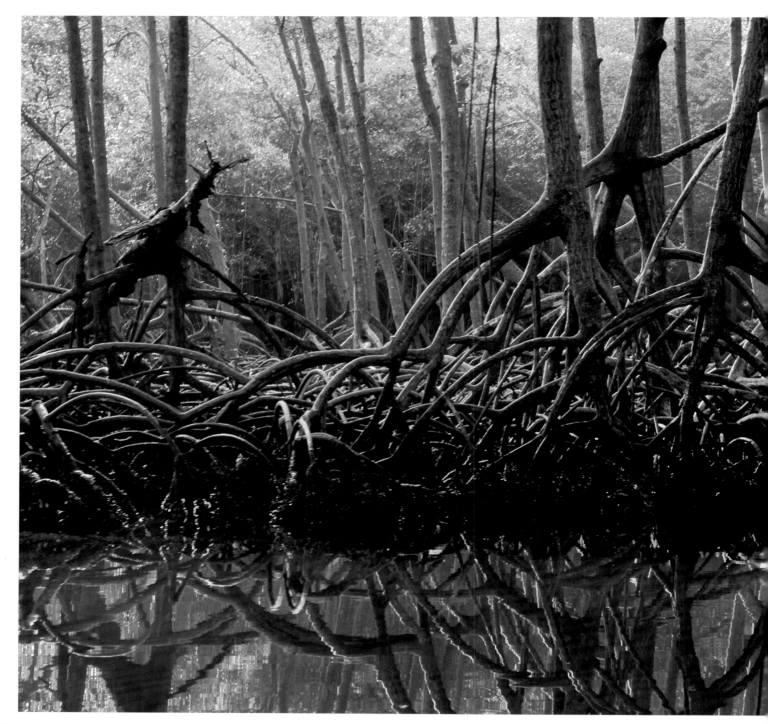

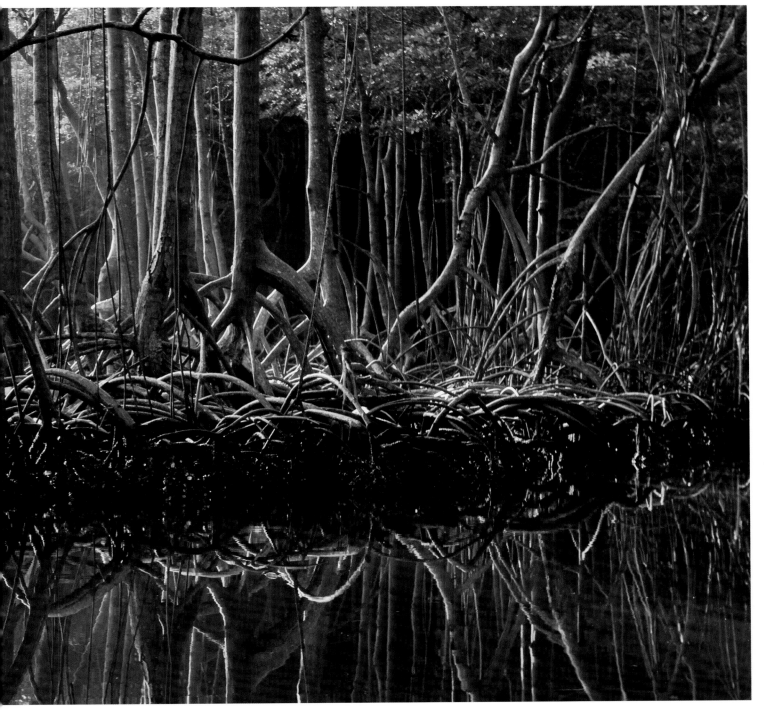

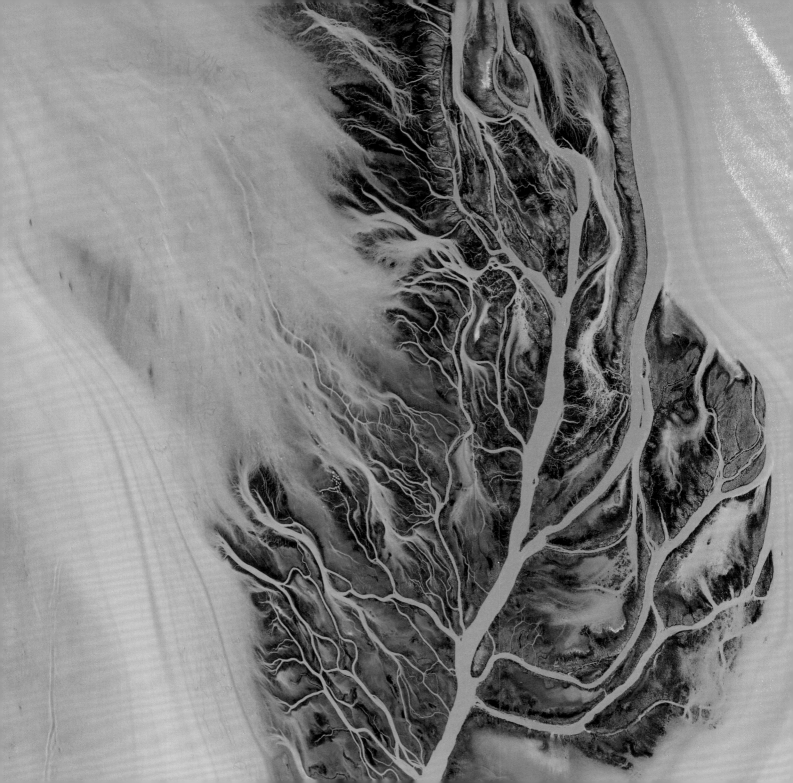

Sorts of Soil

What distinguishes one type of soil from another? First, there's the stuff itself, the mineral content of the parent rocks. And there's the impact of time and the elements on it, turning the material more toward clay, sand, or silt and determining the soil's permeability and porousness. Organic matter, distinctive in character to each region, mingles in as well. Soil particles aggregate: sometimes tight, sometimes loose and airy. The more air pockets between particles, the more water can trickle through—and the better tree roots can stretch down and out, finding what they need to survive.

Landscape and climate matter as well. Erosion happens, whether it's the slow transfer of soil down a mountain stream or the gush of an avalanche. Soils in the lowlands differ from those that cling to rocky heights. Frozen tundra soils weather different conditions from those in the steamy tropics: Temperature, humidity, and seasonal patterns shape the nature of soil as well.

One classification system divides Earth's soils into 12 major orders. The rarest are histosols—bogs, moors, and peatlands, where organic matter takes longer to decompose—and andisols—soils rich in volcanic materials. Each of these covers only one percent of Earth's surface. Most common are inceptisols and entisols—younger soil, often newly deposited in forests, deltas, or floodplains and not as stratified into horizons. Estimates vary, but these two types represent at least a quarter of all soil on this planet.

An aerial view depicts the swirl of algae and plant debris mingling with soil along the banks of Kenya's Southern Ewaso Ng'iro River.

This hierarchical classification system keeps on going, dividing these 12 orders into 64 suborders, then 300 great groups, then 2,400 subgroups, and on and on, down to local slivers of land called soil series. It's an exercise in taxonomy as complicated as the one performed by botanists, who start at a high level of generalization, differentiating between large groups of trees—gymnosperms (palms, ginkgoes, and conifers) and angiosperms (the trees that make flowers)—and then divide those categories into class, order, family, genus, species, and even further into varieties and cultivars. Every apple, for example, comes from a tree of the same genus and species—*Malus domestica*—but there are thousands of varieties of apple.

No classification system exactly matches the world of nature. Arguments between the splitters and the lumpers—those who discern differences versus those who seek similarities—persist in every science. Taxonomies shift around as new discoveries are made. Soils, trees, animals, and even the infinite variety of the human race: All elude categories. That's life. ∎

Soil is alive and characteristic of its location. Here, moss and leaf litter enrich the rainforest floor of Queensland, Australia.

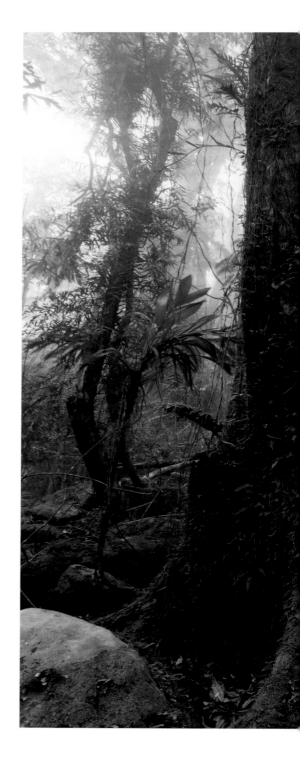

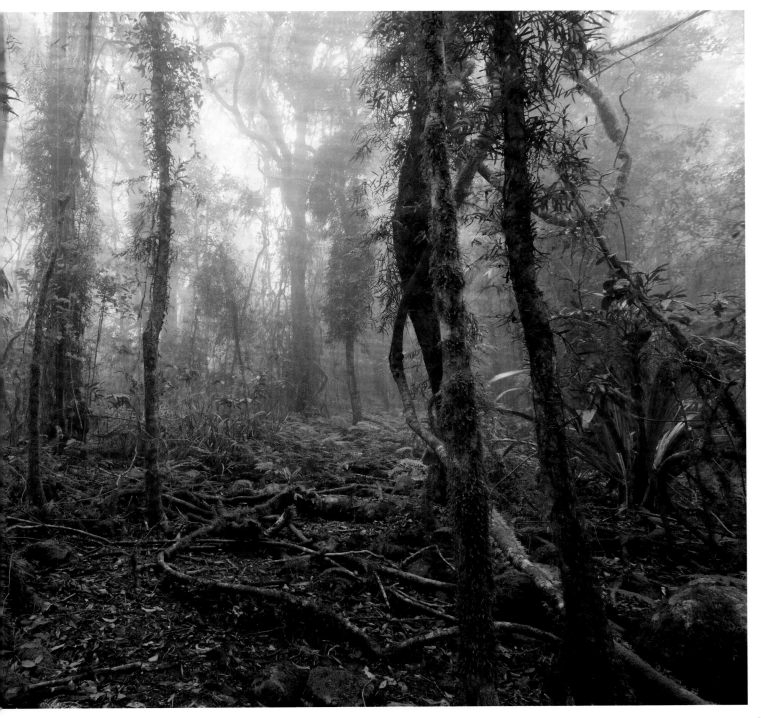

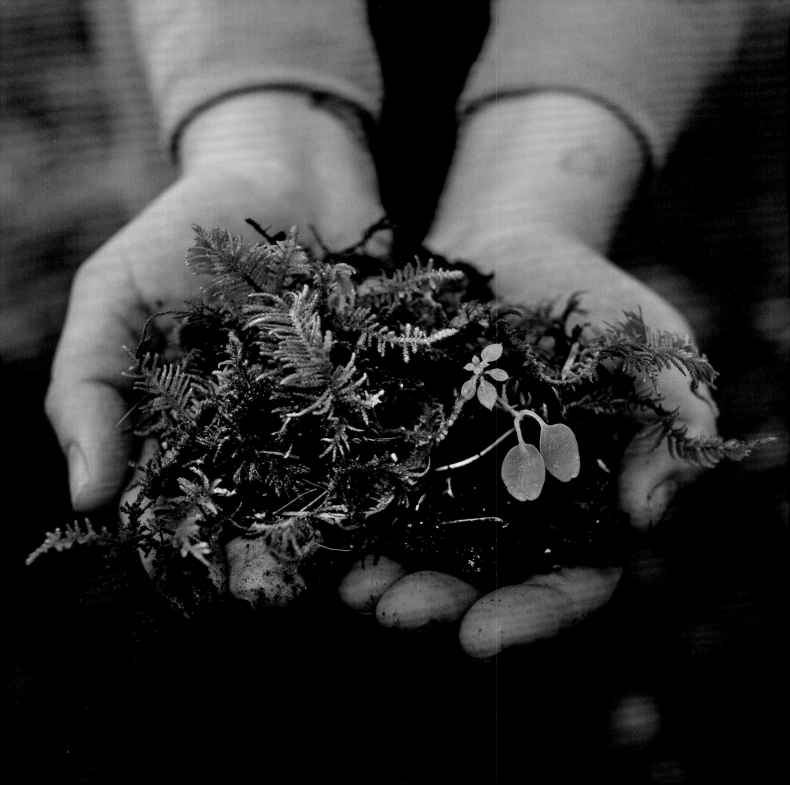

Smiley Dirt

Kids know it. Gardeners know it. And everyone who loves a walk in the woods knows it. Soil smells good. And now, thanks to science, we know what makes that smell: An organic compound isolated by microbiologists in 1965 and named geosmin, from the Greek for "earth" and "odor," exudes that rich, earthy, after-a-rain forest smell. It turns out that geosmin is produced primarily by certain bacteria, but also by beet roots and cactus flowers. Viticulturists work hard to keep it out of their wine, while food scientists are developing ways to manipulate it in beets.

We've learned what gives forest soil that luscious smell, but that's not the end of the story. Why does a good, long inhalation of forest air make us feel so good? Scientists have determined how that happens. The story goes back decades to the work of John Stanford and Cynthia Stanford, British immunologists who wondered why vaccines were more effective against leprosy in people in central Uganda than anywhere else on Earth.

They noticed the phenomenon as they worked in the area of Lake Kyoga, a large, shallow body of water that sprawls between the Western Rift Valley and Lake Victoria. The Stanfords isolated a bacterium, *Mycobacterium vaccae,* common in soils around the world and abundant in the lake's swampy mud and water—and in the bodies of everyone living near it. They determined that *M. vaccae* had provided the people living there with a modicum of immunity to leprosy, hence the vaccines became boosters. Further laboratory research

Research shows that components in soil
can have a beneficial effect on the human psyche.

suggested that the microbe could deter tuberculosis as well.

A few years later Mary O'Brien, a London oncologist, became curious about *M. vaccae*'s broad healing power and tried administering it to her cancer patients. While the treatment did not alter the course of their cancer, it did cheer them up. What was going on? Lab experiments showed that *M. vaccae* reduced anxiety in mice placed in stressful situations. Further studies revealed that *M. vaccae* released serotonin, a hormone that evokes a sense of well-being, similar to the effect of today's antidepressants.

Research continues to this day, analyzing how this common soil component—and maybe others—can help heal mind and body. If it could be turned into a pharmaceutical, this soil-dwelling bacterium might help treat PTSD, schizophrenia, and depression more organically.

Meanwhile, the promise of health and well-being remains underfoot for us all. Take a walk in the woods, dip your hand into its rich soil, and breathe deeply. Ah, the aroma of geosmin! Forests offer a free dose of this natural healing agent. ▪

A woodland walk—as in this American beech tree forest in Virginia—kicks up leaves, dirt, and positive feelings, now under study by psychologists.

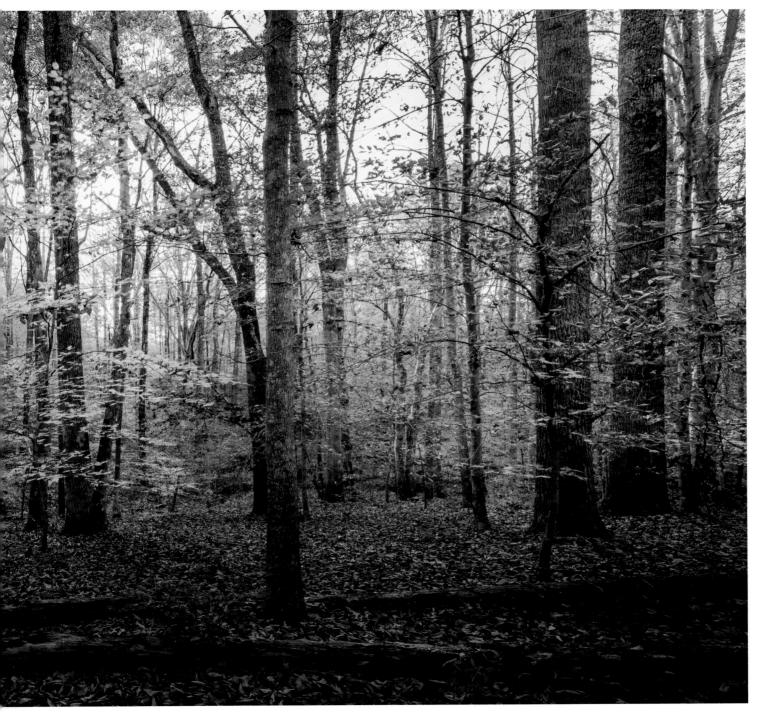

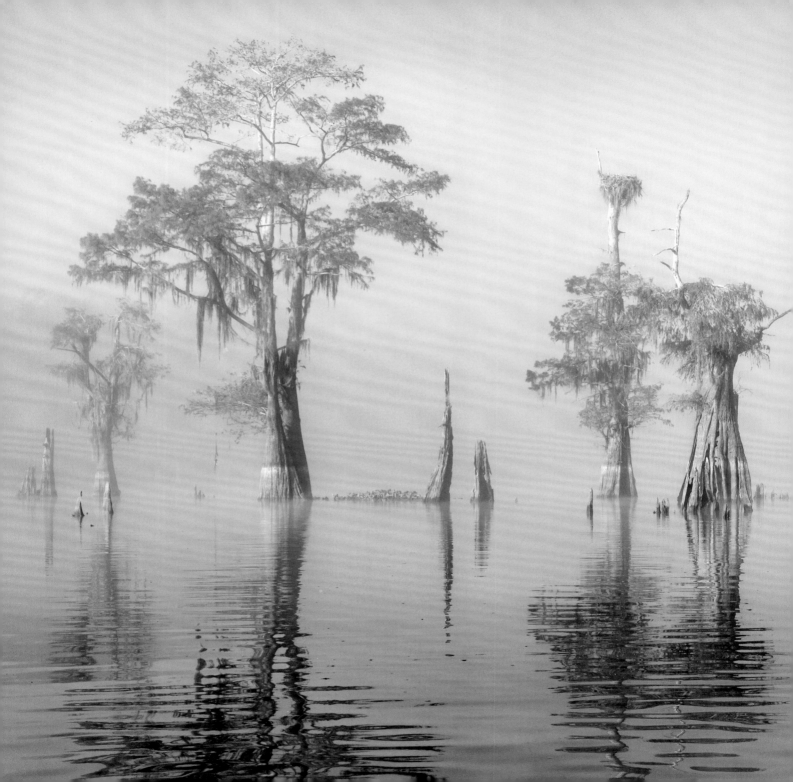

Stilts & Knees

Roots anchor a tree in the ground. Most plunge down and out, but some species have evolved their own root expressions—especially in rainforests or swamps, where the soil is loose and waterlogged and the roots grow underwater. To grip sodden earth and weather the currents, some palms and mangroves, for example, send out stilt roots: props extending from their trunks. Others develop buttresses: wide vertical flanges doubling down at the base of the tree, folds so grand that a person can hide among them, as if in a curtained room.

Most curious of all are the root adaptations of certain cypress species, such as America's bald cypress, which shoots up knees: knobby extensions that stick out of the water, encircling the parent tree like children gathering round.

Why does this happen? The French botanist François André Michaux was one of the first to seek the answer, venturing into cypress forests just after the American Revolution. Traveling from his home in Charleston, South Carolina, he explored many a New World terrain, from Canada to the Bahamas, from mountaintop to marsh. Of the unique knees of the American bald cypress, Michaux reported, "No cause can be assigned for their existence." But that hasn't stopped science from trying to explain them ever since.

They must be pneumatophores, some theorized, from the mid-19th century on. Pneumatophores—from the Greek for "carrying air"—are specialized roots that breathe. But, pointed out a mid-20th-century plant physiologist,

Cypress trees in the Louisiana bayou depend on
complicated root systems, including both stilts and knees.

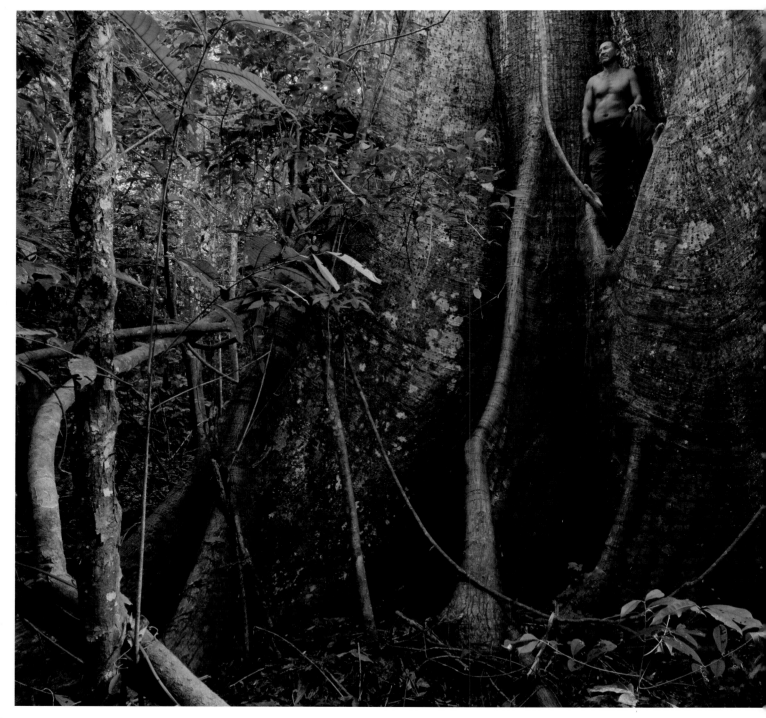

bald cypress knees have neither lenticels (pores on the surface) nor aerenchyma (internal gas transport cells)—both defining features of pneumatophores.

Perhaps they serve a structural purpose, others suggested, bolstering underwater roots. A thorough survey disproved that theory. Could noxious swamp gas be blamed on bald cypress knees? Perhaps they exude methane. Observations found their methane emissions minimal. Could they be absorbing nutrients from the water and sending them back to the parent trees? Or, on the other hand, might they be stockpiling carbohydrates made via photosynthesis, storing up for times of stress?

Every one of these hypotheses has been tested, and every one has proved false. Recent studies have circled back to the pneumatophore hypothesis. Science soldiers on, driven by the quest to discover a purpose, not satisfied to rest knowing that bald cypress knees simply are. ▪

The buttress roots of this ceiba, or silk cotton tree, in Guyana dwarf the human form.

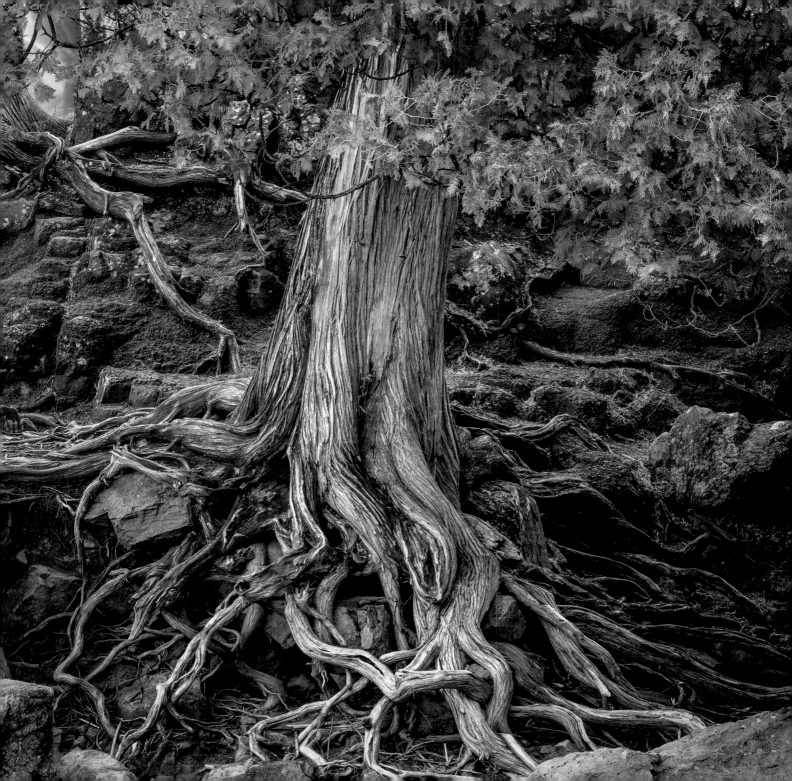

Roots on Rocks

If trees need soil with all it provides—water, nutrients, bacteria, fungi—how on earth does a tree grow on top of a rock?

The scene is dramatic: a craggy cliff, a slice of stone, a bleak outcropping. And there stands a solitary tree, braving the elements. Roots wrap the contours of the rocky base beneath. A trunk rises up, notably stunted yet persistent in its life force, contoured by the prevailing winds. Surely that rock can't provide what the tree needs. Surely it didn't offer a welcoming seedbed for germination.

Chances are that tree was not the first living thing to inhabit that rock. Others prepared the way—lichens and moss, most likely.

Lichens are organisms that combine algae and fungi; the algal part photosynthesizes while the fungal part provides protection. Lichens can be leafy, dangly, or crusty. They can grow on the ground, on tree bark—and on rocks. Rained on, they expand; their filaments push and pry into rock crevices, making minute inroads that moss can appropriate.

Mosses are primitive green plants. They photosynthesize but reproduce by spores, single-celled evolutionary precursors to seeds. Some 12,000 species of moss grow around the world, carpeting rocks, trees, and forest floors. Like lichens, their demand for a growing medium is slim. And they can also burrow into rock fissures, leaving bits of decay as they die back.

Onto this substrate a tree seed might fall. It sprouts a radicle—a pioneering

Tree roots find footholds in Minnesota's Gooseberry Falls State Park, appearing to flow over rocks that strew the hillside.

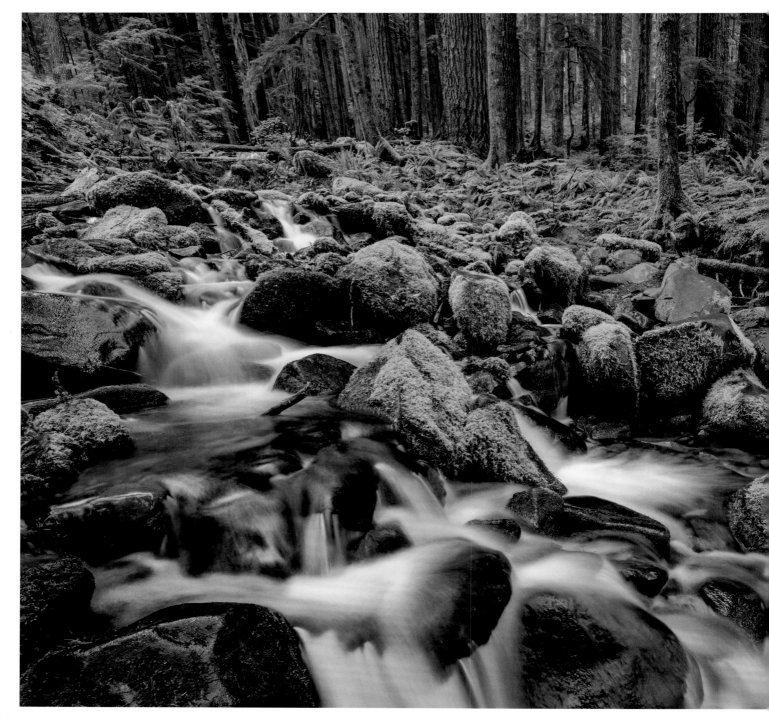

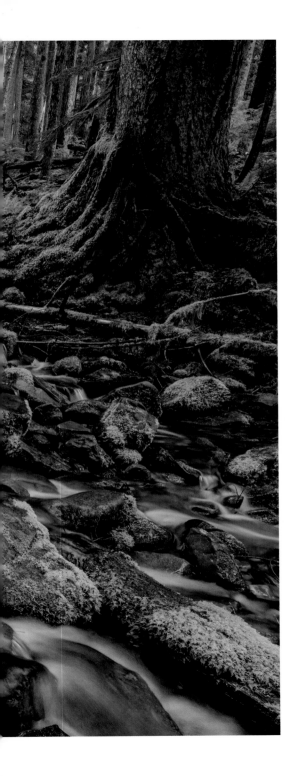

root structure—that somehow manages to find the crevices and bits of soil prepared by lichens and moss, wind and rain. To understand how, consider a recent experiment that compared the underground pattern of a common rice variety with that of a mutant rice engineered for straight downward root growth. Researchers tracked how the two root systems navigated through rocky soil. The root tip of the natural rice twisted and turned, following a helical path that allowed it to corkscrew through the soil farther and faster than the rice engineered to grow straight down.

In the same way, a tree seed that has landed on a rock with just the right conditions can wiggle its way toward water, nutrients, and organic matter, staking its claim to life in its own unlikely place in the universe. ■

OPPOSITE: Flowing water, mossy rocks, trees gripping the rocky soil: nature prevails in Olympic National Park in the U.S. Pacific Northwest.

ABOVE: Lichen, like this bit from northwestern Scotland, helps carve cracks in rocks for tree rootlets to exploit.

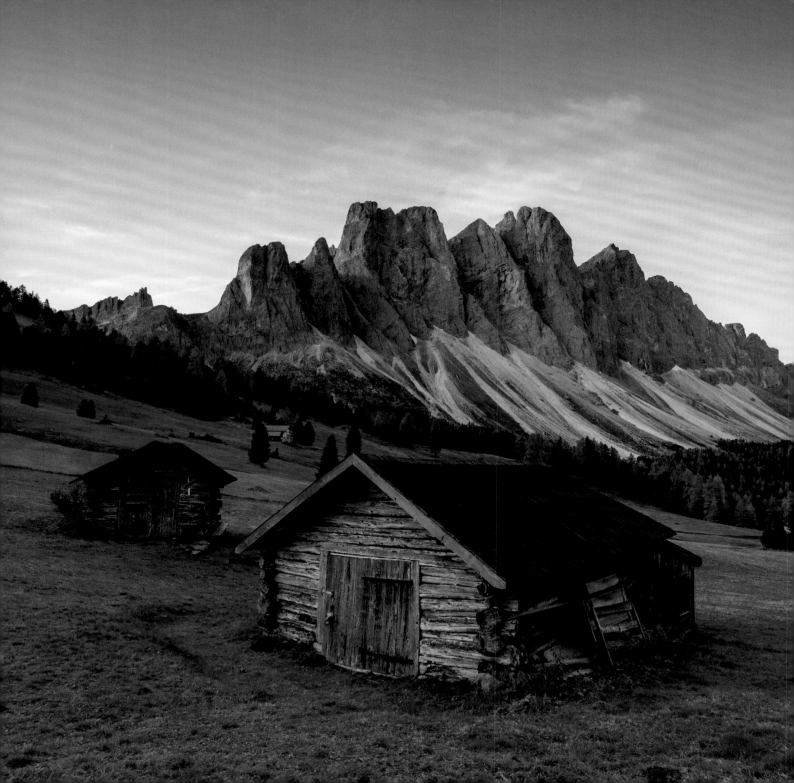

Building Blocks

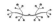

rom trees come the tools of civilization. It is only because wood rots and stone doesn't that we refer to the earliest days of humankind as the Stone Age, rather than the Wood Age. Nevertheless, a few prehistoric wooden artifacts have survived, showing how essential the material has been through the ages.

Two wooden spears—one from Britain and one from Germany—vie for the title of oldest wooden artifact ever found. Stripped of bark and hewn to points by stones, both reveal that even 300,000 to 400,000 years ago, wood was being crafted into tools.

The Clacton spear was found in 1911 on the eastern coast of Britain, entrapped in rock sediment dated to the Pleistocene, when glaciers covered much of Earth. Jagged on one end, smooth and pointed on the other, this 14-inch stick of yew wood was likely a hunting tool from the age of mastodons and saber-toothed tigers.

A similar spear was found in 1995 in northern Germany, where lignite mining has revealed other artifacts as well. Carved of spruce wood, it measures about six feet long, with points carved on both ends. Archaeologists call it a throwing stick, likely used to hunt small game or herd larger animals.

Over time, humans began working larger pieces of wood: whole tree trunks, in fact. Likely the Pesse canoe—a three-meter-long pine dugout found in the Netherlands—represents fleets used to ply many a shoreline. Dated to 10,000 years ago, it's considered the world's oldest boat.

Trees have provided the materials for our homes for millennia.
These aged cottages stand in the shadow of Italy's Dolomite Alps.

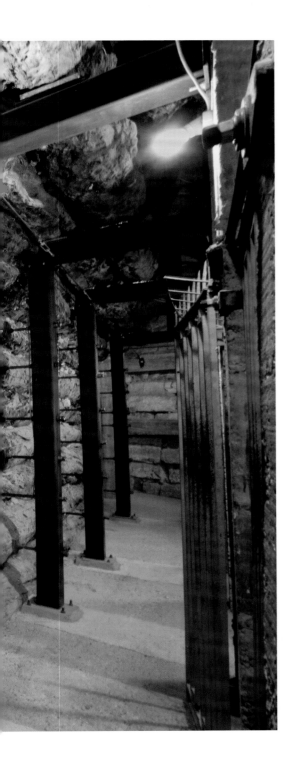

Another wooden creation emerged in a peat bog in Russia's Ural Mountains. Discovered in 1890, these carved and ornamented pieces of larch wood suggest a sculpture some 17 feet tall, a slender figure with eight faces dated at about 12,500 years old, like the cave paintings and carved antlers found nearby. Dubbed the Shigir Idol, it is the oldest monumental wooden sculpture ever found.

Evidence of the use of wood in architecture—and techniques for hewing and joining wood members—dates back almost that far. In China, wooden vestiges remain of stilt houses built by the Hemudu, a Neolithic people also considered early domesticators of rice. And in the Czech Republic, a 2018 motorway construction project unearthed a wooden well liner. Constructed of oak planks connected with tongue-in-groove joints, the wood was intact enough to allow tree ring analysis, dating it to about 5255 B.C.

While most ancient artisans used local wood for their creations, the wealthy have been transporting select woods for eons. Hieroglyphics carved into the Palermo Stone, from the 25th century B.C., document ships transporting timber from Lebanon for Snefru, first king of Egypt's

Modern steel reinforces the integrity of the oldest known wooden building: a regal tomb built underground in the eighth century B.C. in Phrygia—modern-day Turkey.

4th dynasty, who ruled from about 2575 to 2465 B.C. Archaeologists differ on the translation: Was it cedar, cypress, or juniper? All would provide strength and versatility for ships and grandiose palace doors. Records from this date forward reflect a busy international trade in timber of the Middle East.

The world's oldest wood building lies buried under a massive man-made mountain in central Turkey. All around it lie the elite of the Phrygian culture, present and powerful in Asia Minor from the 12th to the seventh century B.C. Some 120 tumuli, or burial mounds, dominate this landscape. The tallest tells a tale of ingenuity built of wood.

Named MM, for "Midas Mound," this 175-foot-tall tumulus was excavated in 1957, revealing a deep underground tomb, still intact, constructed of juniper, pine, and cedar. Within this sturdy log bunker lay the remains of a king whom archaeologists now identify as the father of Midas, supreme ruler of Phrygia during the eighth century B.C. Different from the Midas of Greek myth, clearly this king valued wood over gold.

Trees have helped us humans feed and house ourselves, express our values, and honor our dead. Our use of wood through the ages frames the human story. And we continue to build with the stuff of trees: In 2019, more than 600 million cubic meters of timber were traded on the international market (not including that used in paper and other pulp products). We take the usefulness of wood for granted, but a look back through time reminds us how much the forests have provided. ■

OPPOSITE: Pieces found four meters deep in a Russian peat bog join to form the 17-foot-tall Shigir Idol, the oldest known wooden sculpture.

ABOVE: Found on the British coast northeast of London, the Clacton spear may be the world's oldest wooden artifact.

FAMOUS TREES

TREES THAT ENGULF TEMPLES

Resembling vast columns of wax that have melted down and overtaken the candlestick, the roots of fig and ceiba trees engulf Cambodia's Ta Prohm temple. Built during the Khmer Empire, a vast civilization lasting from the ninth to the 15th century, the complex hosted thousands of celebrants who lived and worshiped there, paying homage to Prajñāpāramitā, the Buddhist embodiment of pure wisdom.

Today, nature reigns eternal. Fig trees grasped hold of these rock walls centuries ago; were it not for these muscular roots, the walls most likely would have tumbled. And were it not for some visionary archaeologists, the roots might have been cleared away, as they were during the 20th century at Angkor Wat, a few miles away—part of a vast temple complex comprising about 150 square miles and more than a thousand buildings, considered the largest religious structure in the world.

Restoration of these remarkable buildings began in 1907, led by a team of French archaeologists. The work ended abruptly during the reign of the Khmer Rouge but began again in the 1990s. All along, while excavation work freed many temple walls and sculptures from the jungle overtaking them, the agreement was to leave the trees in place at Ta Prohm. Now studies show that the trees engulfing these temples are actually shoring them up and protecting them from the elements. They are as much a part of history as the buildings they entwine, says Ros Borath, deputy director of the Cambodian agency overseeing the restorations: "They are part of the memory." ∎

Fig tree roots engulf—and may be preserving—
Cambodia's Ta Prohm temple, near Angkor Wat.

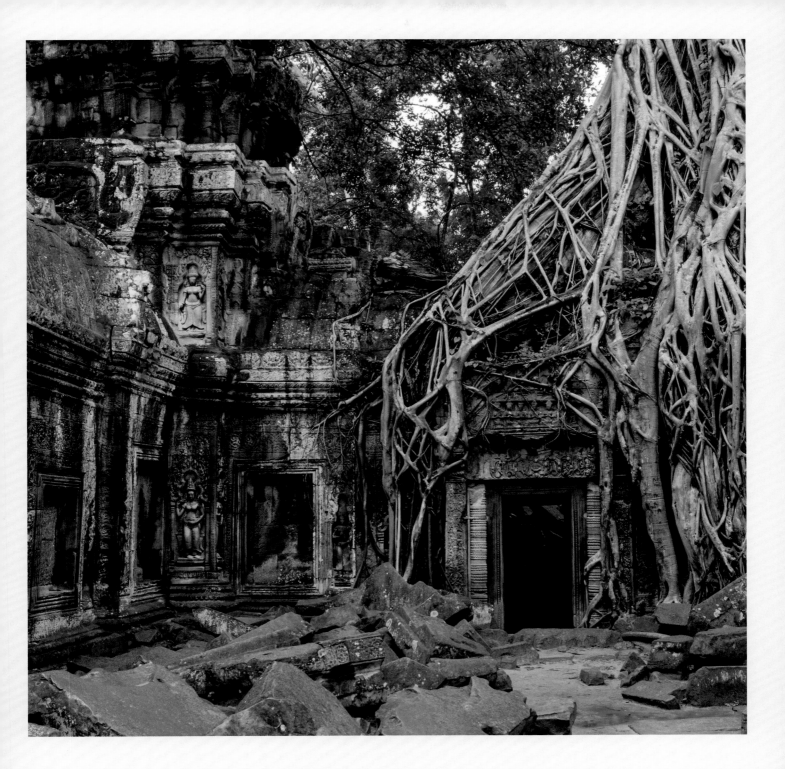

CHAPTER THREE

WATER

Rain falls, sap rises: Trees play a part
in the grand water cycle.

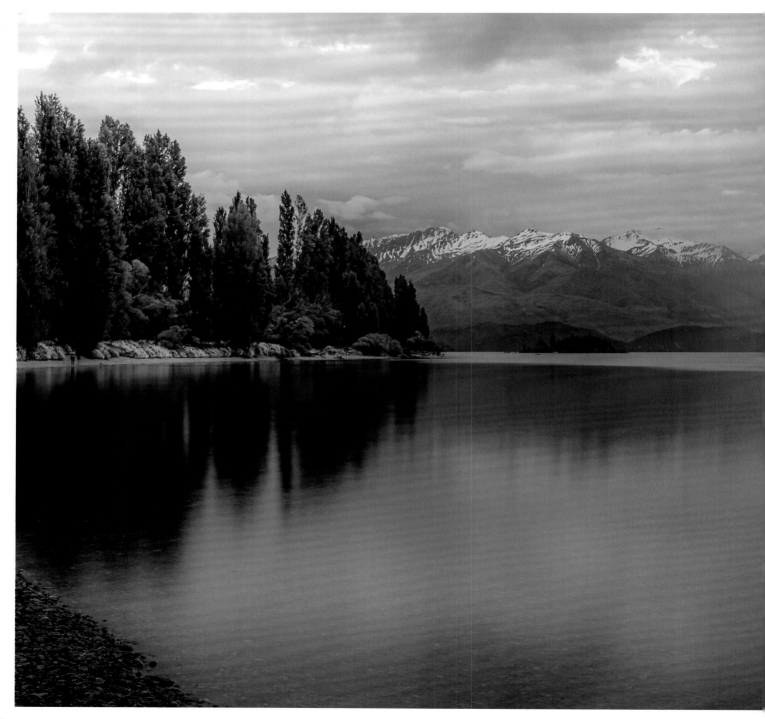

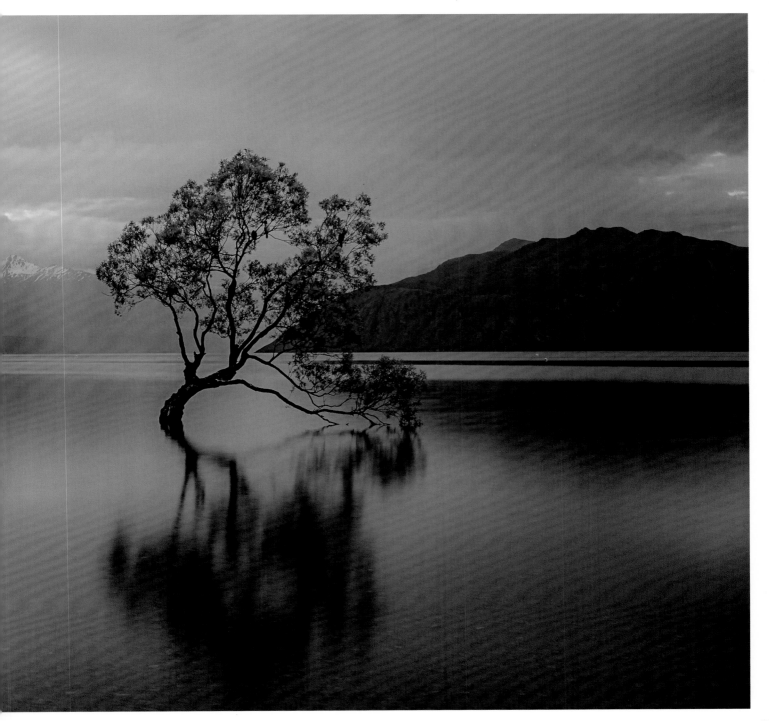

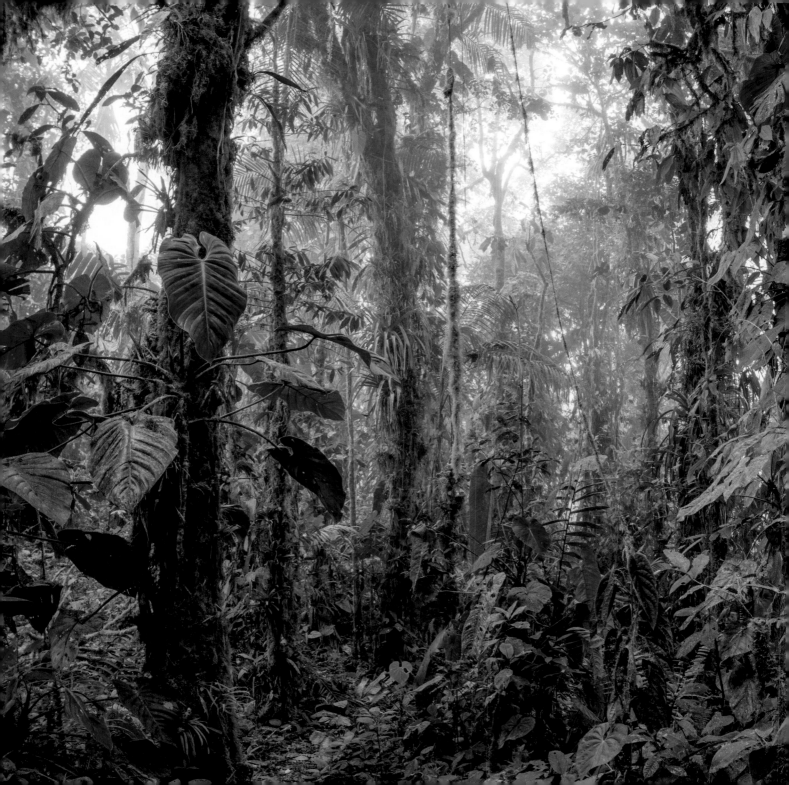

Water In, Water Out

Within the trunk of every living tree, water and nutrients move through a circulation system that transports the life-blood each needs to survive. Water moves from the ground up, and food produced by photosynthesis moves down and around—all through a neatly compartmentalized system of transport cells perfectly designed for the job.

For a vastly simplified picture of the process, imagine a circle—the circumference of a typical tree trunk in cross section—with three concentric layers from the outside in. The outer circle is the protective bark. The next circle in is composed of the phloem cells, alive and actively transporting the sugars generated in the leaves through photosynthesis.

Inside that is the sapwood, or xylem layer: dead cells joined together as tubes channeling fluid from root to leaf. Tree growth happens in these regions. The inner core of the cross section—all that we consider wood, including the inner-most heartwood, prized by carvers and carpenters—is a dense repository of dead xylem, no longer functional as transport cells.

Sensitive root tips draw in moisture from the soil, enriched with nutrients, which allows water to enter the xylem cells. At the same time, at the other end of the vascular system, tiny pores on every leaf transpire water into the atmosphere, creating an upward force. The water moves up, around,

An ever present mist engulfs the rainforest treetops on the western slopes of the Ecuadoran Andes.

PREVIOUS PAGES: A beloved willow drapes its boughs over Lake Wānaka in New Zealand's Southern Alps. Vandals sheared its lowest branches in 2020, yet the tree persists.

and out, irrigating and enriching cells along the way.

The process of photosynthesis occurs in the leaves of a tree. In the presence of sunlight, leaves take carbon dioxide from the atmosphere and water from the ground and turn them into carbohydrates and oxygen. Most of the oxygen is released, while the carbohydrates feed the growing plant. This sugar-rich liquid—the sap—moves down and around, providing cells with essential nourishment. Sometimes the sugar ends up in storage cells in the tree roots, particularly in species that weather freezing winters.

Water in and up through the xylem, water down and around through the phloem, all happening just under the bark of that tree. Now that you know what's happening, can you sense the movement? Maybe tree huggers can. ∎

A magnified cross section of a linden sapling shows the transport cells through which water flows, carrying nutrients up and down the tree.

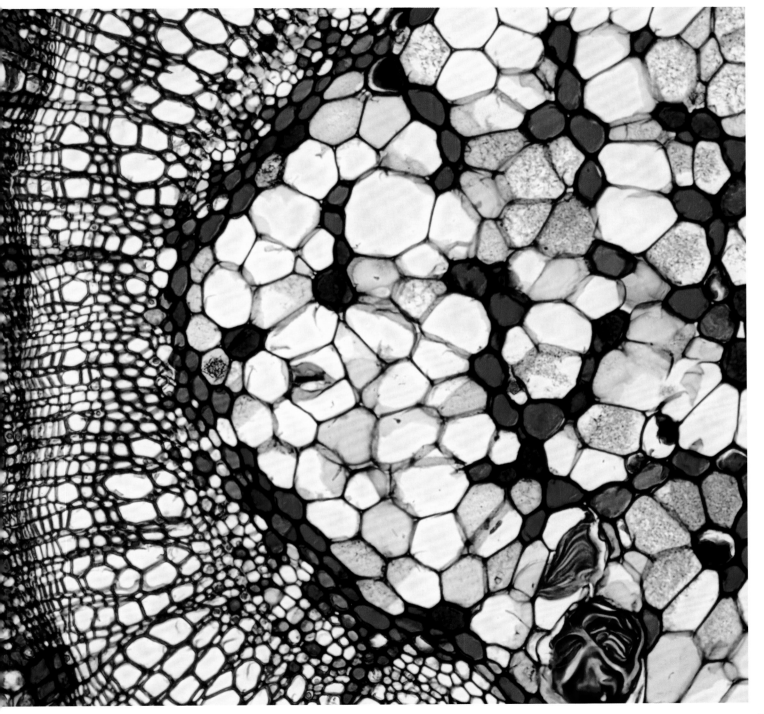

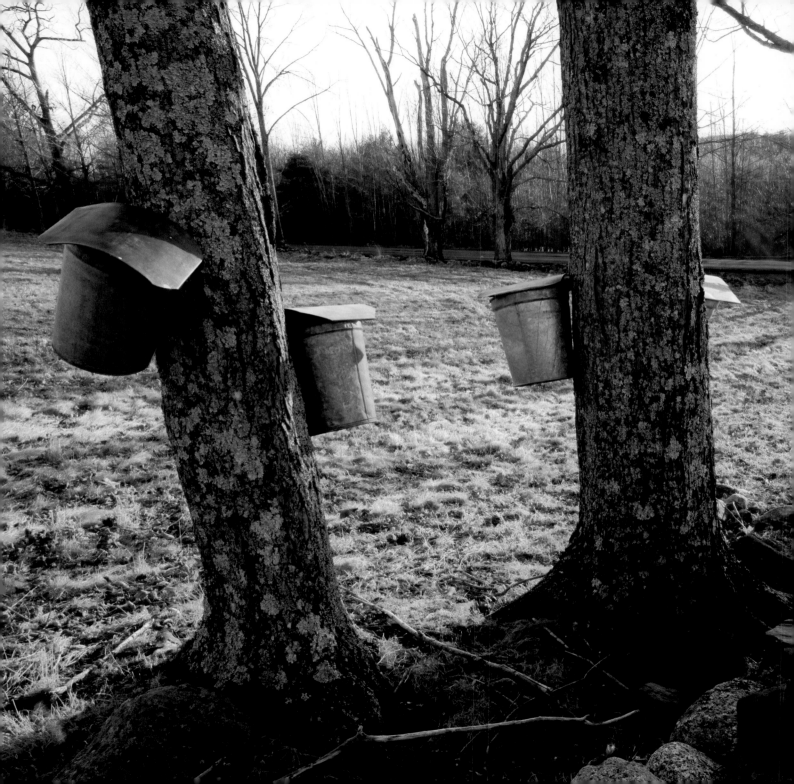

Secrets of Sap

In temperate zones around the world, those who understand the forest sense the time to tap trees. Winter's feeling dreary; days and nights have been frigid for so long. Bare, swaying branches don't even look alive. Then, after the winter solstice, the sun's path begins its slow, imperceptible reascent toward midheaven. The air grows warmer. Nights stay cold, but daytime temperatures rise above freezing. The moment has arrived.

By tapping trees, we borrow from their annual flow of sap. The root system stores sugars through the winter, ready to supply the nourishment needed for spring budding before the leaves begin to photosynthesize. For a precious short period of time every spring, the sweet substance pushes its way up the trunk. Tap a spigot just a little way under the bark, and a fraction of the sap flows into the bucket. Boil that sap down and turn its water fraction to steam, and you're left with only the sugary essence. The standard in the maple syrup industry is 40 gallons of sap to produce to one gallon of syrup.

Sugar maples of northeastern Canada and the United States are the world's best known sources for syrup, but other trees can be tapped as well: birches, alders, walnuts, sycamores. Koreans drink the sap of a native maple as a spring tonic—never mind boiling it down to syrup.

And, as it happens, maple syrup may be more than a breakfast indulgence; it's proving to have medicinal powers as well. One study by the Canadian Forest Service identified 24 different antioxidant compounds in medium-grade

Covered buckets collect springtime sap
from sugar maple trees in New Hampshire.

> "Maples have a far more sophisticated system for detecting spring than we do."

—ROBIN WALL KIMMERER, *Braiding Sweetgrass*

syrup and mentioned that this complex of health-promoting components "may serve to counter the unhealthful presence" of its high sugar content. Further laboratory research suggests that its ingredients reduce cholesterol and lipid levels in the blood, decrease blood glucose levels, and slow the growth of colorectal cancer cells.

Of course, much more work is required before maple syrup can provide a practical cancer cure. Meanwhile, it tastes delicious—and perhaps that's reason enough to enjoy it. ▪

The color and flavor intensity of maple syrup depend on how long the sap is boiled down; all of these samples were made at one maple farm.

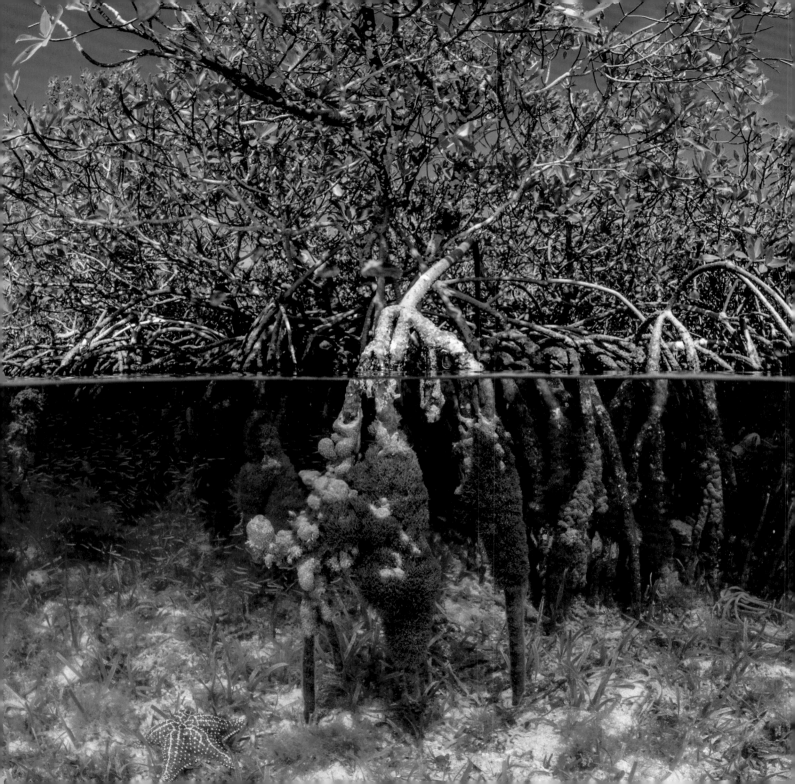

Magic Mangroves

Mangrove forests blanket coastlines around the world—from Baja California to southeastern Brazil, from the Red Sea to South Africa, from the west coast of India to the east coast of Australia—and especially throughout Malaysia and the South Pacific. In fact, it's safe to say that if it's a tropical coastline, it's likely lined with mangroves.

Mangroves put down roots in the murky soil where sea meets land. More than 50 species are assigned the name, grouped together as much because of the remarkable growing habits they share as by genetic relationships. Where they live, the tides wash in and out, sometimes rising to engulf half the plant and at other times leaving roots high and dry. Sea water oozes around them, with salt levels so high they would kill almost any other tree that tried to root there. Yet these survivors have evolved ways to either close off their cells from salt intrusions or sequester salt in special organs, thus protecting the rest of the plant.

Mangroves hold their own amid loose sediment thanks to intricately branching root systems. Stilts and buttresses shoot out like scaffolding to prop up the tree; snails, anemones, barnacles, and other small creatures cling to these stems.

Underwater, the latticework of mangrove roots offers a protective nursery for many creatures. The iridescent rainbow parrotfish, for example—an Atlantic coral reef beauty—spends its juvenile years in among these mangrove

In Belize's South Water Caye Marine Reserve, mangroves
provide essential protection for coastlines and wildlife.

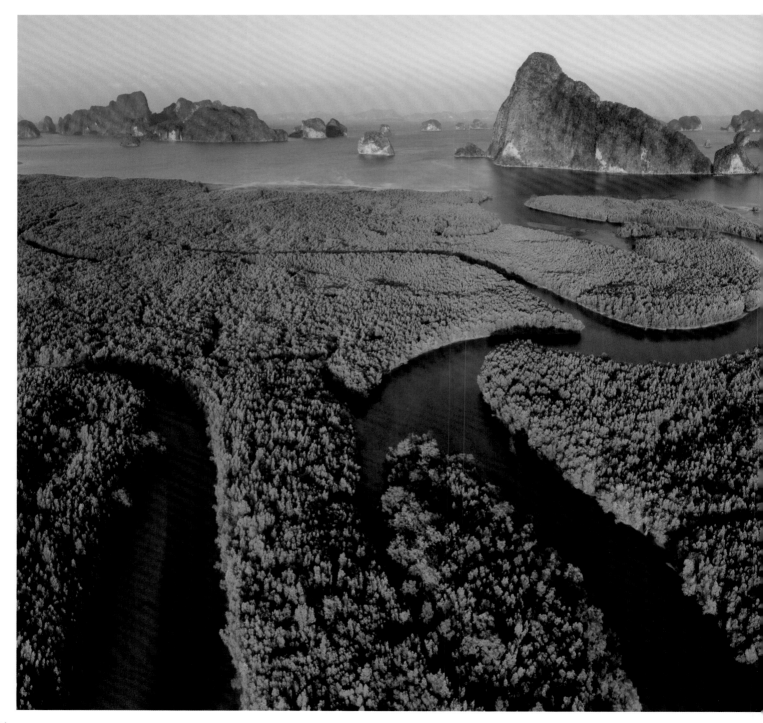

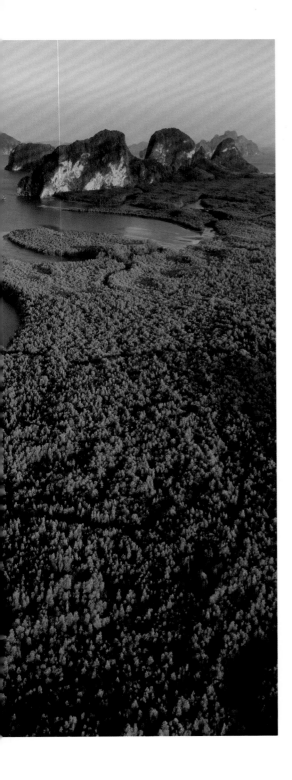

"A thing of beauty
is a joy for ever:
Its loveliness increases;
it will never
Pass into nothingness."

—JOHN KEATS,
Endymion

tendrils. As more than one ecologist has put it, without mangrove forests, there would be no rainbow parrotfish—and without rainbow parrotfish, which eat algae and keep the coral clean, our reefs would decline.

Other animals abound in mangrove forests. The mangrove tree crab—native to the American tropical waters of the Atlantic, Pacific, and Caribbean—lives here and is one of the few crab species that can navigate these structures. Mangrove forests also support magnificent bird populations—some during migration and others all year round. One report estimates that more than 250 species make their way through the mangroves along the Pacific coast

Mangroves carpet the complicated coastal waterways
of southern Thailand's Phang Nga Bay.

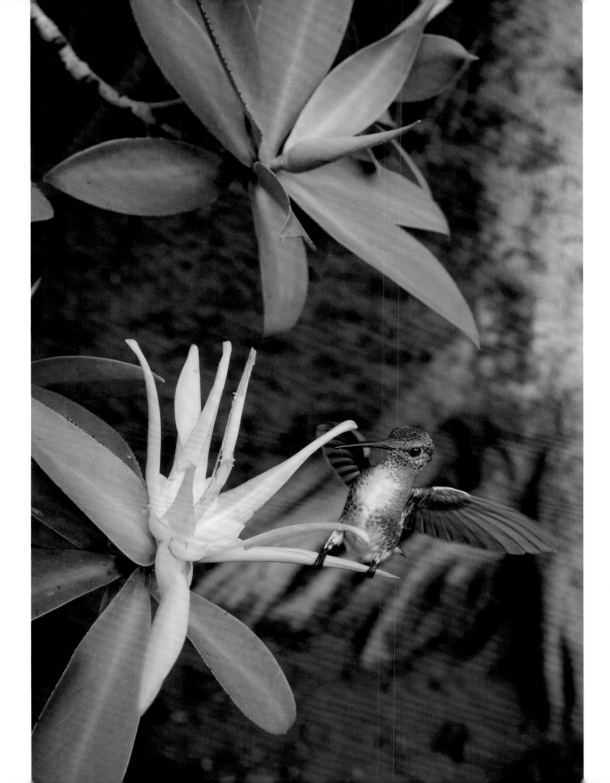

of northern Mesoamerica. The mangrove hummingbird, an endangered species native to Panama, feeds only on the nectar of a particular mangrove species—itself vulnerable in these times of increasing extinction.

Mangrove forests protect human lives as well. Powerful buffers between the ocean and the land, they stabilize coastlines by reducing erosion; they can even stand defense against dangerous storm surges and tsunamis. Sailors facing a hurricane know to drive their boats into the mangroves for safety. Ecologists around the world are encouraging the rescue and establishment of mangrove forests, having discovered that they sequester more carbon in the soil beneath them than rainforests do. Their root systems act as sieves, capturing river pollutants before they empty into the ocean.

Mangroves enrich our lives; their underwater nurseries help sustain fisheries. Environmentally savvy economists are beginning to recognize the value of maintaining a natural coastline, rather than clearing it for housing and resort development. A study supported by the Scripps Institution of Oceanography considered the economic wisdom of clearing out mangroves for development along Mexico's Pacific coastline. Cleared, the property would sell for $1,000 per hectare. But if the mangroves were allowed to remain, fishing in that region could bring $37,500 per hectare every year. Stretched out over 30 years, researchers say, saving these mangrove fringes would bring benefits amounting to more than $600,000 per hectare.

And their value to the world—and to the creatures depending on them—is priceless. ▪

A mangrove hummingbird—*Amazilia boucardi,* found only on
Costa Rica's Pacific coast—seeks the nectar of a mangrove in bloom.

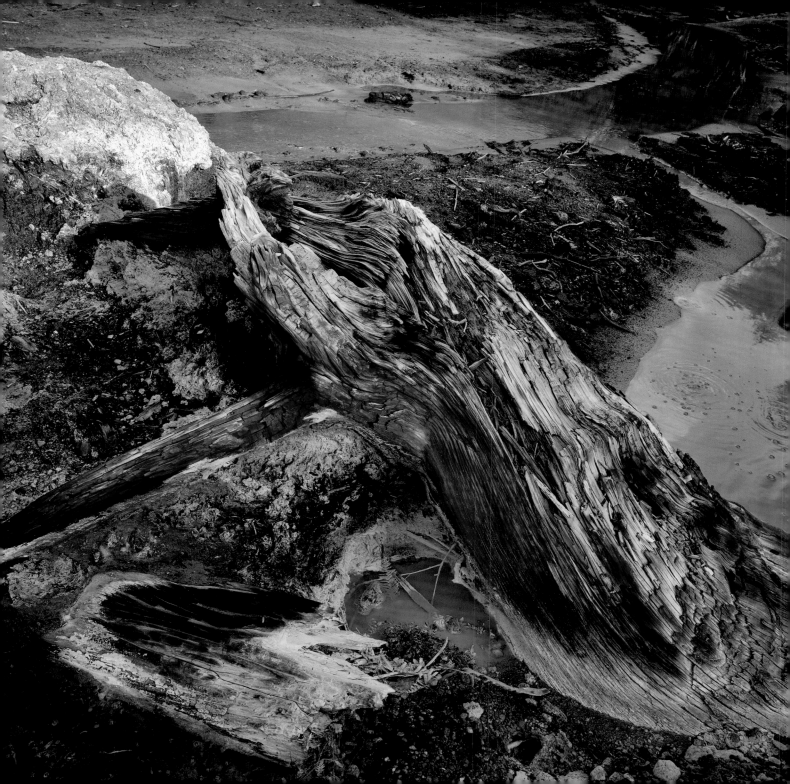

Underwater Forests

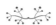

In September 2004, when Hurricane Ivan scraped the southeastern United States, it not only reshaped the landscape of the coastline and beyond; it also wreaked havoc underwater. In its wake, a cypress forest some 60 feet under emerged from out of the seafloor debris that had been hiding it. Wood analyzed from one of the underwater trees still standing put the forest's age at 50,000 to 60,000 years old; back then, these trees stood along the coastline.

Over the lifetime of our planet, sea level rises, sea level falls, and the shape of continents changes. This underwater forest—whole knobby cypress trees, perhaps thousands of them—once stood above water. Today, these trees are no longer growing, but they have not rotted, either. Naturally resistant to decay, they remained whole in their low-oxygen underwater environment. Their existence gives us new information about the shape of land during an ice age 60,000 years ago.

Meanwhile, on the other side of the world, long sunken trees dredged from the peat bogs of New Zealand's North Island are telling a different piece of history. Known as swamp kauri, some of these trees stood strong and tall for a good 2,000 years before they sank underwater. Some may date back as far as 60,000 years, preserved from rotting in the anaerobic sludge.

As humans have developed the land for farms and houses, these ancient logs have come to light. Tree ring analysis of these specimens extends scientists'

An ancient kauri log, likely tens or even hundreds of thousands of years old, rises out of sulfur springs near Ngawha, New Zealand.

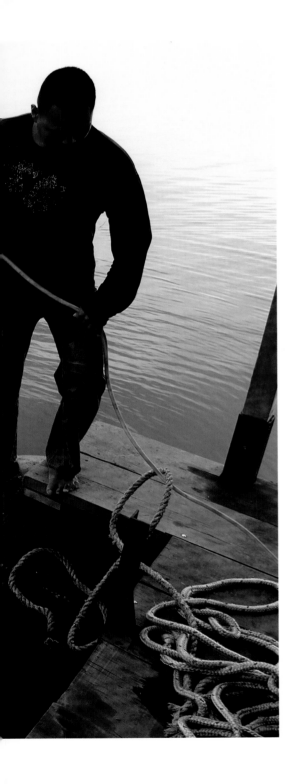

"How tunefully the forests ring!"

※

—WILLIAM WORDSWORTH,
Peter Bell

view of the changing climate of the Southern Hemisphere by millennia. The wood is prized as timber and as an embodiment of Maori spiritual traditions, competing valuations that underlie the government regulations now in place to control the excavation and sale of swamp kauri.

Forests around the world have stories to tell, many several centuries old. But forests long submerged hold even more ancient memories. These elders saw a planet very different from the one we know today. We bring them to light; we honor and learn. ■

From Panama's Bayano Reservoir, created in 1976 to generate hydroelectric power, divers harvest sunken logs of amarillo and cumaru, both prized tropical woods.

FAMOUS TREES

THE TREE THAT REMEMBERS

In the Northland of New Zealand, near the coast of the Tasman Sea, stands a massive kauri tree: Tāne Mahuta, named for the Maori god of the forest. The largest living specimen of its kind still alive today, it stands tall in Waipoua Forest, a government-protected nature preserve since 1952. Many believe Tāne Mahuta is 2,000 years old.

But through the last two centuries, this massive tree has witnessed the demise of its kind in massive numbers. The Maori people who first arrived here performed ceremonies of gratitude as they harvested kauri logs for their longboats. Europeans quickly recognized the wood's value, and by the mid-1800s massive trees were being chuted down steep slopes, milled into construction lumber, nautical spars, and prized furniture.

Today, few kauri trees remain. A fungus called kauri dieback threatens them, and hikers in New Zealand must clean the soles of their boots whenever they visit kauri forests. Many have become dedicated to planting kauri seedlings, while understanding that only future generations will witness the grandeur of these slow-growing trees.

Through it all, the god of the forest stands, silently remembering the time before humans arrived, the time when majestic kauri trees covered every slope and valley of this land. ▪

In New Zealand's Waipoua Forest, Tāne Mahuta evokes a history when these massive kauri trees dominated the slopes.

FOLLOWING PAGES: A bald cypress tree stretches out in both directions, branches above and roots below, in Virginia's Great Dismal Swamp.

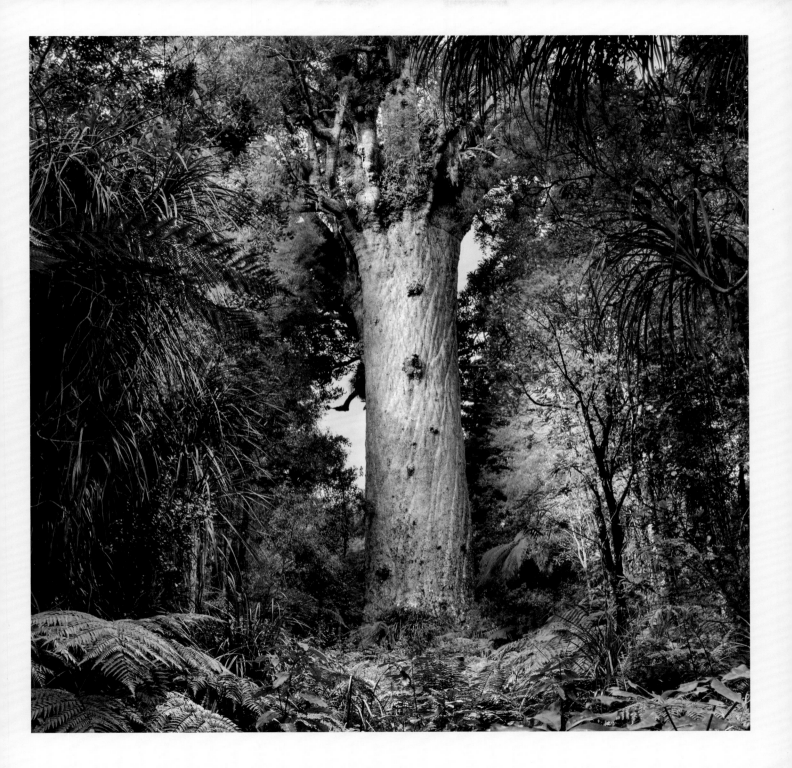

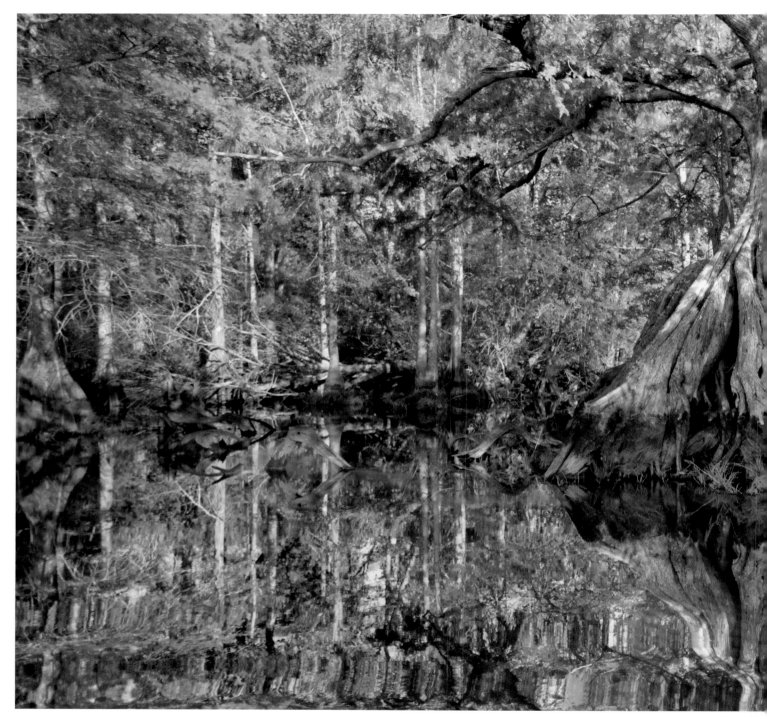

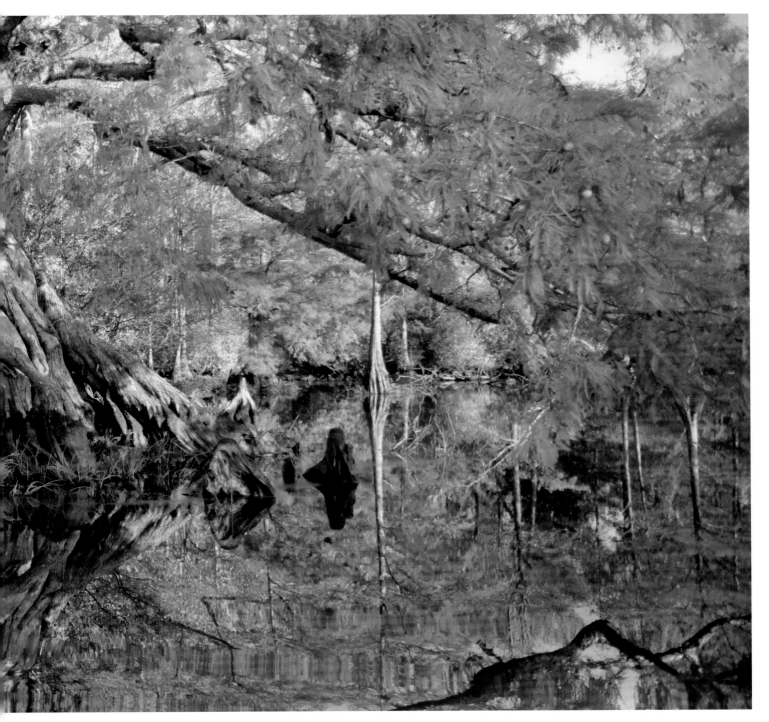

Part of the Solution

When the nations of the world came together for the Paris Agreement on climate change in 2015, they placed much hope in using global forests to alleviate global warming, and they published a statement recognizing "the essential role forests play in the long-term health of our planet, in contributing to sustainable development, and in meeting our shared goal of avoiding dangerous climate change." The statement continued: "We are committed to intensifying efforts to protect forests, to significantly restore degraded forest, peat and agricultural lands, and to promote low carbon rural development," joining "in partnership to reverse deforestation in our lifetimes . . . for the good of the climate, humanity and the world's forests."

It made scientific sense: Increased carbon emissions were accelerating the so-called greenhouse effect, resulting in rising temperatures on land and sea, shifting habitats, fiercer weather, and melting polar ice. Since trees absorb carbon dioxide and exude oxygen and water vapor—all processes that can ameliorate global warming trends—the Paris Agreement, followed by United Nations initiatives, resolved to increase forest cover worldwide as a natural climate solution.

More than 50 nations established their own strategies to plant more trees. Over the two years that followed, volunteers planted more than 100 million in India; in Ethiopia, they planted 350 million. The challenge became a

Smoke sifts through the remaining treetops in Indonesia's Aceh province, the aftermath of a massive clearing effort to establish a palm plantation.

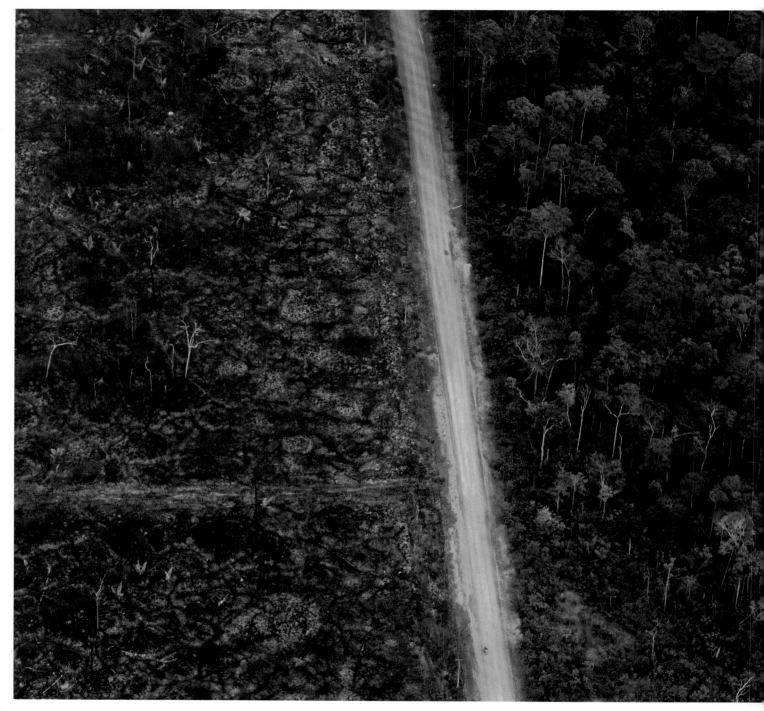

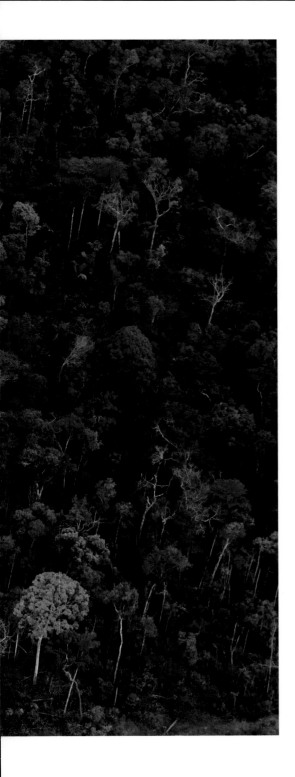

> "The rainforests hold answers to questions we have yet to ask."

> — MARK PLOTKIN, ethnobotanist, quoting a saying from Suriname

contest. Volunteers in Turkey set a record: 303,150 saplings planted in one hour in 2019. In the United States, The Nature Conservancy set a goal of planting one billion trees.

Yet counterforces kept interfering. In the Amazon rainforest, trees were cut down to make way for beef cattle grazing. In Malaysia and Indonesia, rainforests were removed to expand acreage for palm oil plantations. Meanwhile, ecologists remind us that widespread replanting efforts of a single managed species can never replicate the effect of intact forests with many tree varieties. Planting trees certainly contributes to the cause, but the solution is not as simple as it seems. ∎

Stark contrast: A road cuts through the Brazilian Amazon (rainforest on the right, charred remains on the left)—evidence of clearing for cattle ranching and field agriculture.

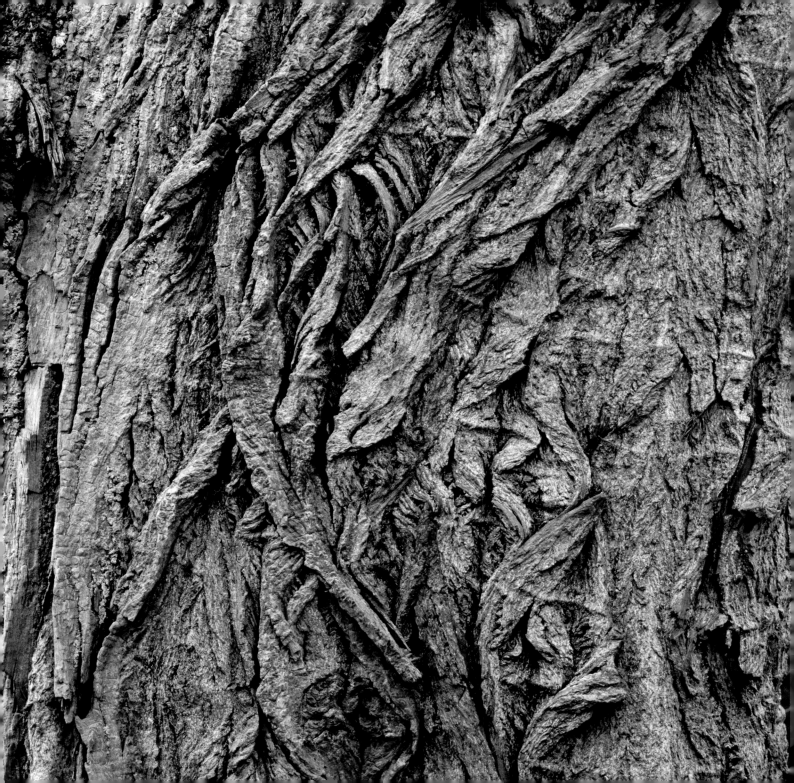

What's Bark?

Bark is the protective skin of a tree. High in suberin—a waxy, waterproof substance—bark keeps water, pollutants, and invaders from interfering with the tree's growth.

In the cross section of a tree trunk, the inner core is made of dead cells; this is the substance we harvest as wood. Live cells grow at the outer edge of the trunk: These consist of phloem, the cells that distribute oxygen and sugar from the leaves down, and xylem, the cells that send food and water from the roots up. The complete process takes place just under the bark.

The phloem layer can also be called the inner bark. Use your fingernail to scrape the skin off a young twig, and you're gouging the inner bark. It's made of live cells, much different in character from the outer bark that covers it or the wood deeper in. As a tree grows, a new living layer of phloem cells develops and the old one sloughs off, becoming bark.

Bark patterns are as distinctive as leaf shapes, species to species: the gleam of white birch bark, striped with black; the big flakes peeling off a shagbark hickory tree; the deep furrows and reddish hue of a Douglas fir. Avid naturalists learn to identify trees by their bark alone.

Through human history, we've eaten, worn, and woven bark; we've learned which tastes good and which treats illness. Cinnamon is the ground inner bark of the cinnamon tree; aspirin first came from the inner bark of willow; quinine, an early treatment for malaria, comes from the inner bark of the cinchona tree.

Enveloping an aged willow tree, gnarled bark builds from the inside out and protects tender living layers of cells underneath.

"The forest is not only something to be understood, it is also something to be felt."

—JOAN MALOOF,
founding director,
Old-Growth Forest Network

Today, we've learned how to harvest bark without harming the tree. Cork—the outer bark of *Quercus suber,* an evergreen oak species cultivated especially in Spain, Portugal, and nearby North Africa—is carefully stripped from a tree only 12 to 15 times during its life span of a century or two.

Bark helps every tree in the world. And it's also helped humanity in many ways. Next time you pry open a bottle of wine, think of the tree that provided. ∎

The bark of cork oaks *(Quercus suber)*—these in southern Spain—is carefully harvested again and again without interrupting the life of the trees.

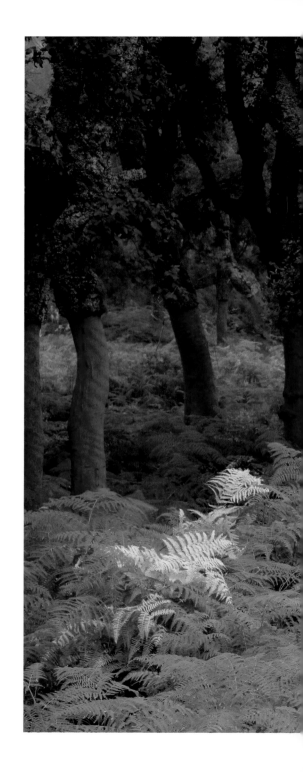

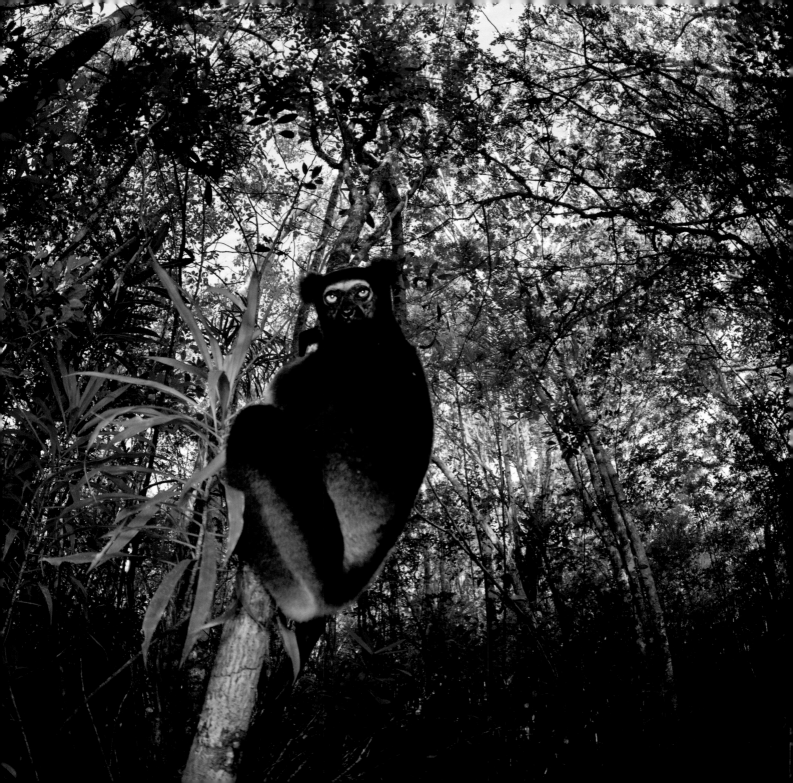

Rain in the Forest

Yes, it does rain in the world's rainforests. But that is only part of the story. In a vast interrelationship that links plants, animals, and atmosphere, these forests also generate precipitation—a cycle that makes these regions essential for the health of the entire planet.

It does indeed rain a lot in the rainforest—on average, more than 70 inches a year. There are temperate rainforests in the chilly North American Northwest and along Chile's southeastern coastline. But the most abundant swath—the tropical rainforests—occurs around the planet's waistline: the stretch of land and water between the boundary lines of the Tropic of Cancer and the Tropic of Capricorn, reaching about 1,600 miles north and south of the Equator. Here, sunlight beams in at an angle close to 90 degrees all year round, with little seasonal variation in the schedule or intensity of daylight. The abundance of life, activity of the water cycle, and importance of these regions to the planet is astounding.

Tropical rainforests have a shape all their own, comprising four layers: the overstory, the canopy, the understory, and the ground. In the overstory, the occasional overachiever tree stretches leaves and branches higher than the rest. The understory contains the tall, relatively bare trunks of the rainforest's trees and vines. Most of the action takes place in the two other regions: in the canopy and on the ground.

The indri—the world's largest lemur, found only in the rainforest
of northeastern Madagascar—lives its life in the forest canopy.

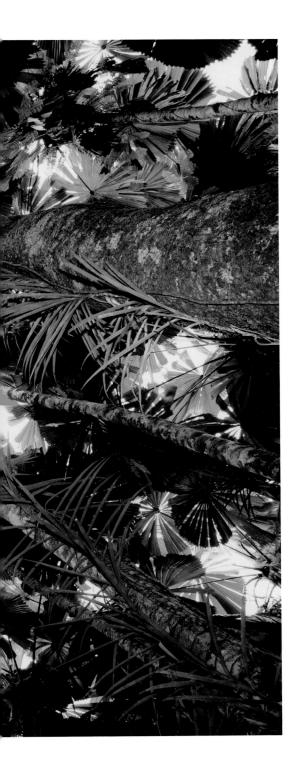

In the canopy, the leaves of trees and vines, along with other clinging plant life, twist together into a teeming mass of green so dense it captures most of the sunlight and lets little light through to the ground below. This is where life is found: Insects, birds, and mammals inhabit the canopy, creeping, leaping, climbing, flying, and letting out hoots and howls. More than half the species on Earth live in the rainforest, and the majority of them inhabit the canopy.

Rainfall blankets the canopy, its plant life designed through evolution to maximize moisture. Tropical tree leaves tend to be waxy, to hold in water, and pointed, to pass that water on. One estimate suggests that because it lands on so many leaves on the way down, a single raindrop takes 10 minutes to travel from rainforest treetops to the ground below.

Year round, tropical rainforest trees drop leaves, flowers, and fruit, creating a bed of decaying matter. While animal life here may not be as loud or flashy, rodents scuttle, worms slither, and insects tiptoe through the litter, enriched by the waste of all the creatures winging and climbing above. Fungi and bacteria thrive.

Water moves from the ground up through the

Look up: Fan palm treetops create a natural stained-glass window as light seeps through the rainforest canopy of Australia's Daintree National Park.

trees' xylem systems, carrying the nutrients freed by decay. Pulled up by pressure variants all the way to the canopy and the overstory, moisture exits the leaves. The whole forest breathes out steamy exhalations, sometimes even creating clouds that hover in the treetops.

Inside the cells of every one of those leaves, photosynthesis happens. Water and carbon dioxide, fueled by sunlight, are exquisitely transformed into sugar—food for the growing plants—and oxygen, released into the atmosphere. All forests perform double duty for the planet, sequestering carbon and replenishing oxygen: processes critical to environmental balance. Because of their vastness, many call our rainforests the lungs of the planet.

But tropical rainforests are under siege. Commercial agriculture, cattle farming, logging, roads, and other sorts of industrial development cause people to level the trees and flatten the forest. Degraded forests catch fire, wreaking even further destruction on the native environment. The fear is that in time, we may see a day when our rainforests are so badly decimated that the planet cannot breathe.

One way out of this death spiral: understanding, valuing, and caring for these crucial habitats. Small life choices intersect with the drivers of their destruction. Do you purchase food made with palm oil, from trees grown on plantations where rainforests once stood? Do you eat beef from farmed cattle, a global industry tearing away at the Amazon? Are you choosing rainforest wood for building—mahogany, rosewood, ebony, teak? Rethink such choices, and you can do your small part to keep the rainforest breathing. ∎

Some 2,500 species of vines, creepers, and lianas (woody vines) inhabit the world's tropical rainforests, compounding the massive photosynthetic leaf area.

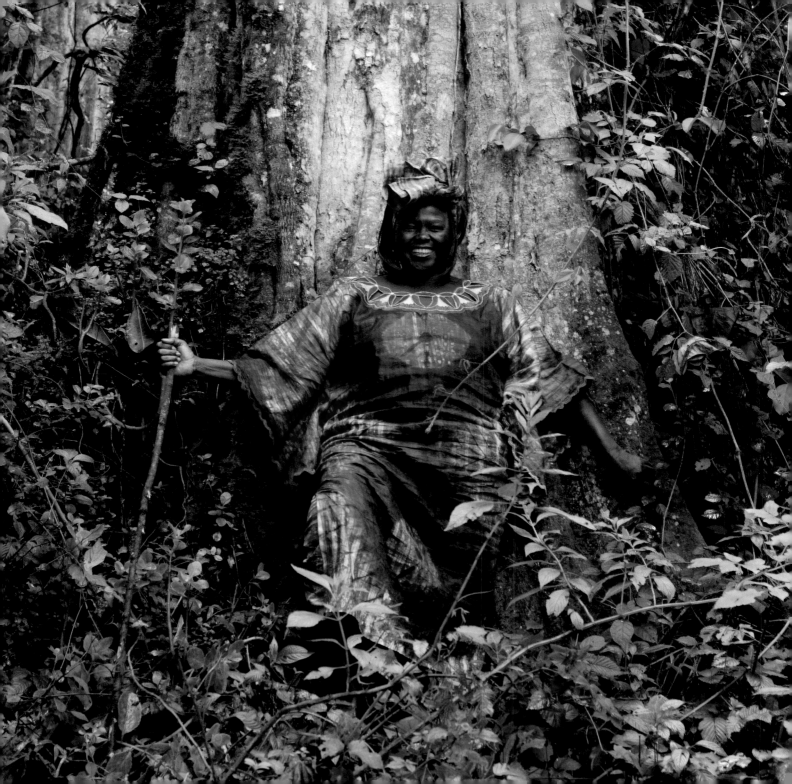

Trees of Peace

In 2004 the Nobel Prize for Peace went to Wangari Muta Maathai, a Kenyan woman who understood the value of planting trees.

Born in 1940 north of Nairobi, Maathai watched over time as village women had to work harder to cultivate their gardens and walk farther to fetch clean water. British colonialists had stripped the land of native trees and replanted foreign species for tea and timber, disturbing the native fauna and depleting the soil. Where rain had once replenished the groundwater, it now ran over the soil and coursed downstream. The old wells had gone dry.

Maathai was a pioneer: one of the first African women to receive a Ph.D. and the first woman to become a department chair and professor at the University of Nairobi. Planting trees became her mission, and from 1977 on, she enlisted thousands of women throughout Kenya to join her quest. Her motto was "One person, one tree"; her goal was to plant trees to equal the population of Kenya: 15 million.

The plan evolved into the Green Belt Movement, an environmental organization dedicated to empowering villages—and, in turn, the women in them. The women recognized that by growing seedlings and planting trees, they could bind the soil, capture rainwater, provide food and fuel, and ultimately secure a more solid future. By the time of her death in 2011, Maathai had inspired the planting of more than 50 million trees.

A friend to the trees: Environmentalist Wangari Maathai won the 2004 Nobel Peace Prize for motivating fellow Kenyan women to plant millions of trees in their homeland.

"We are called to assist the Earth to heal her wounds and in the process heal our own."

—WANGARI MAATHAI,
Nobel Prize lecture, 2004

Nobel officials acknowledged that in honoring Maathai, they were broadening the definition of the prize for peace and recognizing environmental protection as an important path to a brighter future. Maathai's vision still drives her fellow Africans, who are now dedicated to planting a 5,000-mile Great Green Wall of trees, shrubs, and grasses across their continent by 2030. ∎

From 1977 on, women joined Maathai's Green Belt Movement, recognizing the value of trees in preventing erosion and maximizing available fresh water.

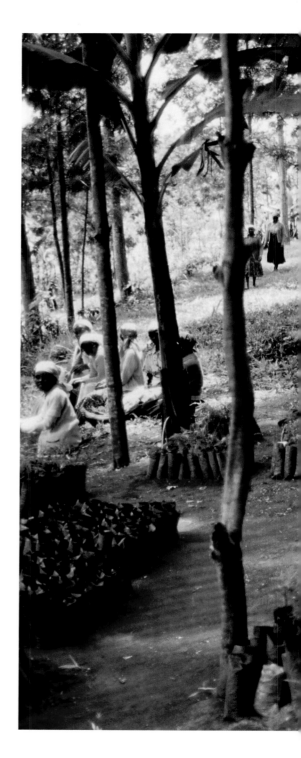

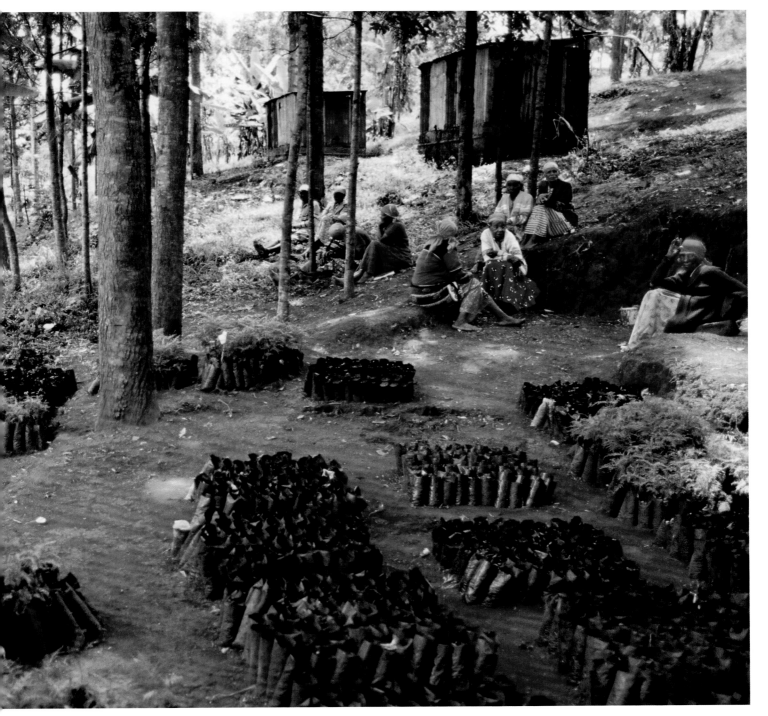

THE STORY OF THE MAPLE

The Anishinaabe of North America's Great Lakes region tell a story about the maple tree. Long ago, sweet, thick sap flowed through the trees all year round; the people could simply tap a tree and drink syrup all day long. Earth Mother had provided that gift, but her grandson worried that it made life too easy. He did not want his people to become lazy. So he flew up above the treetops and showered water down on them. That is why maple sap can only be gathered at a certain time of year and requires time and patient work to turn it into sweet syrup.

Maple trees like this one, gloriously golden, dapple the
North American landscape in shimmering autumn hues.

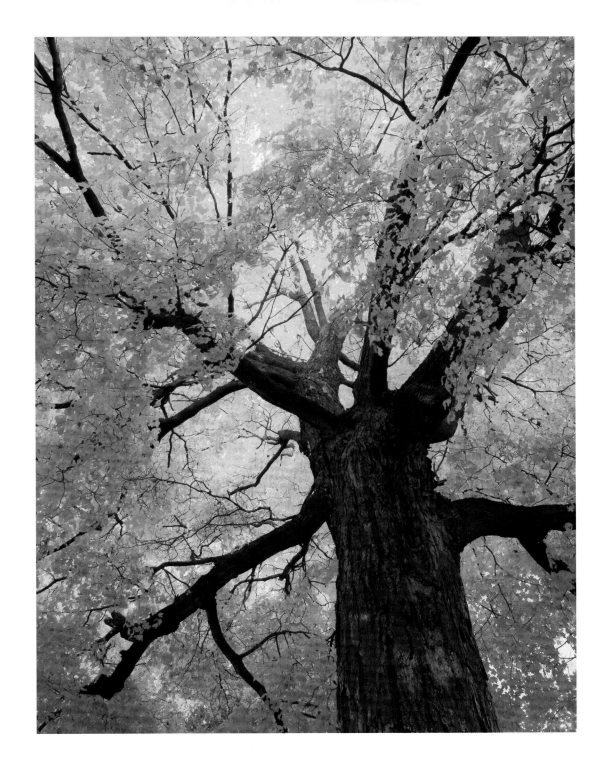

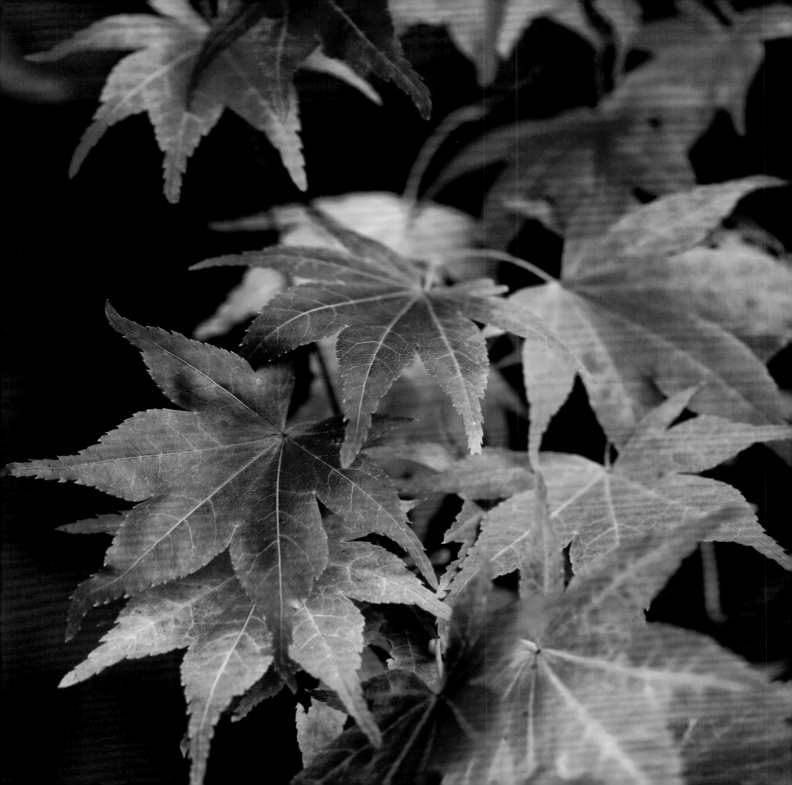

Anatomy of a Leaf

No matter what the shape—broad, flat, and papery, like oak and maple; tough little needles, like pine and spruce; sturdy fronds, like palms—leaves are the industrious energy machines where photosynthesis happens.

At the cellular level, the typical leaf has a cross section with three layers. Cells on the top layer, the epidermis, are designed to keep water in. The bottom layer, also epidermis, is stippled with stomata—openings through which gases travel. The middle layer, the mesophyll, is where the action is. Cells there contain chlorophyll, a pigment that makes leaves green and absorbs light, the driver for photosynthesis.

Water courses up the tree trunk, out the branches, and into the leaves. On many a leaf you can actually discern the intricate veiny structure—the ultimate destination for all that moving water.

At the same time, carbon dioxide enters the leaves' stomata. Sunlight strikes the chlorophyll-rich cells, and magic happens. Water plus carbon dioxide, fueled by sunlight, undergoes a chemical transformation, rearranging molecules and resulting in oxygen exiting through the stomata and carbon-based sugars coursing back down through the phloem. Thanks to this leafy process, every tree replenishes the oxygen in our atmosphere and makes its own food.

Sunlight contains all the colors of the visible spectrum, and chlorophyll absorbs all but green. It reflects green light—hence the color of leaves. In

The prominent veins in Japanese maple leaves complete
the track of nutrient-rich fluids between roots and treetops.

"Between every
two pine trees
there is a door leading
to a new way
of life."

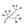

—JOHN MUIR,
notes on Ralph Waldo Emerson's writing

temperate climates, the chlorophyll engine loses steam in autumn as the days grow shorter. With less chlorophyll to dominate the light absorption, other pigments in the leaves shine through—xanthophyll yellow, carotenoid orange, anthocyanin red—and for a little while each year, the forest glows with brilliant colors as trees prepare for winter rest.

The next time you kick your way through a pile of fallen autumn leaves, remember the service that each offered to the tree that created it. ■

Look closely at the underside of a tree leaf to see its
intricate network of transpiration pathways.

Desert Trees

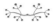

Frankincense trees sprout from dry wadis in Oman. Baobabs tower above barren scrub in Madagascar. Ghost gums cling to red-rock outcroppings in Australia. Each has survived conditions that would challenge, even kill, other species. These are the trees of the desert.

A recent survey of the world's drylands—places receiving less than 16 annual inches of rain—turned up 1,576 species of trees. Close to half are native to either Madagascar or Australia, and more than a quarter belong to the legume family, sharing characteristics that can include deep roots, thorny trunks and branches, resinous gum, feathery compound leaves, and pods bearing bean-type seeds. Each modification likely plays some role in the trees' ability to survive in the driest of conditions.

More than 200 of these desert species are acacias, found on every continent of the world but Antarctica. Some acacia species are famous for their gum, the sticky resin that trees exude when wounded (and the natural origin of chewing gum). Gum arabic, as it is often called, has been harvested from acacia trees for millennia. It is still used to manufacture candy, valued as a dietary fiber and prebiotic, and included in formulas for glue, paint, and other materials that benefit from its sticky texture.

Acacias are also celebrated as one of the first scientifically confirmed example of trees that communicate with one another. Giraffes eat the leaves of the umbrella thorn tree, a scrubby acacia native from Sudan to South Africa. The

Massive trees, their trunks engorged to weather lengthy dry spells,
line Madagascar's so-called Avenue of the Baobabs, near Morondava on the west coast.

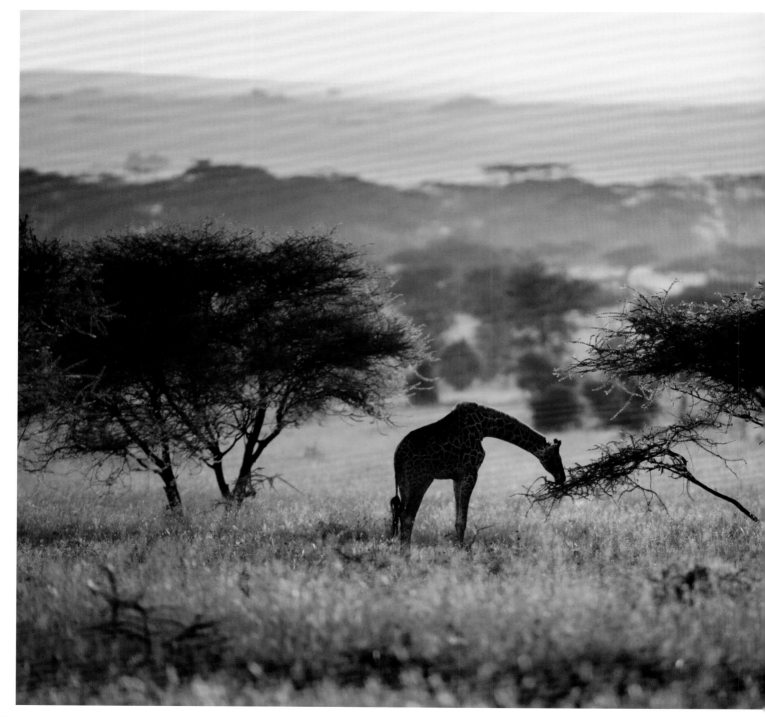

acacia responds in two ways: The leaves quickly develop a bitter compound, making them unpalatable, and the tree gives off ethylene gas, which wafts to neighboring acacias. These trees, in turn, become more bitter before the giraffe arrives.

Many acacias enjoy symbiotic relationships with ants, which drill into the tree's swollen thorns and lay their eggs inside; the larvae develop, protected within the thorns, while the parent ants eat nectar from the flowers. Some acacias even develop special protein-rich organs on the tips of their leaves, which the ants harvest to feed their young.

Ants scurry over branches and leaves, making the trees less appealing to browsing predators. Some studies even suggest that as they travel up and down, the ants distribute beneficial bacteria that help the tree fend off disease. Certain species of ant inhabit certain species of acacia; clearly, each has found its match.

The trees of the desert are as wise as they are hardy: They have learned how to thrive in stringent circumstances, weaving communities of interdependence with the creatures that share them. ∎

When giraffes munch on acacia leaves—seen here in Tanzania's Serengeti National Park—volatile emissions reach nearby trees, which then exude a chemical that discourages further browsing.

FAMOUS TREES

THE TREE FROM THE DREAMTIME

For the Nyikina people indigenous to western Australia, *larrkadi*, or the boab tree, inhabits the dreaming—the beginning of time—as do so many other natural phenomena. As they tell it, one boab tree is actually the bones of a primordial snake; another once hoarded all the water until the sand frog speared it, refilling the rivers and creeks.

In these outback lands, there are practical reasons as well to honor the boab, a tree botanically (and likely linguistically) related to the African baobab. To the Aboriginals, the boab tree indicated precious groundwater, and its bulbous trunk could be tapped for drinking in times of drought. And the tree offers many other benefits: Boab leaves and fruit pulp are edible, its fruit husks make good bowls, and its bark eases stomach ailments.

Ancient carvings grace some Australian boab trees. This individual, whose massive trunk expands almost as broadly as its leafy crown, is known to have been an honored repository for ancestral relics, long since collected by eager archaeologists. But in the modern era, its reputation took an unfortunate turn from sacred to profane, and today it embodies the horrors of colonialism more than the ancient mysteries. In the belly of this tree, so legend has it, white overlords chained renegade Aboriginals on the way to jail in Derby.

While that story has been debunked, its reputation lives on—as does this proud tree, estimated at 1,500 years old and now on many a tourist's must-see list when they visit the region. ∎

This famous boab tree near Derby, Western Australia,
long predates the legend that it was used by colonialists as a prison.

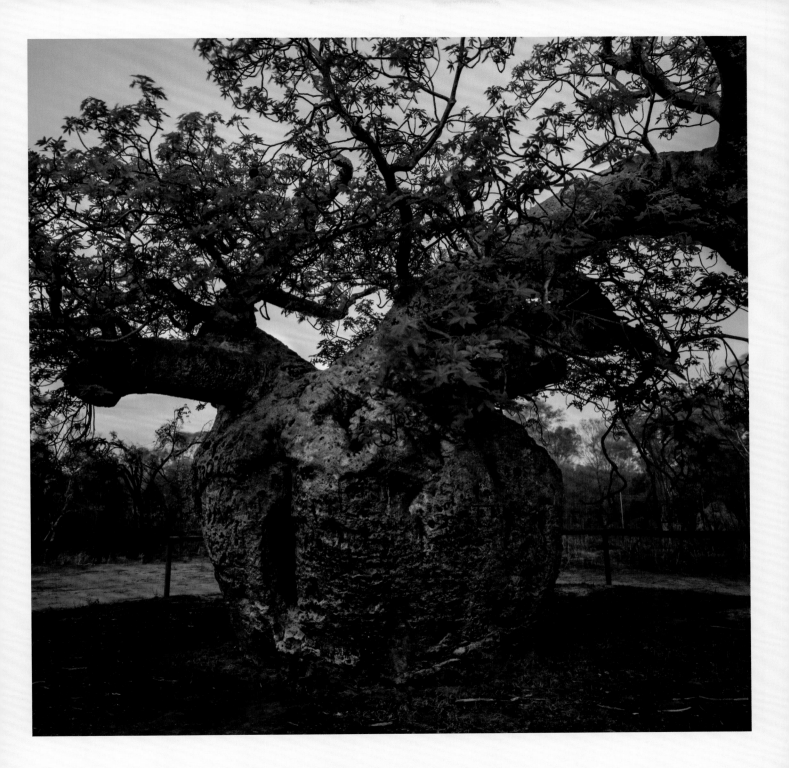

CHAPTER FOUR

AIR

Trees breathe in, breathe out,
enhancing the air with subtle fragrance.

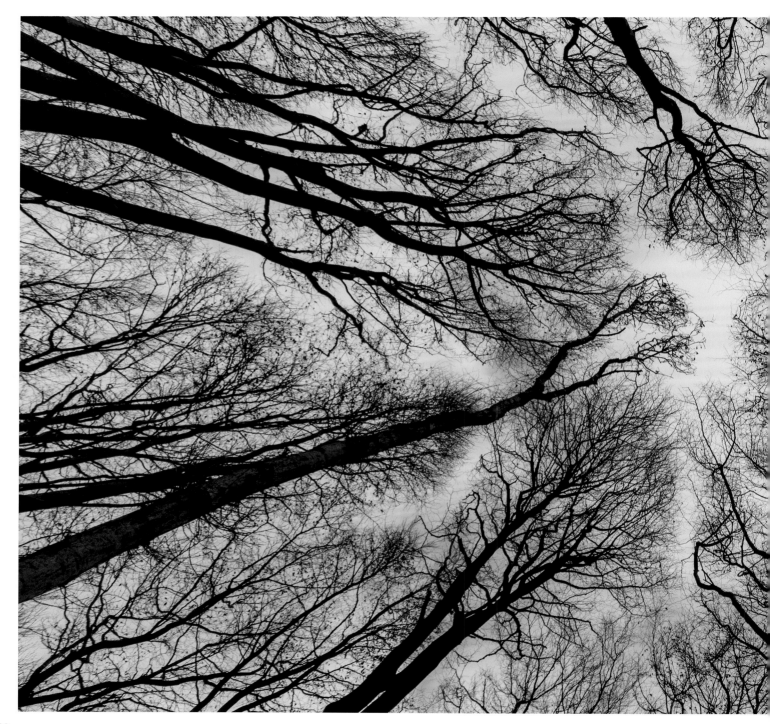

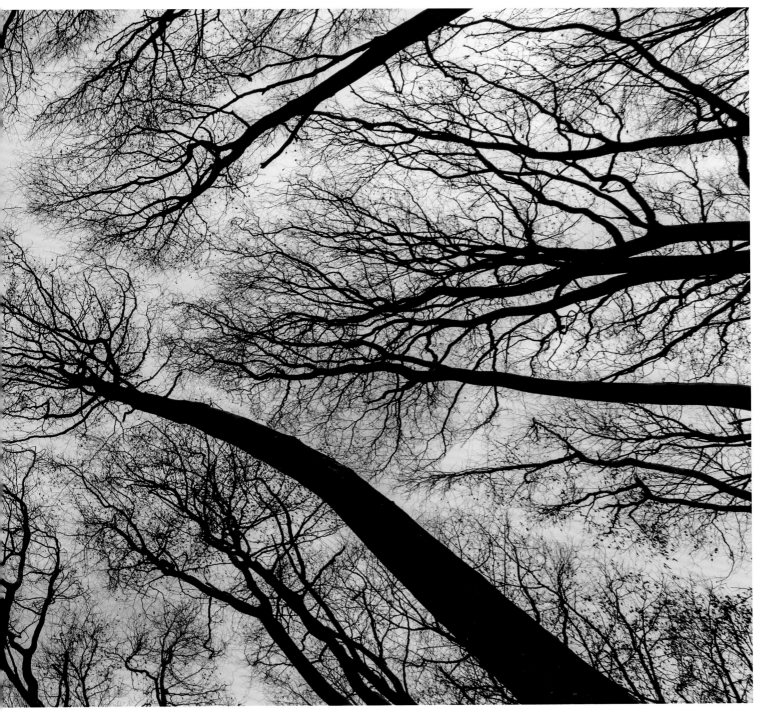

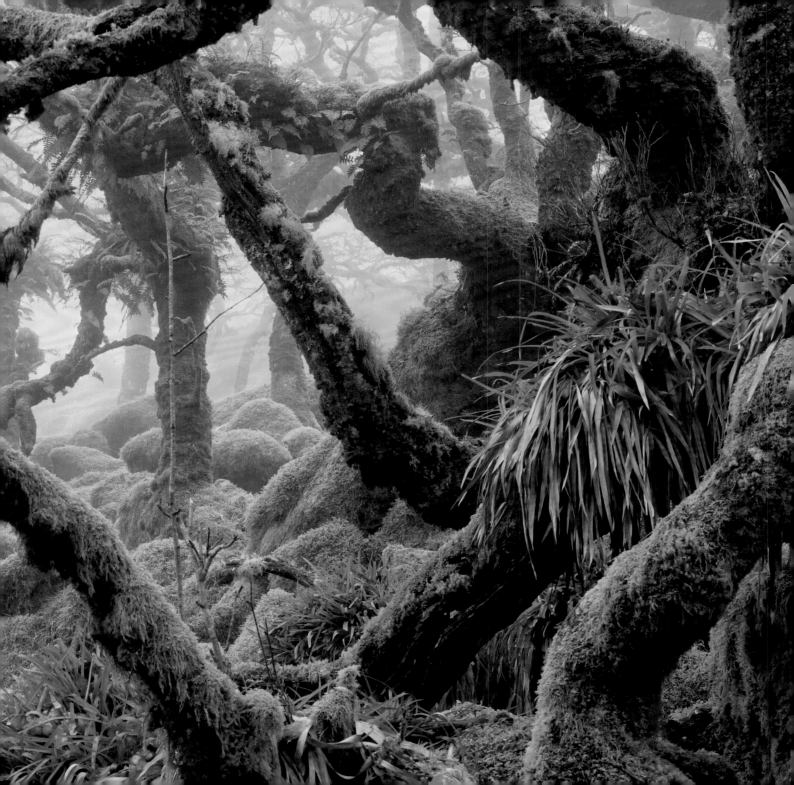

The Power of Green

Impressionist paintings show trees shimmering with all the colors of the rainbow, but the forest still predominates in green: the shy yellow-green of springtime treetops, the cold silver-green of spruce needles, the ruddy green of moss underfoot. All derive from the miracle of photosynthesis, by which plants source the energy they need to stay alive.

One might ask, why green? What purpose does that color serve in the forest? To answer that question, an interdisciplinary team—experts in electronics, physics, botany—casts photosynthesizing leaves as light-harvesting antennae and sees green as nature's ingenious way of leveling out plants' energy intake.

Sunlight hits the cells of a leaf in uneven and unpredictable ways, with fluctuations by the second and by the season as leaves flutter, shadows flicker, and the angle and intensity of the sun's rays change through time. A steady intake of green might actually overpower the cells. By absorbing blue and red light, but not green, leaves avoid overkill.

While trees reject green light—and hence reflect it, making their leaves appear green to human eyes—it turns out to be good for our human bodies. Many studies reveal that we benefit from time deliberately spent in green spaces, whether parks or forests or even rooms with houseplants. But the value of green goes deeper: For some, it appears that green light can counteract pain.

Lichens and luxuriant moss blanket everything—trees, stumps, rocks, forest floor—
in Wistman's Wood, part of Dartmoor National Park in Devon, U.K.

PREVIOUS PAGES: Beech trees, in all their wintry nakedness, reach to the sky in Dorset, U.K.

Migraine sufferers are often photophobic—that is, bright light exacerbates the condition. But health care providers are discovering that exposure to highly controlled green LED lights can mitigate the pain. Further research conducted by Mohab Ibrahim at the University of Arizona was designed to discern whether relief was the result of green light cast body-wide or perceived through the eyes. Lab rats were actually fitted with contact lenses that blocked out green. The outcome: The best pain relief came when green shone into their eyes.

Could green light therapy help with chronic pain management, with after-surgery recovery, even with sleep? All are possibilities. Meanwhile it's reassuring to know that a walk in the woods—while untested in laboratory rats—will fill your eyes with healing green. ▪

Numerous species among the 3,000-some types of palm trees sport fan-shaped leaves.

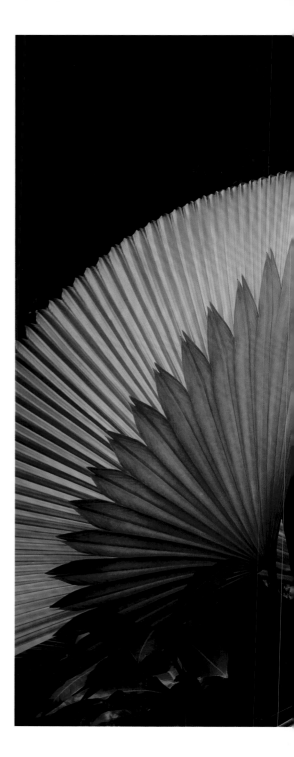

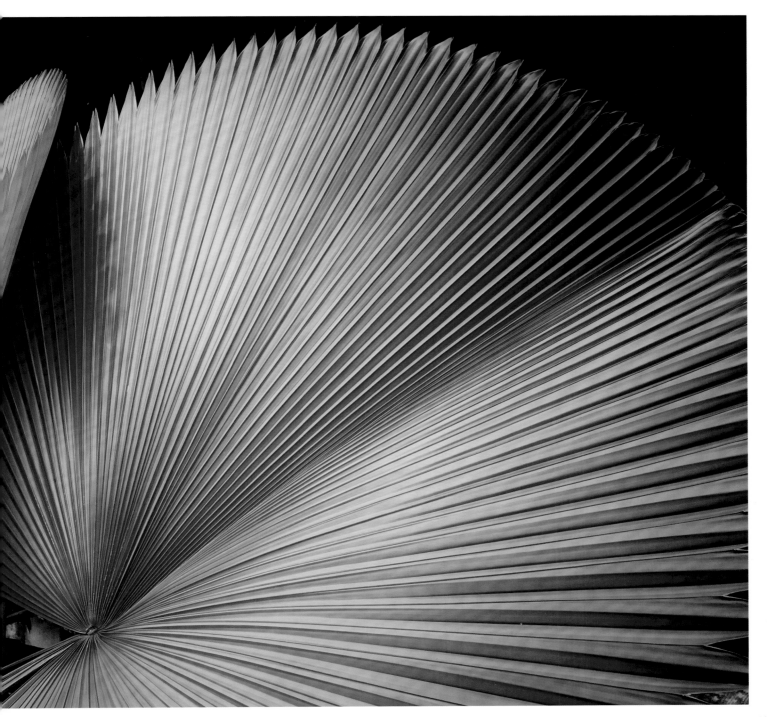

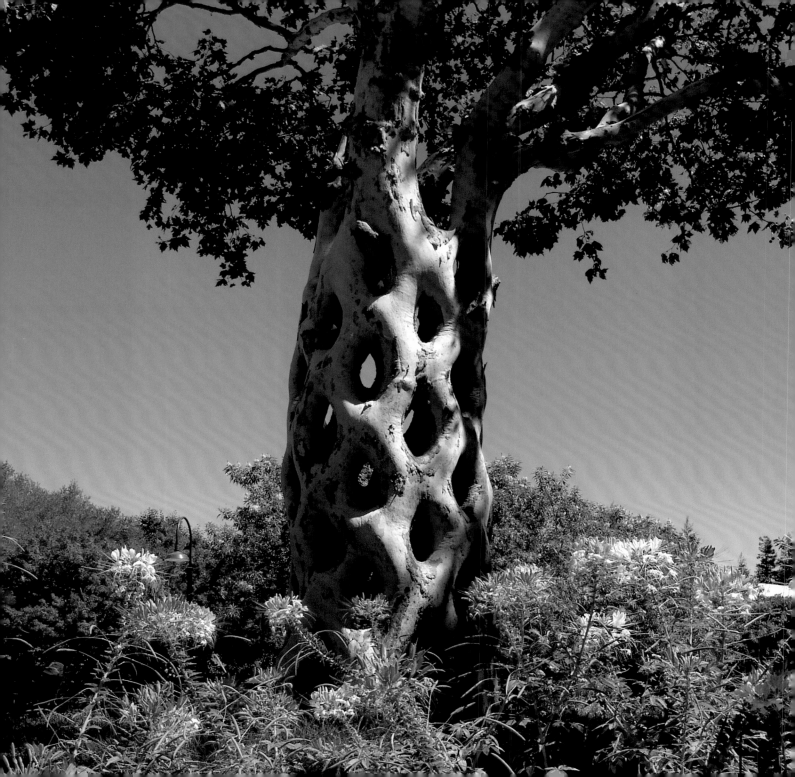

Living Sculptures

The trees in a California park called Gilroy Gardens are celebrated for their amazing shapes. One, called the Basket, features six sycamores that weave loosely together into a single trunk, resembling a hollow lattice. Another—a box elder known as the Revolving Door—splits into four branches that grow out, up, and back together in near-perfect right angles. Dubbed the Circus Trees, they are whimsical examples of grafting, a technique practiced for millennia. Theophrastus, a student of Aristotle, wrote about it as early as 300 B.C.

Horticulturists can join tree limbs to one another thanks to the cambium layer of cells located just under tree bark. Like stem cells in humans, these are undifferentiated units with the potential to specialize in different directions as the tree develops; when the cells in two cambium layers meet, they can grow together. In 2020, biologists captured microscopic videos of the process, revealing that grafted plants actually exchange organelles, or internal cellular contents, as they join.

Orchardists use this technique to propagate beloved fruit varieties by joining rootstock selected for hardiness with scions, or twig cuttings, from trees known to produce the favored fruit. For example, when Old World grape varieties were smitten with a blight to which New World vines were immune, the solution was to graft European twigs onto American rootstock. By the same token, familiar apple varieties may have started as a single random seedling, or sport, as they

The Basket, one of the grafted oddities at California's Gilroy Gardens,
is made of six sycamore trees woven together long ago.

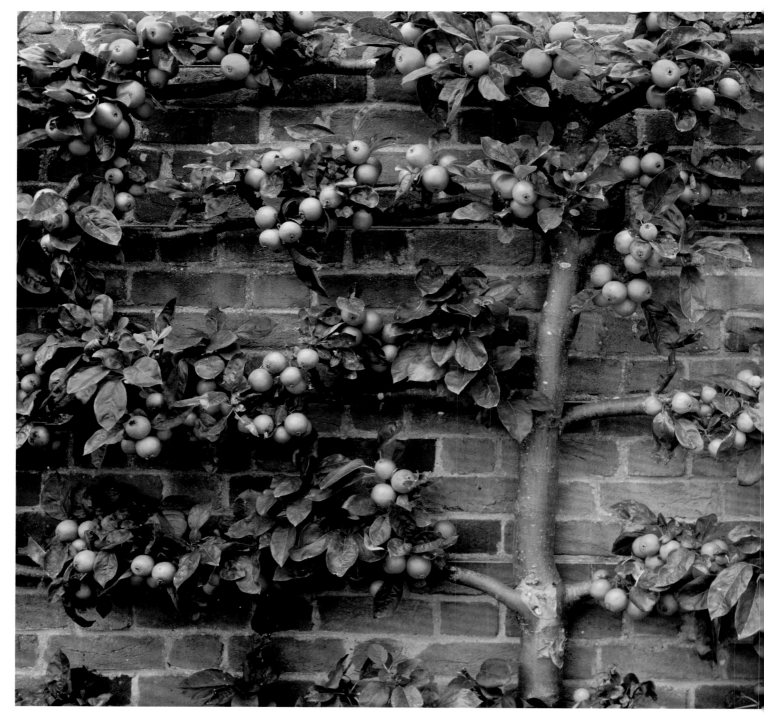

are called—but since you can't reproduce a specific flavor by planting the apple's seeds, every Red Delicious apple ever savored (except the very first) has grown on grafted twigstock. Sometimes a whole tree is grafted onto hardy rootstock. But for others, just branches are grafted on—a practice that might allow you to harvest Jonathan, McIntosh, Golden Delicious, and Granny Smith apples from a single tree.

Gilroy Gardens' Circus Trees demonstrate another time-honored tree-sculpting technique: espaliering, or reshaping flexible young tree branches, often flattening them against a wall or up a trellis. The technique may date back to ancient Egypt; the word comes from French and Italian roots meaning "shoulder," since espaliered trees are often trained to stay within easy reach. The supporting wall reflects heat and light, extending the fruiting season, and economizes on the space each tree requires.

To some sensibilities, espaliered trees please the eye; to others, they seem a departure from the normal shapes of nature. Regardless, they manifest the flexibility and energy of the growing tree and, as in the case of Gilroy's Circus Trees, our human inclination to reshape nature. ∎

Ripening apples cluster on a tree espaliered against a brick wall in Surrey, U.K.

BAUCIS & PHILEMON

In his *Metamorphoses*, the Roman poet Ovid
tells of the day Jupiter and Mercury roamed the
countryside, seeking food and shelter. No one obliged
them until they came to the tiny cottage of an elderly
couple, Baucis and Philemon. They gave their visitors a
humble meal and watched with amazement as the bowl
of wine constantly refilled itself, which signaled that
their visitors were immortal. Jupiter told them not to
fear and, in gratitude, granted their wish to die together.
When the end came, as they embraced for their final
farewell, their bodies sprouted leaves and branches.
Baucis and Philemon became an oak tree and a linden
tree, their two trunks intertwined forever.

Baobab trunks in Madagascar twist around in an everlasting embrace.

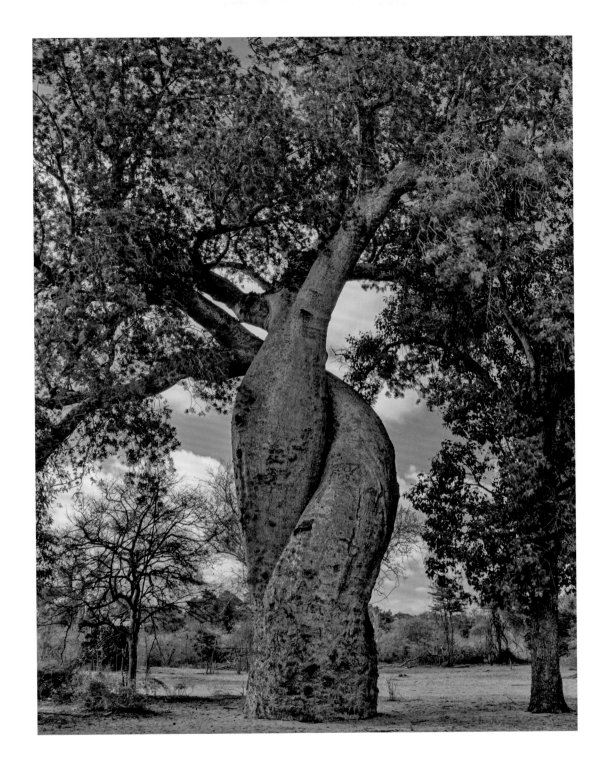

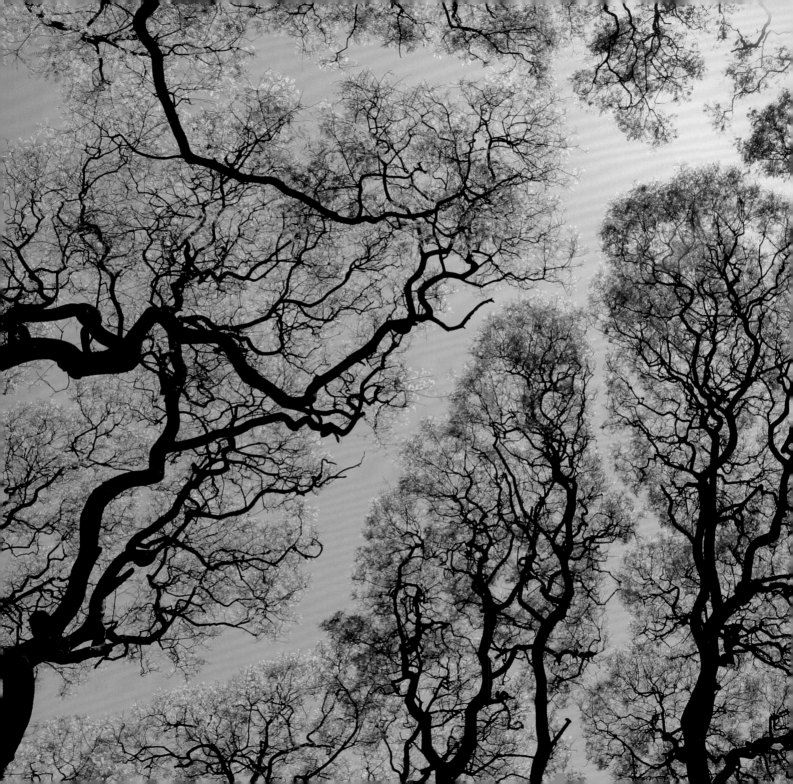

The Forest in the Air

The forest is breathing. Just as animals breathe in and out, so plants experience the exchange of gases as well. The air in a forest does not just surround the treetops; it moves in and out of the leaves, and its chemistry is affected by doing so.

At the peak of its growing season, a tree's leaves open up to the air. Minute openings called stomata take in and let out gases. This process is necessary for photosynthesis: Carbon dioxide comes in, oxygen and water vapor go out. The Smoky Mountains should really be called the Aerosol Mountains: It's not smoke but forest volatiles and water vapor that produce the haze.

Beyond water vapor, many other gases emerge from trees and infuse the forest air. Terpenes—among the best known classes of plant-derived volatiles—find their way into our lives as menthol, camphor, and turpentine. There are tens of thousands of terpenes, each unique to the species that generates it. All share a basic chemical building block: isoprene, a molecule made up of five carbon and eight hydrogen atoms. It is terpenes that give pine and rosemary, eucalyptus and cedar their distinctive scents.

First and foremost, terpenes serve their source trees. Some appear to repel predatory insects; others help heal wounds. Hot weather seems to increase volatile activity, and it's likely that some trees emit certain terpenes to survive the stress of overheating.

This view looking up in Buenos Aires reveals the phenomenon of crown shyness: the inclination of some trees to leave gaps between their highest branches.

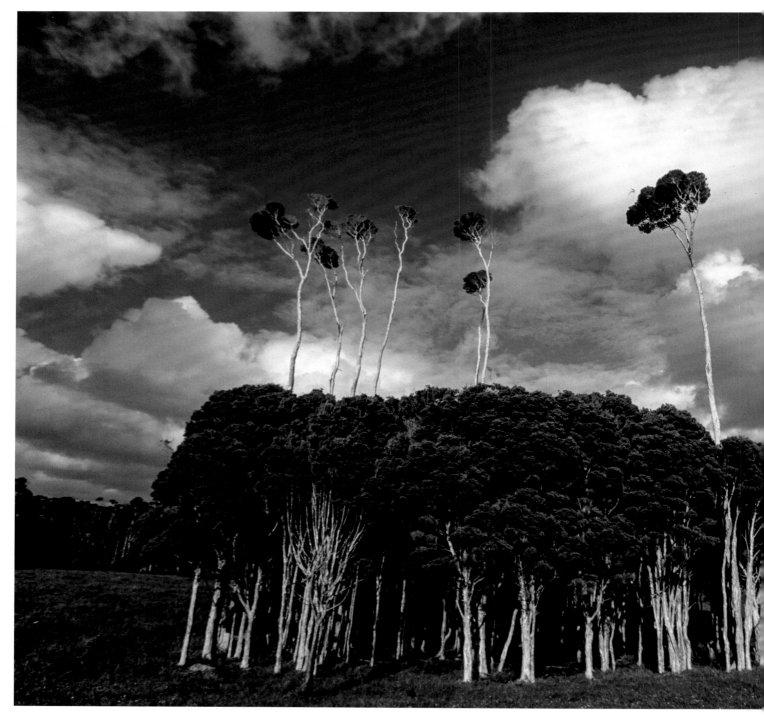

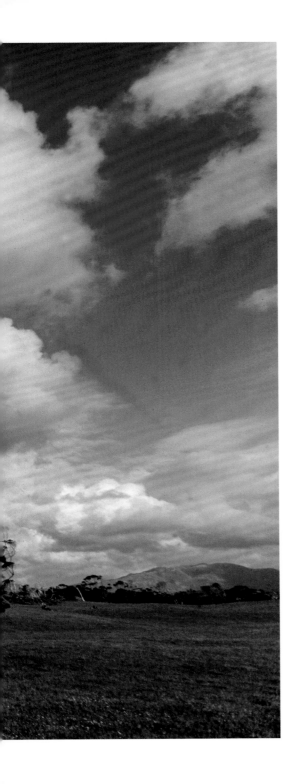

> "A primitive forest, druidical, solitary and savage . . . a just palpable wild and delicate aroma."

> —WALT WHITMAN, "An Ulster County Waterfall"

Today, medical science is confirming what Indigenous healers have long known: Forest volatiles can help humans as well. According to a study conducted by South Korean scientists and reported in 2017, a number of terpenes have been found to have salutary effects on those who breathe them in: Linalool, found in lavender, reduces lung inflammation; myrcene, found in hops, combats some forms of cancer.

So walk in the park or hike through the forest. Breathe in, and thank the trees for sharing their volatile essences with you. ▪

A few individuals stand up above the crowd in this copse of eucalyptus and tea trees in Tasmania.

Time-Honored Aromas

Alluring fragrances waft through history. The spice trade linked Europe, the Middle East, and Asia in ways that shaped the world. Cinnamon, the powdered bark of a tree native to Sri Lanka, fueled the Dutch East India Company, the first global enterprise. Nutmeg (the seed) and mace (the seed's wrapping) are derived from trees native to a region of Indonesia long dubbed the Spice Islands— today's Moluccas.

Frankincense and myrrh—paired by biblical tradition as the Magi's gifts brought to the infant Jesus—come from trees native to regions bordering the Red Sea. Short and gnarly, with flaky bark, these species brave the dry heat and poor soil of the region. When an incision is made in the bark, they exude a sticky resin. Gather and dry lumps of this resin, and the result is frankincense and myrrh tears, as they are called. When burned, they release pungent aromas.

Frankincense and myrrh have been valued through the ages. Hatshepsut, Egyptian queen of the 15th century B.C., ordered myrrh trees be brought to her. (One botanical historian calls this the first plant-hunting expedition in history.) Pharaonic beauties ground burned frankincense to make kohl, the ancient eyeliner. Frankincense and myrrh have perfumed religious rites from ancient times on, dating back to their usefulness in embalming; their fragrance masked the smell of death, and chemical agents in myrrh slowed decay.

The scarred trunk of a frankincense tree in
Oman tells of many years of harvesting its resin.

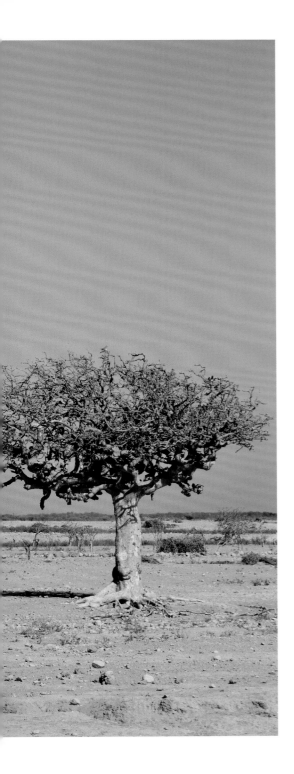

Frankincense may prove to have significant medicinal promise, as researchers are exploring its effect on osteoarthritis, colitis, even hepatitis C and cancer. And it continues to be used worldwide in religious ceremonies, to the point that demand is overwhelming supply.

Today, the world's frankincense is in peril, due to the ill effects of drought, human overpopulation, and livestock grazing. The throes of subsistence living in Somaliland and Ethiopia, where most is harvested today, can mean that trees are tapped too often. While tradition dictates a harvest season and no more than a dozen cuts per tree per year, the rules are often overthrown. One frankincense tree suffered more than 120 incisions in a single season. A nonprofit called Save Frankincense has organized policing and education programs, hoping to protect the industry.

Modern perfumers still turn to trees for their formulations. Balsam, lemon, bitter orange (or neroli), sandalwood: All derive from trees. Myrrh and frankincense remain fixatives in modern perfume making, their chemistry blending with others' to make fragrances last. As the human quest for fine aromas persists, trees continue to lend their charms. ▪

Myrrh trees in the southern Arabian Peninsula: From them, drops of resin are harvested for incense and fragrance fixatives.

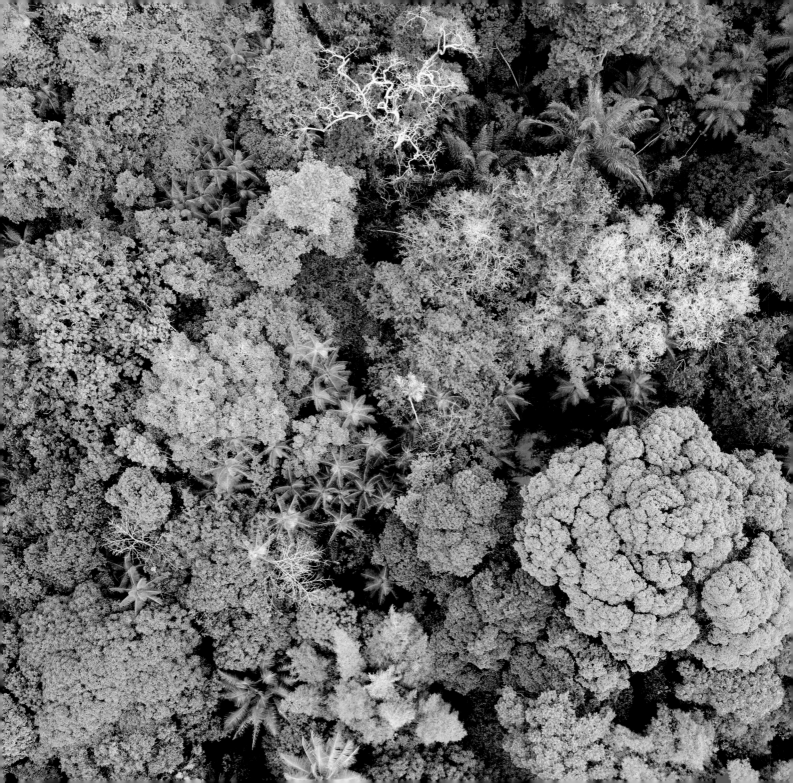

The Forest Canopy

Walk through the woods, and what do you see? At your feet, moss and leaf litter, underbrush, a shrub or stump. At eye level, the trunks of trees. Gaze upward, and you'll see the leaves.

For centuries, this was how the forest was studied: from the ground up. But today, curiosity and technology are combining to take the gaze of scientists up and over the treetops. As a result, the importance of the forest canopy—the crowns of all those trees, taken together as an organic whole—is coming more clearly into view.

How best to study this essential part of the forest? Some researchers hoist themselves up with ropes and harnesses. Towers constructed at key points are useful but stationary; massive construction-type cranes go up and over with more maneuverability. Swinging walkways now weave through canopies around the world, allowing exploration along a different axis. Some researchers ascend in balloons or blimps, hovering above the treetops and dipping down for a better view. Others send drones to take photographs and measurements.

Once there, researchers continue to be daunted by the task of enumerating the species, both flora and fauna, that inhabit forest canopies. The number is likely in the tens of millions, with as many as six million insect species alone. Some spend their lives up here, rarely descending—sloths and kinkajous, for example. The number of plant species may approach the millions, too—not only trees but also ferns, vines, mosses, and so on. One estimate suggests the forest canopies of the world host 24,000 species of epiphyte alone: nonparasitic plants, such as

The canopy of the Amazon rainforest is a dense mosaic of green, created by an assortment of tree species.

orchids and bromeliads, that grow atop tree branches.

Forest canopies are the place where the biosphere meets the atmosphere. Canopy covers more than a quarter of the planet's total land surface, making it a critical factor in any climate equation. Evapotranspiration—the movement of water from land to atmosphere via evaporation and plant transpiration—has a cooling effect, counteracting the heat of the sun.

Given this dynamic interaction, the rainforest canopy balances temperatures locally. But its impact resounds beyond the immediate surroundings. While environmentalists tend to champion the Amazon rainforest as a global carbon sink as well as a cooling contributor, an international team of experts reported in 2021 that dramatic changes in the Amazon landscape—logging, clear-cutting for plantation farming, construction of roads and dwellings—have chiseled out the canopy and made the Amazon a net contributor to warming.

We can reverse that trend, scientists believe, with a judicious combination of study and motivation, saving the remaining rainforests and restoring those that have been degraded. The fate of the planet may hang in the balance. ▪

Some canopy dwellers, such as this three-toed sloth in Panama, live most of their lives in the treetops.

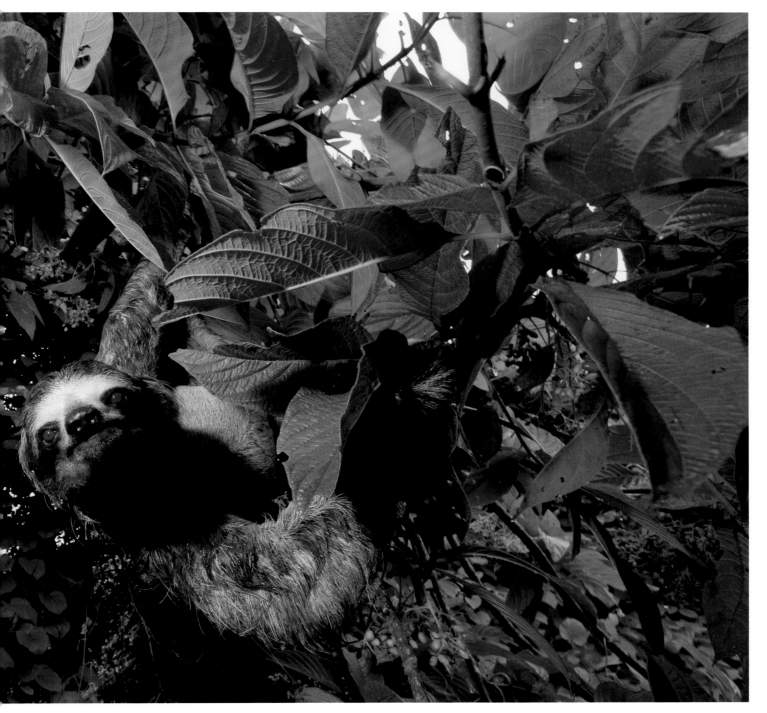

FAMOUS TREES

THE TREE THAT CONFERS BLESSINGS

In 1433, local Hindus believe, a woman named Thimmamma lost her husband to leprosy. In her grief, she joined him on the funeral pyre. Her devotion was so vivid that a banyan tree—*marrimanu* in the local language—took root at the place where she died. Today, it bears the largest known single-tree canopy in the world, recorded as five acres but estimated by some to have grown to as many as eight.

Because of the way banyan trees grow, this monumental specimen appears to have thousands of trunks; in fact, they are roots that have grown downward from developing branches and established themselves in the ground below. Walkways direct thousands of devotees past Nandi, the bull-faced god that guards the site, and into the temple at the tree's center. There are found effigies of Thimmamma and her husband, to whom many pray—especially couples hoping to conceive, believing perhaps that the tree's fecundity will inspire their own.

As elsewhere in India, in accordance with Hindu tradition, pilgrims tie colorful bits of fabric on the massive tree's branches, each representing a prayer. Those seeking fertility bring cloth of saffron yellow.

According to arborists, Thimmamma Marrimanu may be more than 600 years old. Jewelry excavated at the temple site under its canopy hints at its history as a place of sacrifice and prayer—as well as its grandeur, spreading out and providing blessed shade in the hot reaches of southern India. ■

A single photograph can capture only a small portion of India's Thimmamma Marrimanu: All these roots and branches emerge from one tree.

FOLLOWING PAGES: Springtime magnolia blossoms splash the sky with pink near the Thomas Jefferson Memorial in Washington, D.C.

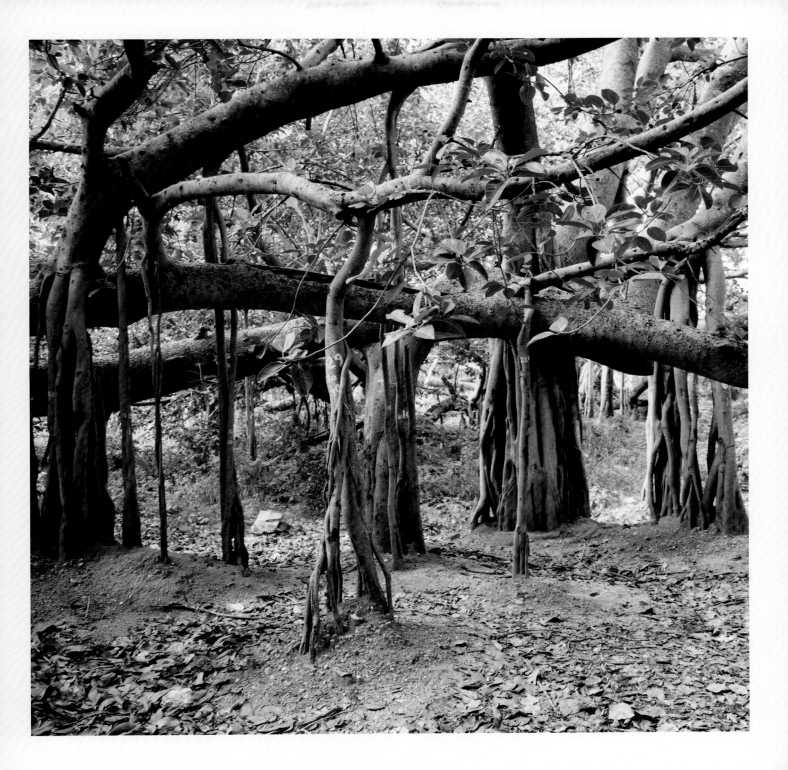

Sex in the Trees

Trees have sex right out in the open. They couldn't propagate any other way.

Like animals, trees have male and female organs. Reproduction occurs when pollen from the male portion of the flower reaches the female and fertilizes it. If you look very closely at, say, the flower of an apple tree, you will see the stamens holding the anthers—the male organs from which pollen emerges—and the pistil leading to the ovule, the female organ that receives the pollen. Ultimately, the fertilized female portion of the flower matures into viable seed, resulting in a cherry, a walnut, a locust pod, a coconut: the offspring and next generation.

In some species, like the apple, a single flower contains both male and female parts. Botanists call these "perfect" flowers—but they're not necessarily perfect in spreading the genetic wealth. The flowers of these species may self-pollinate or, like apples, depend on insects or other pollinators to carry the promise of fruit to flowers on other trees.

Other species develop male or female parts in separate flowers, termed "imperfect." Oak trees, for instance, bear imperfect, or sex-specific, flowers. In spring, the male catkins dangle in the wind and oak pollen fills the air. Female flowers, beginning as tiny nodules on oak branches, receive the pollen. Over summer they bulge up into ripe acorns, which drop in autumn: seeds for new trees.

Pale pollen-bearing stamens (male) surround a dense cone of pistils (female) in the tulip poplar flower. The cone matures into a cluster of samaras, or winged seeds.

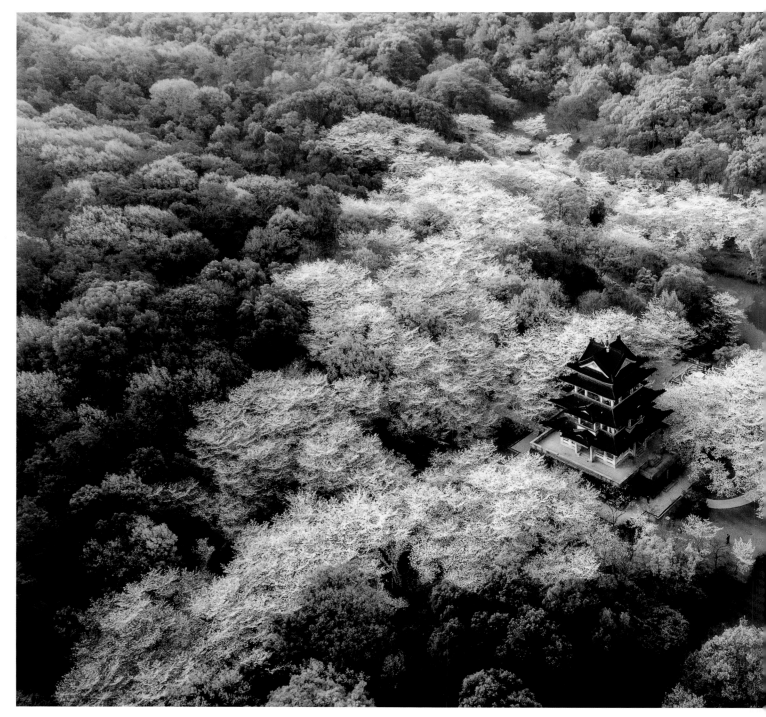

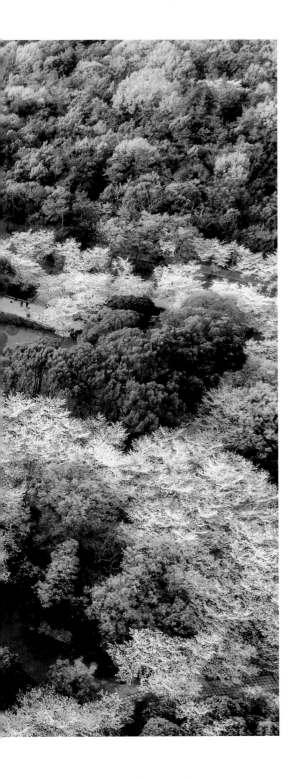

> ## "And if you would know God, . . . you shall see Him smiling in flowers, then rising and waving His hands in trees."

—KAHLIL GIBRAN,
The Prophet

Species that grow distinct male and female flowers on the same tree are called "monoecious." Pollen from the male flowers may fertilize female flowers on that same tree or may find its way to female flowers on other trees of the same species.

Some species take separation even further, in which only male or only female flowers will grow on a single tree. These trees are termed "dioecious"; holly, aspen, willow, ginkgo, and persimmon are all examples. A holly tree with red berries, a ginkgo tree that drops stinky seeds:

Full-bloom cherry trees in China's Yuantouzhu—
Turtle Head Island—wend like pink rivers through leafy green.

These must both be female trees, bearing the fruit. Landscapers make these distinctions, sometimes for the sake of the berry, but sometimes wanting to avoid the seed.

With an array of evolutionary strategies for making sure that pollen gets from one place to another, the flower is a remarkable invention. Its evolutionary design is hundreds of millions of years old—though how many millions is still uncertain, since flowers fade so easily that their presence is rare in the fossil record. Yet fossils found in Nanjing, China, reveal something that looks like a flower, with petals surrounding a style connected to a seed receptacle. Named *Nanjinganthus dendrostyla* for its place of origin and distinctive parts, it has been dated to 174 million years ago—the Jurassic period. Perhaps *Stegosaurus* browsed on these plants.

In 2015, a team of biologists from Sweden, France, Belgium, and Colombia published a study of the structure of fossil flowers found around the world that pushes their origin back even further—as far as 250 million years ago.

But fragile flowers past have kept their secrets. We may never find the fossil evidence for the very first. We do have living proof in the forest today, though, that sex in the trees has turned out to be a successful strategy. ∎

At the twig end of a northern red oak *(Quercus rubra)*, male flowers called catkins
dangle their pollen-bearing strands in spring.

Many Fruits

Many think of fruit as breakfast or dessert. But to a botanist, it is the receptacle of maturing seeds. An acorn and a coconut, an apple and an almond, a papaya and a tamarind pod: All are the fruit of trees, promising regeneration. Fruit's many configurations reflect the many strategies that have evolved among tree species to protect, disperse, and propagate their kind.

Some tree species embed their seeds in sweetness. These are the fruits we know best: apples and quinces, plums and peaches, cherries and elderberries. Some of these bear multiple seeds in the core, while others wrap around a single pit. In a peach, for instance, the seed is double wrapped, encased in a hard shell and then enfolded in flesh that softens and sugars up as it ripens.

Many of these fruits change color, from green toward red, as they mature: a signal to birds and mammals that they are ready to eat. That's all part of the survival strategy, because the animals digest the fruit flesh but the seeds pass on through, deposited far from the mother tree with starter fertilizer included.

Botanically speaking, nuts are fruits. The nutmeat we eat is the seed of the tree. Some, like walnuts, cradle the seed in a protective shell surrounded by a tough outer husk. Recent studies identified cells unique to walnut shells that create three-dimensional, asymmetrical, multilobed linkages with neighboring cells, resulting in a nut that's hard to crack.

Indeed, the shelled nuts we buy in the grocery represent just half the walnut

Last year's acorn becomes this year's oak. When conditions are right,
a rootlet dives down and a leafy sprout shoots up.

> ""I went out to
> the hazel wood,
> Because a fire was
> in my head . . .""

—W. B. YEATS,
"Song of the Wandering Aengus"

seed. To germinate, the two halves must work together. Nestled inside their protective casing, they provide the food needed for the tree sprout as it emerges. Many a walnut gets stashed away by a foraging squirrel and forgotten. In just the right circumstances, its outer shell ages and falls away; the germinating force from within pushes a rootlet out, seeking soil in which to anchor a new sapling.

Some trees simply send seeds out on the wind. When mature, maple seeds helicopter to the ground. Cottonwood seeds parachute down, lofted along thanks to fluffy hairs attached. Every one of these arboreal strategies fulfills the mandate of the life cycle: to be fruitful and multiply. ∎

Humans have long manipulated the genetics of beloved harvests like peaches—but the basic mission of a fruit is to propagate its kind.

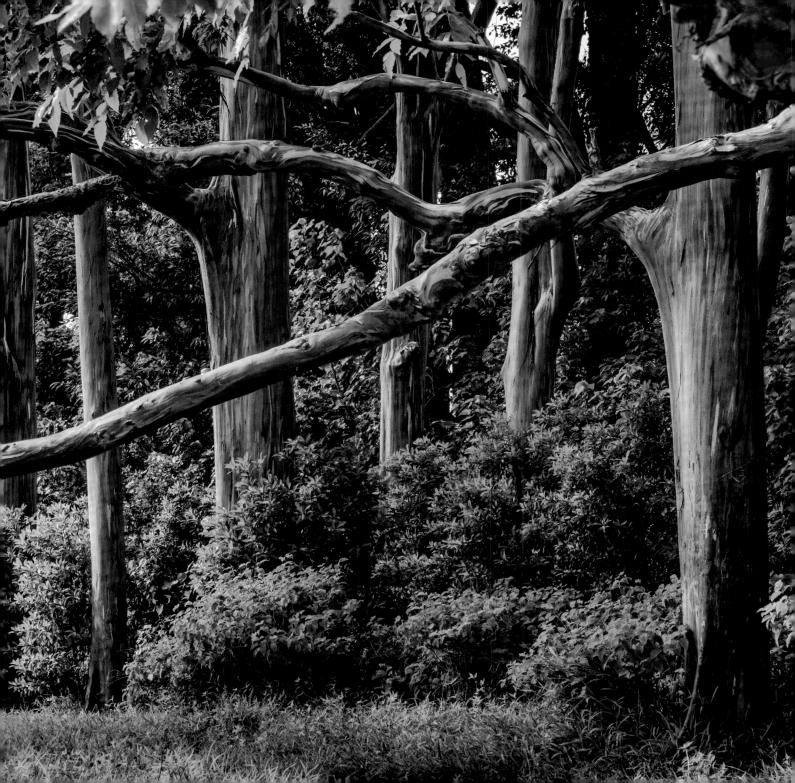

The Art of Branching

Which came first, brains or branches? In a strictly evolutionary sense, trees long preceded the human brain. So it would make sense that we would turn to them as a metaphor to sort out our own abstract ideas.

Tree of knowledge, family tree, diagrams of species or sentences: The metaphor of branching is so prevalent in our thinking that we sometimes forget its literal source in nature. The tradition of envisioning realms of thought as branches dividing off a single trunk dates back centuries. Medieval philosophers divided knowledge—*scientia*—into major fields—*ethica, philosophia, practica, mechanica*—and then subdivided those further—*physica, mathematica, poetria,* for example. Illustrations even included leaves and tendrils.

Renaissance diagrams of human knowledge became more abstract but kept the metaphor of branches alive. For Athanasius Kircher, a 17th-century German Jesuit, the *arbor philosophica* represented all human knowledge. At its root sits *Abyssus nihilum:* nothingness. Key dichotomies of human life branch off symmetrically—rationality and irrationality, for example. At the tree's apex were such virtues as *bonitas, intellectus, concordia*—happiness, intellect, peace—harmonious with the Christian holy trinity.

The theory of evolution updated the metaphor for modern science. While Charles Darwin's notebooks contain only one sketch using branching lines to

Rainbow eucalyptus trees on Maui, Hawaii, dance around
each other in a complex branching scheme.

> "Earth and Sky,
> Woods and Fields . . .
> teach some of us more
> than we can ever
> learn from books."

—JOHN LUBBOCK,
The Use of Life

represent his revolutionary ideas, science educators began to explain evolution by reference to the ancient tree of life. Extant species inhabit the branch tips; to trace back in time to prehistoric shared ancestors, you move from branch tips down the branches and ultimately down the trunk to the roots. In a famous 1879 depiction, German scientist Ernst Haeckel plotted species from "primitive animals" at the base of a tree trunk to "mammals" at the top—with "MAN" crowning all.

But new science throws these illustrations into question. It's a tangled tree, as science writer David Quammen puts it, if it's a tree at all. To

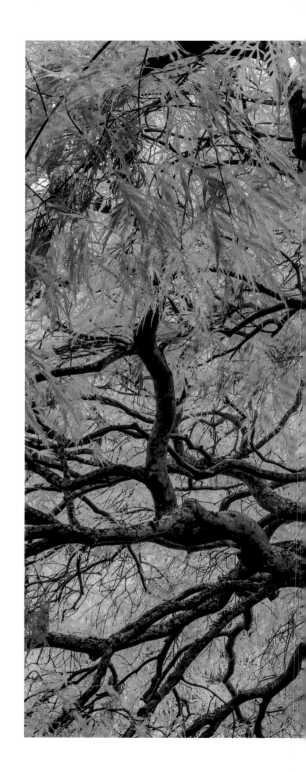

The pattern of ever dividing branches, as in this spreading Japanese maple tree, appears in philosophy and science from early on in human history.

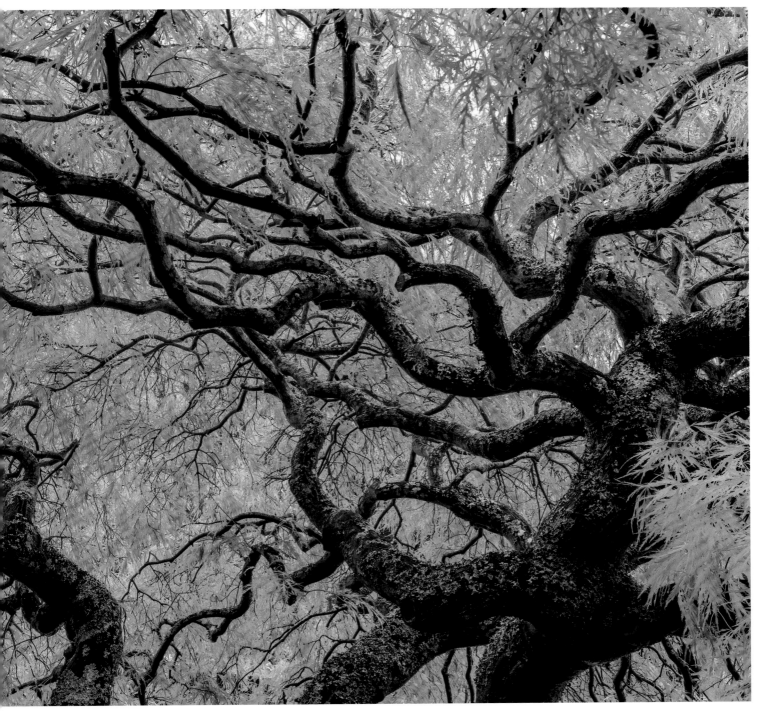

230

represent the 2.3 million species now known, thanks to the finesse of 21st-century genetics, a graphic representation of Earth's many life-forms must take on a new shape.

So a team of scientists came up with an ingenious reconfiguration. Imagine those branches curling down and around, meeting to form a circle, with the earliest ancestors in the center and all known species around the edge. This is the revolutionary new Open Tree of Life—open to study, but also open to change, since as many as 15,000 new species are added every year.

Today, the tree of life has become a circle of life, ever growing and changing, but still an inspiring metaphor to convey human understanding. ■

OPPOSITE: Not all take the term as literally as Russia's Lermontov family did in the 1930s, but the metaphor of a branching tree works well in genealogy.

ABOVE: Central to this fifth-century B.C. breastplate—made of gold in Thrace, today's Balkans—stands the tree of life, surrounded by palm leaves and lotus flowers.

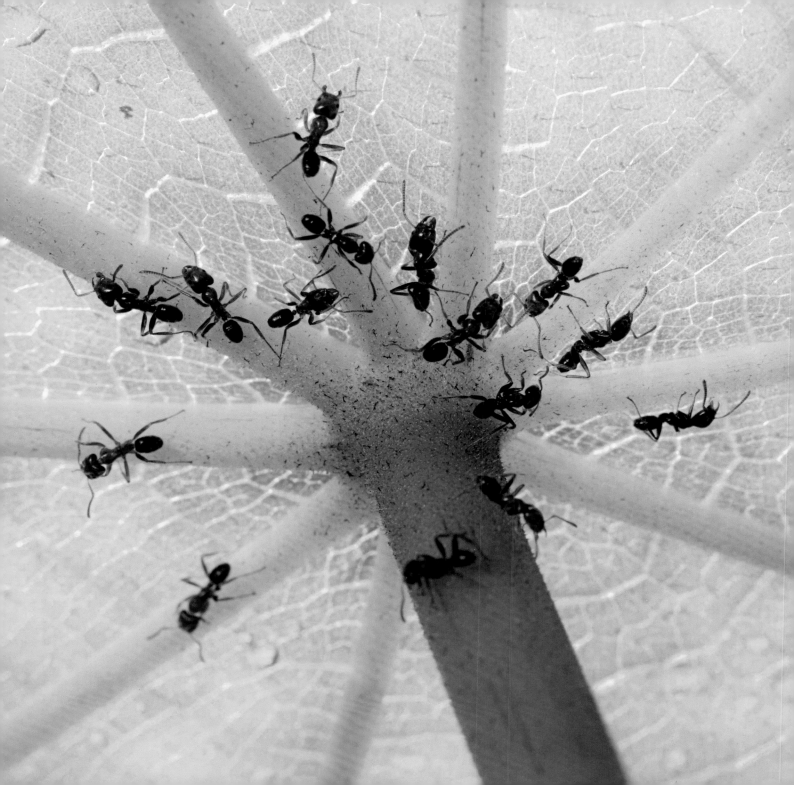

Insect Relations

Trees and insects: It's a love-hate relationship millennia in the making. While there are some partnerships that benefit both—even guarantee survival—other insect intrusions can decimate forests.

First, the good news. Insects contribute to the livelihood of trees in a number of ways. The best known is pollination. As winged visitors seek nectar from blooming flowers, they pick up pollen from one and leave it behind on another. Other insects collect tree seeds—some deliberately, some by chance—thus aiding trees in dispersal and regeneration. But the most interesting interactions pair an insect species with a tree species for the mutual benefit of both, symbiotic relationships that suggest how they coevolved.

In the American tropics, a fast-growing tree called *Cecropia* and several species of *Azteca* ants enjoy an intricate, mutually beneficial relationship. A queen ant drills into the hollow interior of a young twig, repurposing the plant tissue from the inside out to plug up the hole once she is inside. She lays her eggs, and the larvae develop inside the protective space. Worker ants visit crooks in the branches where the tree exudes tiny droplets rich in carbohydrates and lipids: ant food.

If a parasite vine begins to wind around the tree, the ants gnaw away at its leaves; if an insect intruder appears, they swarm onto it and tear it apart. The

In Panama, *Azteca* ants cluster around the leaf stem of a *Cecropia* tree, within which females will nest and larvae will mature.

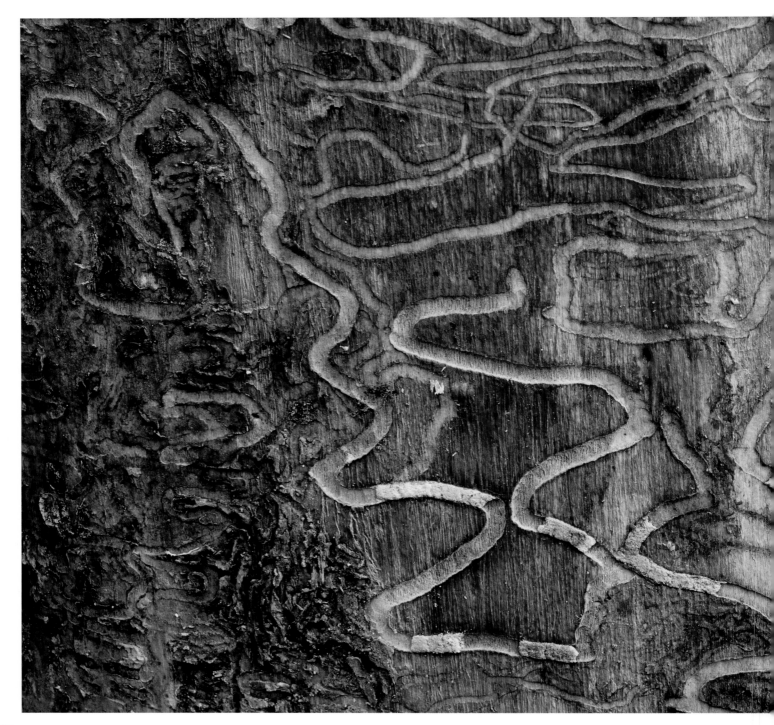

"In the path of
compassion even if
we can save an insect
that has a huge impact
on the cosmos."

—AMIT RAY,
Walking the Path of Compassion

ants even militate against furry herbivores like sloths and monkeys. In all these struggles, the *Azteca* ants have a defensive advantage: Their feet hook like Velcro onto minute hairs up and down the *Cecropia* stalks, giving them firm purchase as they defend their partner tree. These intricate interrelationships suggest that *Cecropia* and *Azteca* have co-evolved over millennia to help each other.

At the other extreme, insect-tree relations can be devastating to the forest. In Massachusetts in 1869, a young entrepreneur named Étienne Léopold Trouvelot hatched plans to

Tracks left behind: Under the bark of dying trees, telltale signs indicate the presence of emerald ash borers, an invasive beetle decimating North American ash trees.

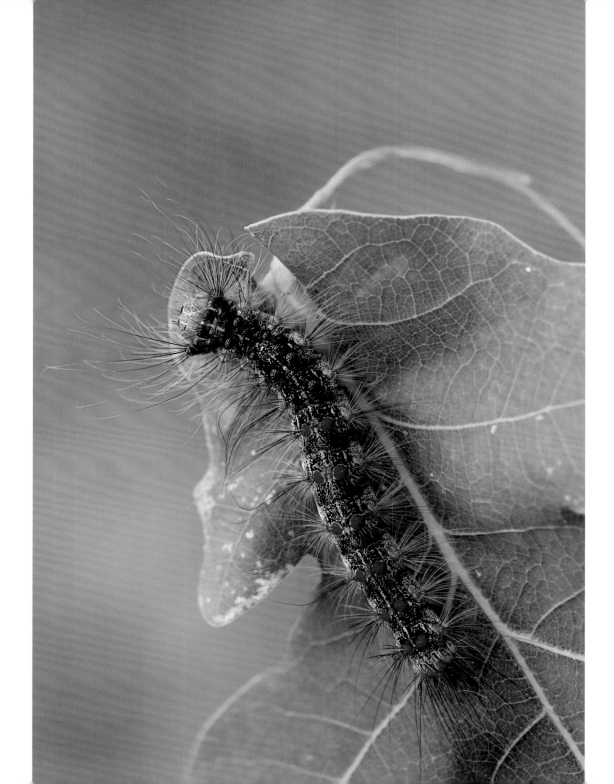

energize the American silk industry and ordered insect eggs to be shipped from Europe, intending to cross the species with silkworms. Some escaped his control, and 20 years later, European gypsy moth caterpillars were defoliating New England forests where oaks predominated. To this day, foresters work hard to defend the northeastern United States from European gypsy moths—and from an Asian species of gypsy moth not yet established but equally threatening.

The origin of today's worst northern temperate forest invader is not as well understood. The emerald ash borer, an iridescent green beetle native to eastern Asia, has been invading ash forests in North America and southwestern Russia since the early 2000s. This insect lays eggs in the bark of ash trees. Larvae burrow under the bark and eat through tender phloem tissue, creating rivulets that can ultimately girdle and kill the tree. This species may have emigrated in wood-based packing materials or shipping pallets—no one knows for sure. But since its first discovery in Michigan in 2002, the emerald ash borer has spread through the eastern half of the United States and Canada. In the first 10 years of its presence in North America, it killed some hundred million trees.

There is an underlying moral to be found in these three stories. When trees and insects co-evolve, beautiful synergies can occur. But human interventions can bring disparate species together in unintended yet destructive ways, upsetting the balance in the forest. ∎

Unintended consequences: Brought to the United States to enliven silk manufacturing, the gypsy moth caterpillar has become a menace.

Moon Trees

In 1971 Apollo 14 astronaut Stuart Roosa carried 500 tree seeds with him to the moon and back. Roosa had earlier worked as a smoke jumper, fighting forest fires. His love of the forest made him the perfect candidate as the orbiting keeper of seeds representing six native American species: loblolly pine, sycamore, sweet gum, redwood, and Douglas fir.

Back on Earth, the seeds got jumbled, dissipating the scientific focus. Still, nearly all germinated, and soon NASA was distributing saplings. From Alabama to Washington state, from Massachusetts to California, trees started from seeds that had been to the moon were planted. One sycamore joined the botanical garden in Asheville, North Carolina; another took root in the International Forest of Friendship in Atchison, Kansas.

Some now stand by space industry locations—Florida's Kennedy Space Center, Maryland's Goddard Space Flight Center, and a Lockheed Martin facility in Pennsylvania. Others grace the grounds of schools, libraries, and civic headquarters across the country. A sweet gum and a redwood even found their way to Brazil, in the cities of Santa Rosa and Brasilia.

While some are ailing and some have already died, many of these moon trees still stand, their seeds having survived a lunar voyage, their systems having conquered the demands of putting down roots in various soils and climates. Their immediate value to science may not have been fulfilled, but they still convey a larger message of the resilience and universal life force of the tree. ■

At NASA's Goddard Space Flight Center, moonbeams backlight a
sycamore sprouted from a seed carried to the moon and back in 1971.

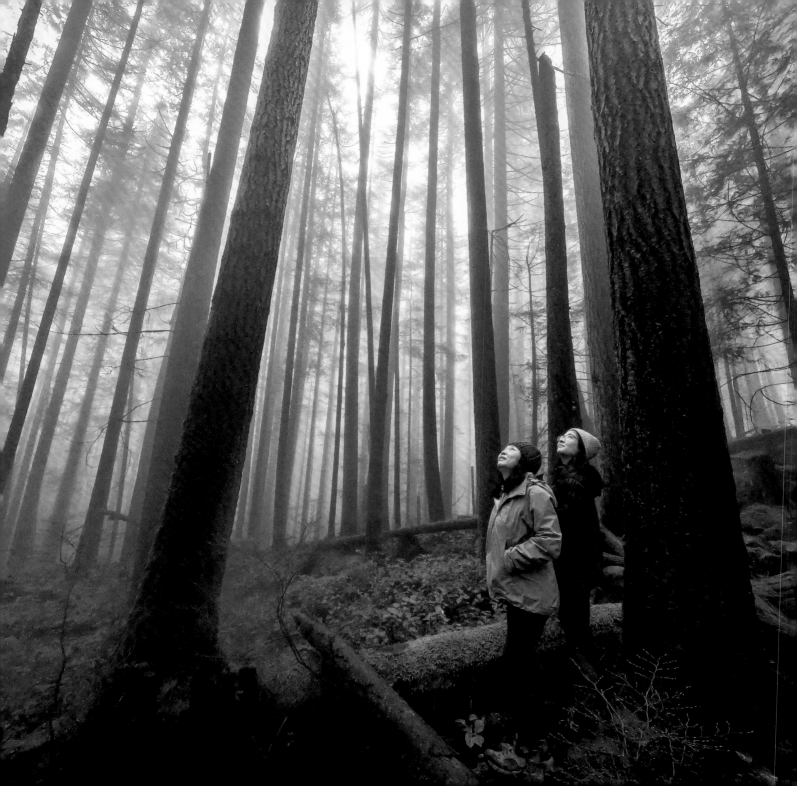

Breathing in the Forest

Most people breathe a sigh of relief as they embark on a woodland walk. It may be a stroll through the park, an escape from concrete and commotion. Or it may be a hike into the forest, where nature's abundance floods the senses and overtakes all thoughts. We sigh, and then we breathe in air shared by the trees—and that's what makes all the difference.

Researchers today are examining the elements in forest volatiles that make us feel so good. It's a physical as well as an emotional experience. Certain terpenes exuded by trees have the right molecular formulation to make a walk in the woods a pleasure. Those that have received the most laboratory attention are pinene and limonene—unfamiliar words but familiar fragrances, coming especially from pine trees and citrus trees respectively. Researchers call these BVOCs—biogenic volatile organic compounds. Tropical trees exude the most, and evergreen forests generate more than their deciduous counterparts. Their concentration in the forest air is highest in early afternoon, as the trees go through their daily cycle.

The salutary effect of forest BVOCs is remarkable, as evidenced by laboratory experiments on their chemistry and impact on human health. They reduce inflammation. They appear to be natural antioxidants. They seem to increase muscle relaxation, thus aiding in sleep, alleviating pain, calming anxiety, and serving as general antidepressants. They heighten protective features of the immune system, and even dampen the tumor growth associated with some

A walk through the forest near Vancouver, British Columbia,
refreshes mind and body, due in part to volatile compounds given off by the trees.

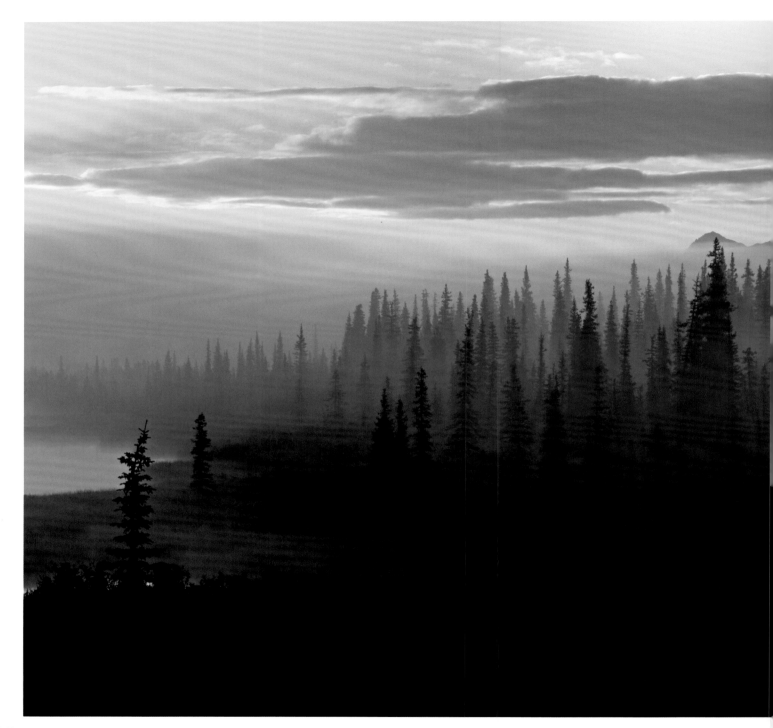

> "This is the forest primeval. The murmuring pines and the hemlocks, Bearded with moss, and in garments green . . ."

—HENRY WADSWORTH LONGFELLOW, *Evangeline*

cancers. In short, researchers are pursuing significant clinical and pharmaceutical possibilities in the essences found in forest air.

These findings make forest volatiles sound like wonder drugs—and maybe they will prove to be. But laboratory investigators always hedge their conclusions with provisos. So while they can analyze the chemistry and observe the effect of these compounds on laboratory animals, they cannot factor in (or segment off) the grandeur of the forest scenery, the muscle stretch of a walk, the refreshment of leaving all one's cares behind.

For all that, we still need to go for a walk in the woods. ∎

BVOCs—biogenic volatile organic compounds—mingle with morning fog in the treetops above an Alaskan forest.

FAMOUS TREES

THE TREE THAT INSPIRED SCIENCE

It all starts with a narrative written by William Stukeley, a 17th-century natural philosopher. He recalled that after dinner with his friend Isaac Newton, the two of them went outside, where, "under the shade of some apple trees," Newton asked rhetorically, "Why should that apple always descend perpendicularly to the ground? . . . Why should it not go sideways, or upwards, but constantly to the earth's center? Assuredly, the reason is, that the earth draws it."

And with that, the origin story of Newton's theory of gravity was born.

Indeed, an apple tree has now grown at Newton's Lincolnshire home for hundreds of years, honored as the inspiration for his celebrated science. When the original tree tumbled in 1820, devotees salvaged its wood for memorabilia. Roots left behind sprouted anew, and to this day, a strangely S-shaped apple tree is tended in the garden at Woolsthorpe.

The fruit it bears is a rare variety called Flower of Kent, a greenish cooking apple that reddens as it ripens. Its seeds have traveled into orbit and back: British astronaut Tim Peake carried them to the International Space Station.

But trees sprouting from those seeds will not bear the same fruit. Only clones, grown from twigs or rootstock, will bear Flower of Kent apples. Starts from the famous Woolsthorpe individual have now been transported to dozens of locations on every continent but Antarctica. Offspring of the tree grace many a university campus and research park, reminding 21st-century scientists that although physics may have evolved far beyond Isaac Newton, today's ideas sprouted from his observations under an apple tree. ∎

This gnarly apple tree at the historic home of Isaac Newton commemorates the legend that a falling fruit inspired his theory of gravity.

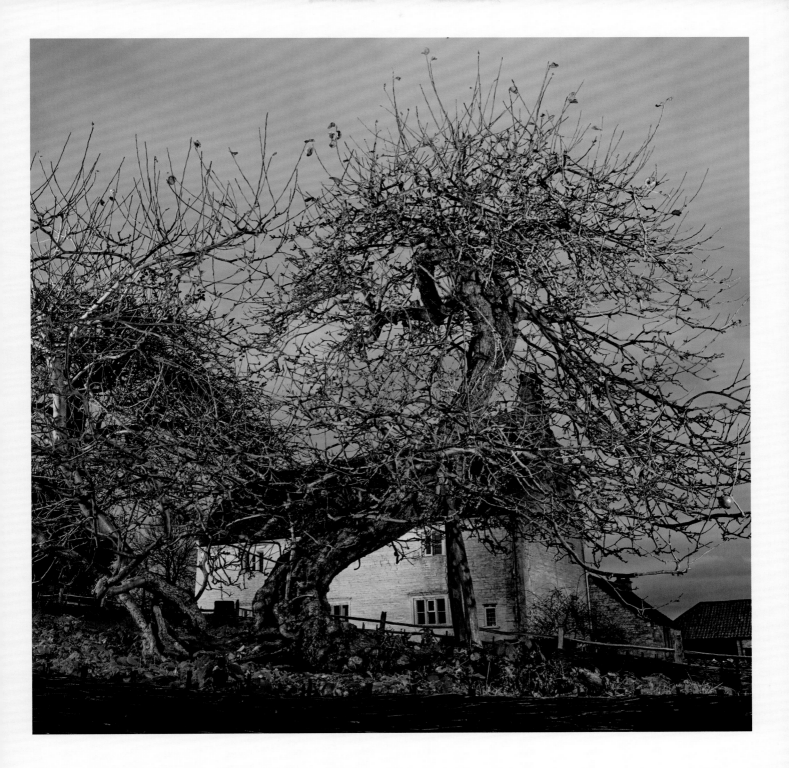

CHAPTER FIVE

FIRE

Forest fires rage and destroy;
new life rises phoenix-like from the ashes.

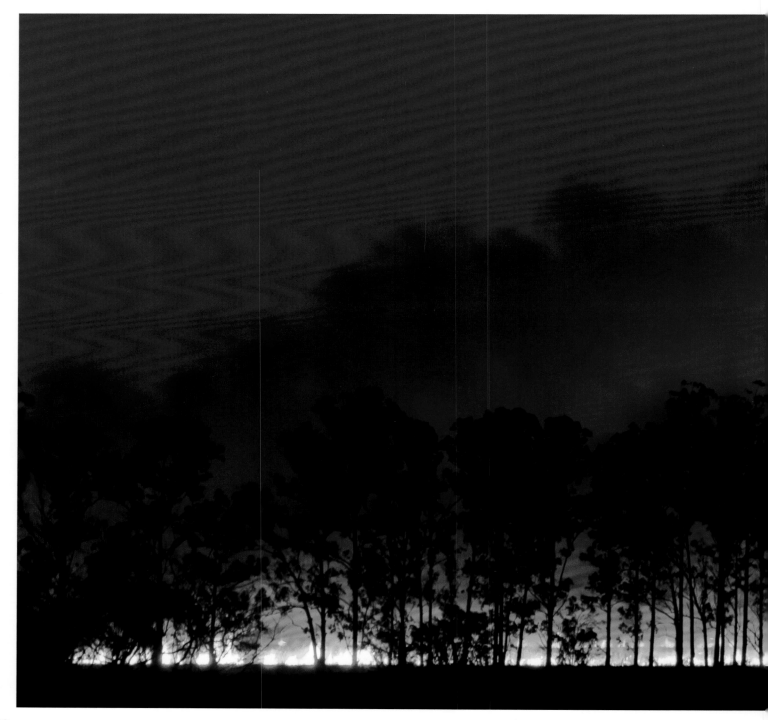

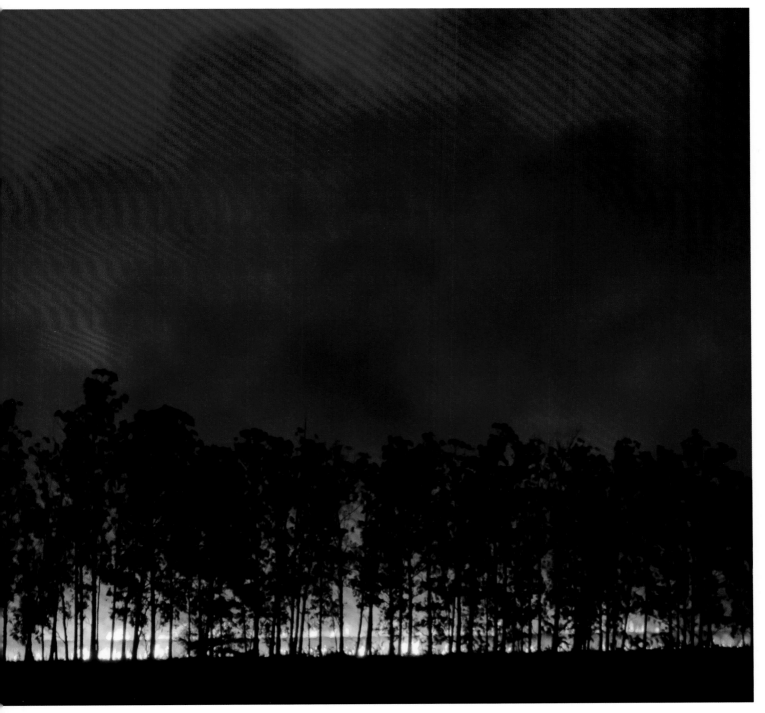

Burn, Forest, Burn

The news today is devastating. Vast swaths of forest burn out of control on multiple continents, triggered by human activities, local and global.

But the truth is, forest fires predate humankind. A natural force shaping the evolution of trees and other forest inhabitants, fire has long been a necessary phase in their regeneration. In fact, the early 20th-century U.S. policy decision to suppress any forest fire actually set back trees and harmed the environment. Realizing that, forest managers have reshaped their response to fire.

Some tree species require fire to reproduce; their seeds do not germinate unless they get burned. *Banksia,* small trees native to Australia, bear magnificent cob-shaped flowers, orange, yellow, or magenta in color. Those cobs mature into conelike receptacles for tough little seeds that can go for years without sprouting. Only when they reach a temperature far above normal—as high as 175°F for some species—do the innermost cells of these tree seeds begin to stir, developing into the follicles that will become roots and shoots.

A similar story can be told about North America's lodgepole pine, which bears cones that hold seeds tight until fire releases them. In both cases, the tree has embedded the seeds in a waxy substance that melts only at high temperatures—a survival mechanism that not only outlasts forest fires but requires

Seed heads of *Banksia* hold tight until they reach a high temperature; only then will they germinate.

PREVIOUS PAGES: Stewards of the land respect fire as a necessary step toward forest regeneration, as in this controlled burn in South Africa.

them. Other species depend on underground strategies, roots sprouting even when treetops have burned down. Eucalyptus species grow special buds deep under their bark, activated when fire singes the tree trunk.

Just as our relationship with forests has changed in modern times, so has our relationship with fire. As tribal lands were colonized, the prevailing attitude was to snuff out all blazes in order to preserve economically valuable timber. In the United States, a newly established Forest Service witnessed devastating fires in the summer of 1910. Eight million acres burned; 85 people died. The outbreak solidified the importance of the 1908 Forest Fires Emergency Act, which granted the Forest Service unlimited funds to keep forest fires from burning.

Decades later, scientists began questioning the wisdom of that practice as they discovered how natural phenomena, including fire, weave together holistically. By the 1960s, foresters were recognizing fire as a natural component of forest ecology, and therefore an important part of forest maintenance. Today, forest care includes techniques for controlled burning—echoing the practices of Indigenous peoples who have cared for forests around the world for millennia. ■

Managed burns—as shown here in a pine forest in the southeastern United States—can reduce the possibility of uncontrollable forest fires.

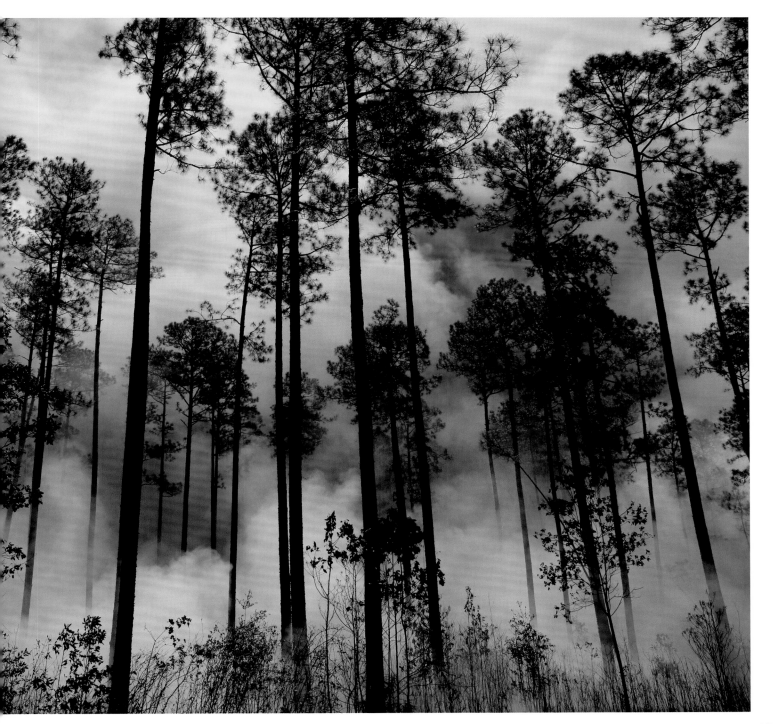

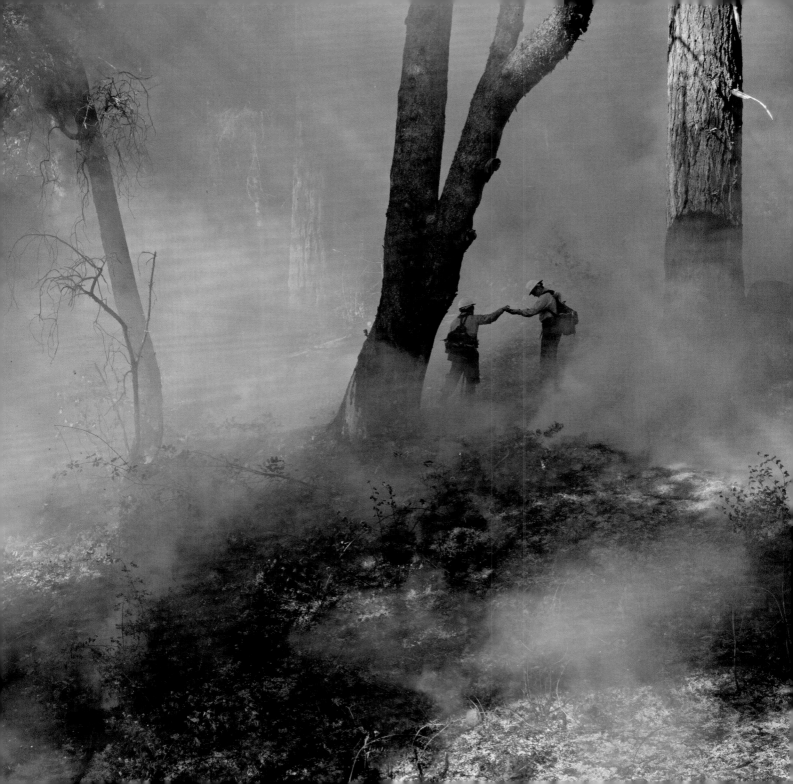

Making Friends With Fire

There are still arguments about when—but none about whether—fire shaped the evolution of *Homo sapiens*. Even chimpanzees use wooden sticks as tools and pay attention to naturally ignited sparks: two prerequisites for learning to use fire. Charred bone and plant ash found in South Africa's Wonderwerk Cave have led some to suggest that hominid ancestors were manipulating fire two million years ago. But fire leaves little behind—including evidence of the passage from foraging to tending to generating flames.

Once early humans controlled fire, they could cook meat and root vegetables. They could tolerate the changing seasons and the cold of temperate regions. They could bake clay into pottery. Physical characteristics changed over millennia: Teeth got smaller and brains got bigger. Many link those changes to learning about fire.

Fire may have shaped human evolution, but now civilization is reshaping fire in terrifying ways. For one thing, wildfires are not what they used to be. Those in Australia, Siberia, the North American West, and the Amazon rage with extent and intensity far beyond the forest—and far beyond what the forest needs. The reasons are many, all ultimately to be traced back to human activities.

Additionally, some regions still experience what researchers call a fire deficit after decades of enforced fire suppression, whose legacy leaves more combustible material on the forest floor. Human encroachment—dwellings,

In Weitchpec, California, a community within the Yurok Reservation, foresters follow Indigenous guidance and use fire to encourage forest growth.

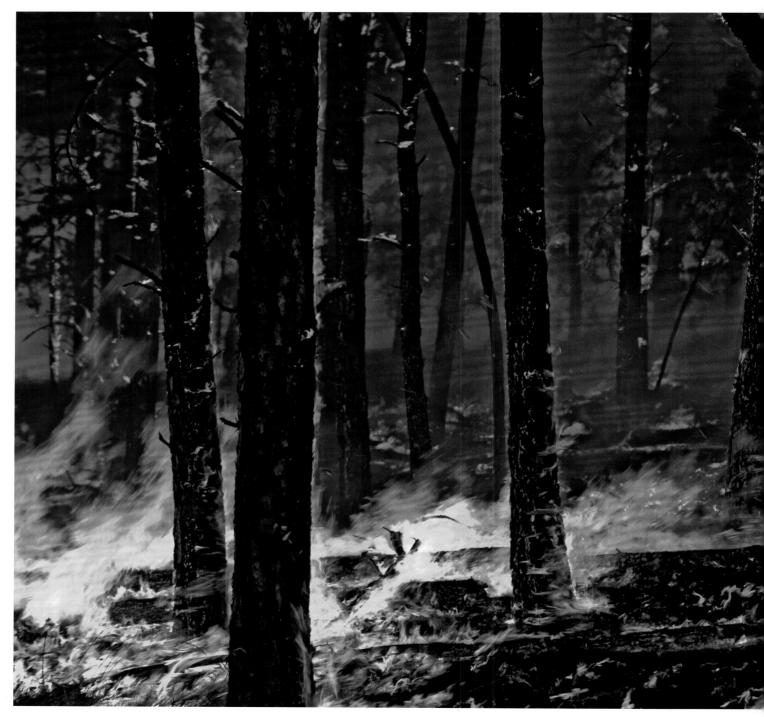

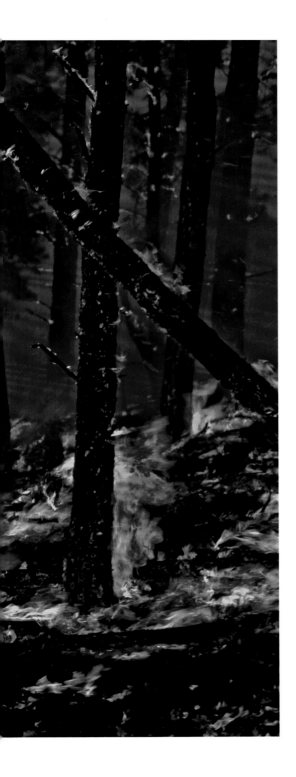

"That's what our elders wanted. They wanted us to come together to care for those trees, to not fear fire but to revere and respect it."

—FRANK KANAWHA LAKE, ecologist and Karuk tribal member

infrastructure, clearing for agriculture, converting old forests to tree plantations, even replanting with non-native ornamentals—creates a more vulnerable landscape. And the effects of a warming planet combine in disastrous ways: Higher temperatures dry out the land and turn the forest to tinder; more intense storms bring more wind and lightning; bigger fires generate their own weather systems, compounding the problems.

And yet fire is revered as a powerful ally among those who live close to nature. Gond people in central India manage a forest burn every year to

In June 2020, it took two days to suppress a wildfire in South Dakota's Custer State Park—at 60 acres, it was a small conflagration compared with recent outbreaks elsewhere in the American West.

harvest the new leaves of tendu, which they dry and use to roll bidis, or Indian cigarettes. Indigenous people throughout North America burn the underbrush as they tend the landscape: Gitxsan and Wet'suwet'en people of British Columbia to gather blueberries, Karuk people of northwestern California to collect acorns, nearby Yurok people to encourage new crops of bear grass and hazelwood, the flexible shoots preferred for basketry.

Can we learn from these ancient ways? Today, tribal elders advise professional foresters, and the wisdom of controlled burning infuses modern forest management practices.

The challenges of planetary climate change demand response from many directions. Finding ways to befriend fire once more is one of them. ∎

Thanks to epicormic buds—growth originating from the trunk—
eucalyptus trees can regenerate after surviving a fire.

Banking Tree Seeds

If fire or war, pestilence or global climate change were to decimate our forests, what could we do? Some visionaries are working on answers to that haunting question.

The practice of banking seeds to protect against the threat of extinction goes back more than a century. It began with the Russian botanist Nikolai Vavilov, who braved Stalin's wrath and collected seeds—primarily grain crops—from around the world. This legacy of service to agriculture continues at Moscow's Vavilov Institute of Plant Industry, and initially dominated the founding of the world-famous Svalbard Global Seed Vault in Norway.

In 2001, the United Nations adopted its International Treaty on Plant Genetic Resources for Food and Agriculture, dedicated to the conservation of agricultural resources with the larger goal of fighting hunger around the world. Seven years later, Norway opened its remarkable seed storage facility, a high-security vault tunneled into a rock mountain, deep in the permafrost on the Arctic island of Spitsbergen, part of the Svalbard archipelago. Wheat, beans, oats, rye—thousands of variants of the world's most important food crops are stored as expertly dried seeds housed under tightly controlled conditions.

Meanwhile, under the aegis of Britain's Kew Gardens, the Millennium Seed Bank began its collection of wild plant specimens. Working with regional groups from around the world to collect and preserve the seeds of both common and endangered plants, the group stores more than two billion seeds representing

Seeds come in many shapes, colors, and sizes.
Some 40,000 wild plant species are preserved in Kew Gardens' Millennium Seed Bank.

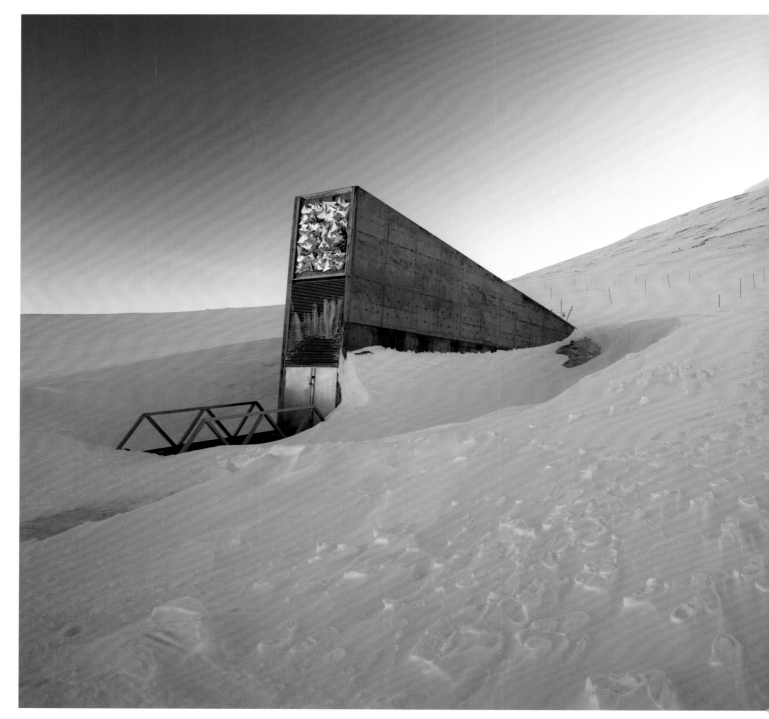

some 39,000 species in temperature-controlled underground facilities in Sussex.

Both these global missions have broadened to include tree seeds in their collections. The first tree seeds—Norway spruce and Scotch pine—arrived at Svalbard in 2015, with hundreds more added in the years since. A Global Tree Seed Bank, part of Kew's Millennium project, preserves specimens collected by some 50 partner groups around the world.

Trees, however, present a challenge to these projects. Viable seeds from, say, mangroves or tropical forest canopy trees, must be handled completely differently from those of rice or wheat or beans. They cannot be dried and stored at below-freezing temperatures for long periods of time. Avocado and papaya trees, tea shrubs, and even some oaks and maples—indeed one-third of all trees—make seeds that botanists call recalcitrant: Drying them actually kills them. Cryopreservation—storage at ultra-low temperature in liquid nitrogen—holds promise.

We can save trees by caring for them in parks, fields, and forests, and we can guarantee their future by banking their seeds. Both ways, we are taking steps to preserve the planet—and our future. ■

Enter the Svalbard Global Seed Vault here, where deep under the permafrost seeds for thousands of the world's plants are preserved.

HOW TREES CREATED KENYA

The Kikuyu people say that Ngai created Gikuyu and Mumbi, the parents of everyone, and sent them into their homeland of Kenya. In time they had nine daughters but no sons. When their daughters came of age, Gikuyu sat under the *mugumo*—the holy fig tree—and prayed for sons to marry his daughters. The answer he received was that each daughter should go into the forest and cut a twig as tall as herself. Gikuyu built a fire, threw all the twigs in, and set a lamb on it to roast. From that fire emerged husbands for his daughters, and from these pairs arose the tribes of Kenya.

Sunset silhouettes a solitary acacia in Kenya's Masai Mara National Reserve.

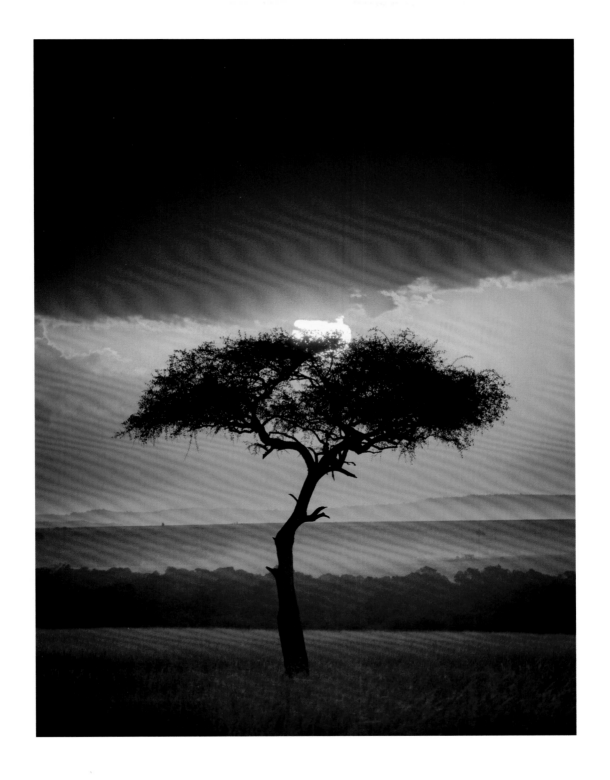

FAMOUS TREES

THE TREE THAT SHELTERED FREEDOM

Three miles from the place where the first slave ship landed in Virginia in 1619 stands a monumental live oak tree. Known as the Emancipation Oak, it may already have taken root when the first enslaved African people arrived. It had grown into a sturdy specimen by the 1860s. Richmond, just 75 miles away, was named the capital of the Confederacy, and yet Union soldiers occupied nearby Hampton's Fort Monroe. When three escapees from slavery sought refuge in the fort, commanding officer Benjamin Butler sheltered them, refusing to return them to the plantation owners. More escapees followed suit. Fort Monroe became known as Freedom's Fortress, guarding over a growing community dubbed the Grand Contraband Camp.

Teaching reading and writing to enslaved people was then a crime in Virginia. Nevertheless, in 1861 a brave woman, Mary Smith Peake—her mother a free Black woman and her father a white Frenchman—began offering lessons to Black residents of Hampton in the shade of this very oak tree. And here, in 1863, the Emancipation Proclamation was read aloud for all to hear—an event sometimes cited as the first public announcement of the historic document in the South.

Mary Peake's classes evolved into the Butler School for Negro Children, which became in 1868 the Hampton Normal and Agricultural Institute, then Hampton Institute in 1930, and finally Hampton University in 1984—one of the nation's preeminent historically black universities. And through it all stood the Emancipation Oak, a living reminder of a long and difficult history. ∎

Tradition has it that people gathered in the shade of this oak in Hampton, Virginia, to hear the Emancipation Proclamation read aloud in 1863.

FOLLOWING PAGES: Trees stretch up out of still water in Ningguo, Anhui province, in eastern China.

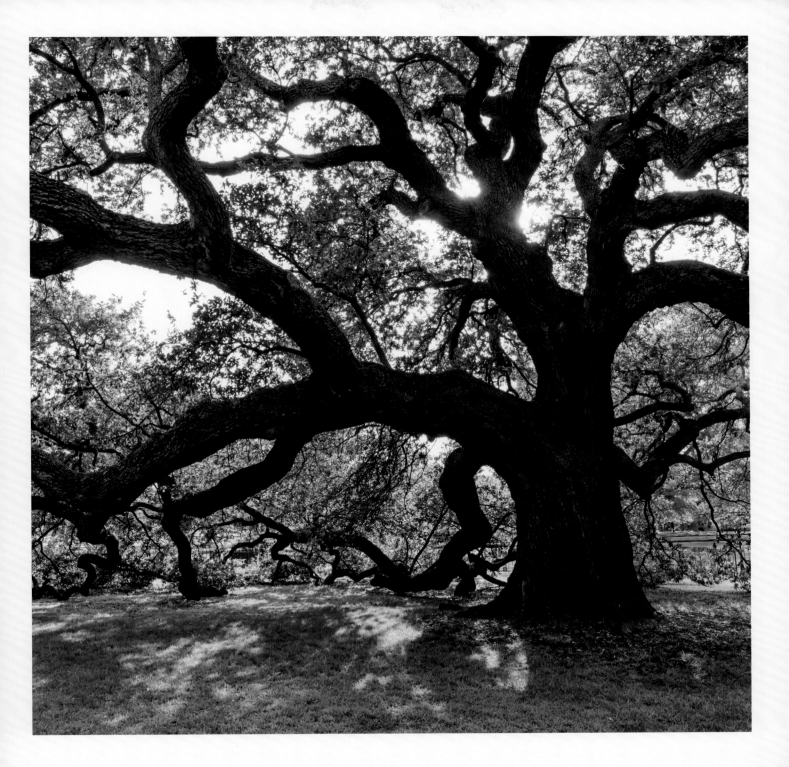

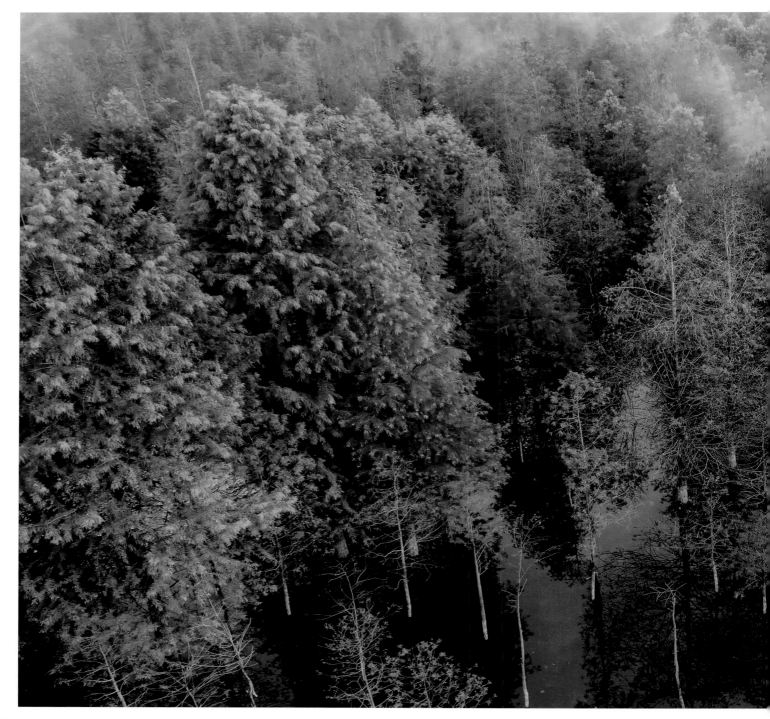

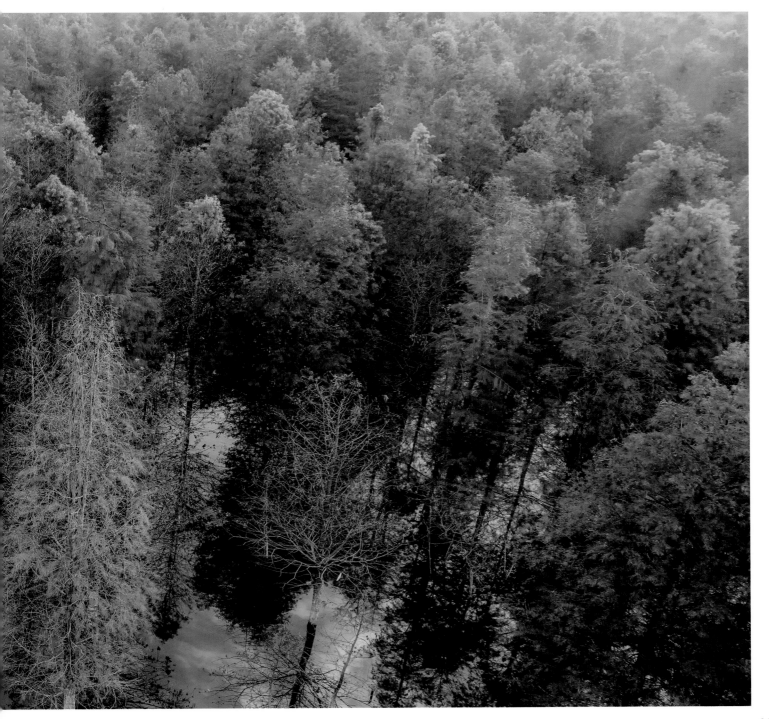

Rekindling the Creative Flame

I only went out for a walk," wrote John Muir in his journal. But, he discovered, "Going out, I found, was really going in."

So many share Muir's sense that a walk in the woods can stoke the fires of creativity and self-expression. Why and how does that happen? To conduct empirical studies of time spent in nature, researchers must turn a wordless experience into measurable behaviors. Attention restoration, soft fascination, awe: These are three key experiences they focus on to observe the effect of the forest on the psyche.

"Attention restoration" is the ability to refresh mentally after the fatigue of prolonged focus. City traffic, insistent technology, multitasking, a demanding job—all contribute to "directed attention fatigue," identified by psychologist Stephen Kaplan in his seminal 1995 paper. Subsequent studies even pinpoint the areas of the brain overtaxed in the process. Nature, Kaplan argues, can restore one's mental energy. It offers the sense of getting away from everyday stressors, a connection to a larger world, and a feeling he calls "soft fascination."

The allure of nature allows this restorative state of mind. You are alert and paying attention, but relaxed enough that your mind can wander. "Clouds, sunsets, snow patterns, the motion of the leaves in the breeze—," writes Kaplan, "these readily hold the attention, but in an undramatic fashion." Attending to these phenomena is effortless, and even allows underlying brain activity that may be suppressed during more deliberate concentration.

Time spent in the forest can enhance
self-reflection and reignite the creative spirit.

Beyond soft fascination, the forest can also evoke a sense of awe—another experience hard to put into words. One study defines it as "a response to things perceived as vast and overwhelming that alters the way you understand the world." It's not the same as pleasure: Researchers confirmed that by showing one group a short video featuring whales and waterfalls—phenomena selected to evoke awe—and another group a video featuring parades and confetti, chosen to evoke happiness. A shared survey afterward showed that while both groups felt good, those who experienced awe were more willing to give to others, preferred new experiences over more possessions, and felt as if they had plenty of time to do what they wanted to do.

By going into the forest, we go deeper into ourselves and can become more creative and compassionate. That's a vastly simplified interpretation of hundreds of psychological studies from over a few decades, all confirming what many experience: A walk in the woods refreshes the mind and rekindles the imagination. ▪

An elevated walkway through Finland's Salmajärvi National Park brings hikers eye to eye with the treetops.

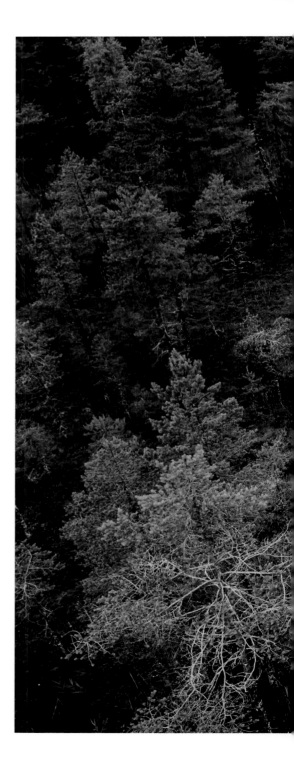

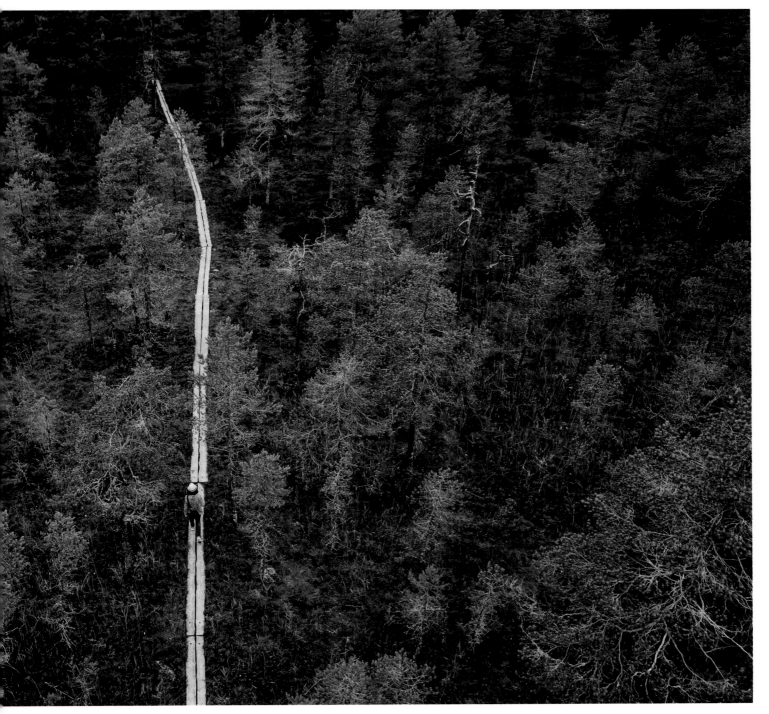

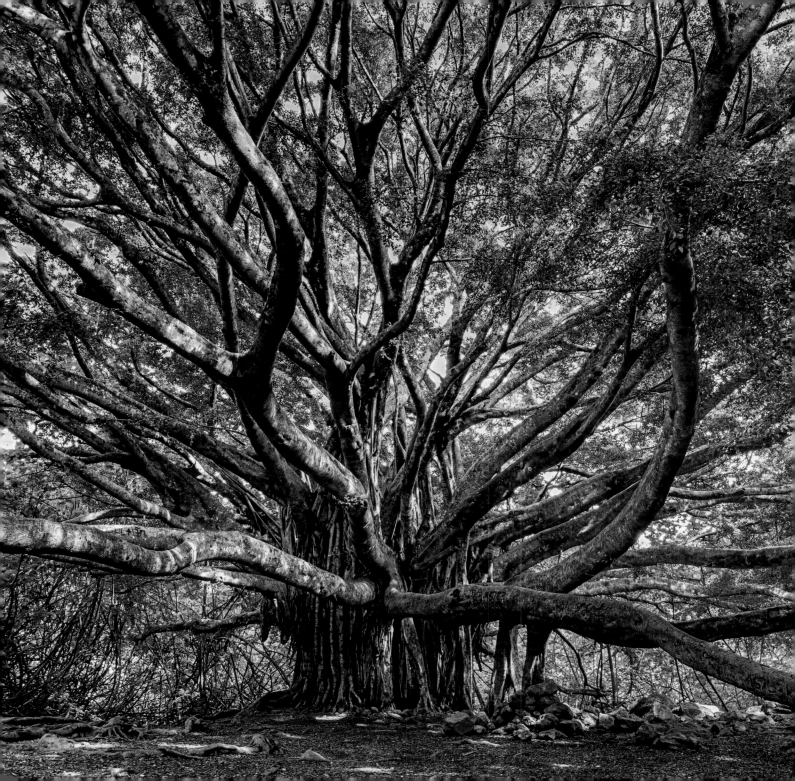

The Immortal Banyan Tree

In central and southeast Asia, where they grow, banyan trees have the reputation of defying death and living forever. Perhaps it's because of their mammoth proportions, their tendency to spread aggressively, or their life span long past any human's. It could be the many medicinals one can harvest from their roots, bark, leaves, and fruit, or the merciful shade they provide in sun-baked climes. The very word "banyan" comes from the Gujarati for "trader," after those from centuries past who displayed their goods under the spreading branches of these trees.

Even their counterintuitive growing habit—seeds sprouting from other trees' branches, roots dangling down to find the ground—suggests some sort of botanical magic. In Sanskrit, the banyan was called *nyagrodha,* the down-grower. Ancient Hindu texts identify it as the cosmic tree, symbolizing the struggle toward enlightenment. Likely for all these reasons, India honors the banyan as its national tree.

Botanically identified as *Ficus,* banyans are also called strangler figs, for their inclination to wrap around and overwhelm neighboring trees. In fact, there are some 900 species of *Ficus* trees, originating in East Asia but now growing worldwide. Biologists find particularly fascinating their intimate relationship with pollinator wasps, a phenomenon called obligate mutualism: The figs need the wasps, and the wasps need the fig trees. Without one another, neither would survive.

A massive banyan appears to welcome visitors with open arms
on the Pipiwai Trail in Maui, Hawaii.

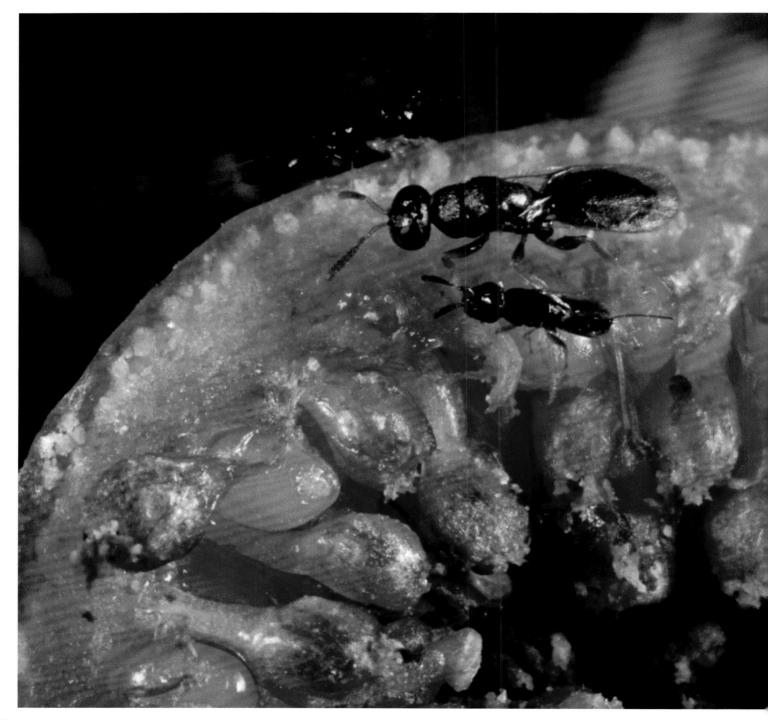

"Forever cherished be the tree . . ."

—EMILY DICKINSON

Fig fruits ripen from inside out, with female flowers clustered inside the unripe fruiting body. Tiny female wasps make their way into the immature fig, gathering pollen from male flowers as they go. Inside, they lay eggs in some female flowers and pollinate others. The larvae mature inside the growing fruit. Male wasps fertilize females and then burrow tunnels out of the fruit. Fertilized females escape out the tunnels—and start the cycle all over again. Each species of fig tree appears to have a matching species of fig wasp that visits it.

Hindu tradition links the banyan tree to the divine triumvirate of Vishnu, Brahma, and Shiva, and says that other deities dance among the branches. Scientists may not express it quite that way, but even they view these trees with reverence and wonder. ∎

Certain species of wasps and figs depend on each other for survival; these coexist in the tropical cloud forest of Monteverde, Costa Rica.

Matchsticks

Toothpicks, matchsticks, chopsticks, popsicle sticks, hockey sticks, drumsticks. Baseball bats and tennis rackets. Rowboats and rocking horses. Lobster pots, birdhouses, beehives. Cradles and coffins. Everywhere you look, there are things made of wood. And that's not including the things made of cork, paper, or wood-derived chemicals—or the kindling, firewood, logs, charcoal, and chips we burn to cure meat, boil water, cook our food, and warm our homes. For all these gifts, we have trees to thank.

So many things we take for granted are made out of wood, which is essentially dead cells. In every tree, growth happens all around the outer edge. Year after year, a new growing layer of cells develops on the outside, and the old layer joins earlier ones, widening the tree's girth as it grows. The oldest cells are the heartwood, choice construction material. Slice a tree trunk horizontally, and you see the heartwood as the inner set of rings. Slice a tree vertically, and the heartwood shows up as tighter grain.

Over the ages, builders and craftspeople have selected wood using a broad range of criteria: strength and ductility, density and weight, color and figure—the patterns of annular rings, branch twists, scars and knots, or even insect invasions that create patterns and may be emphasized as the wood is sawed. Some trees offer wood that is easy to carve or nail; others not so much, but the terms "softwood" and "hardwood" refer botanically to cell and seed structure,

In Kerala, India, manufacturing methods turn trees into tiny slivers,
then slivers into functional matchsticks.

not workability. Soft, pliant balsa wood comes from a tropical hardwood tree, for example.

Wood is so much a part of our built world that we don't even think about where it comes from; it's simply there. Yet the global demand for wood products is constant and growing. According to the United Nations' Food and Agriculture Organization, in 2019 the world production of wood primarily for carpentry and construction—logs, boards, plywood, and particleboard—totaled 2,866 million cubic meters: a volume greater than the water in a million Olympic-size swimming pools. That's a lot of trees.

Timber logging drives deforestation in many regions of the world. Replanting trees for the purpose of future logging can only go part of the way in reestablishing the natural balance. Governments and nonprofits have established standards and monitoring practices to enforce an ethic of environmental stewardship in the logging industry. Everyone can participate, starting with the simple recognition of the many ways we depend on wood every day. ■

Logs stacked in a Canadian timber yard symbolize that country's role as a global producer of softwood lumber and derivative wood products.

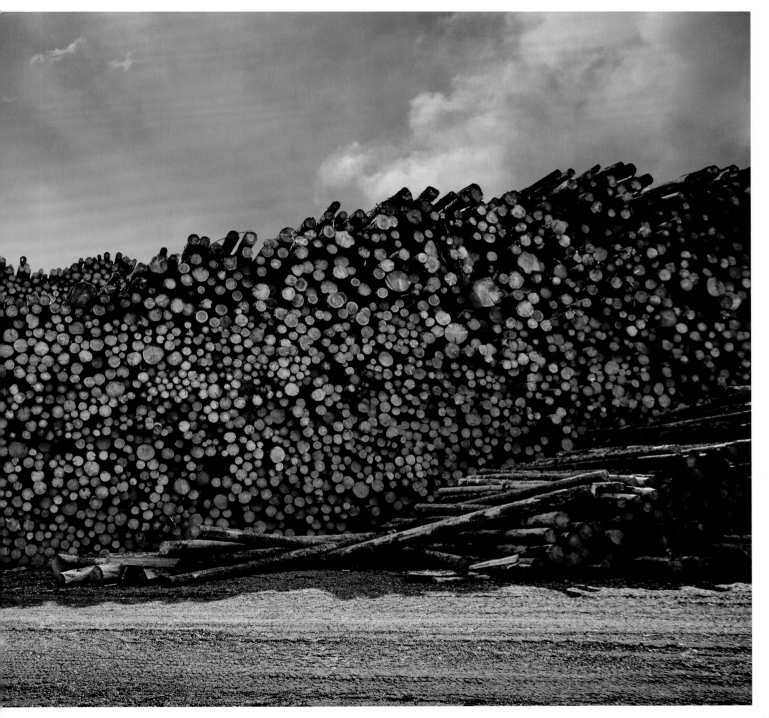

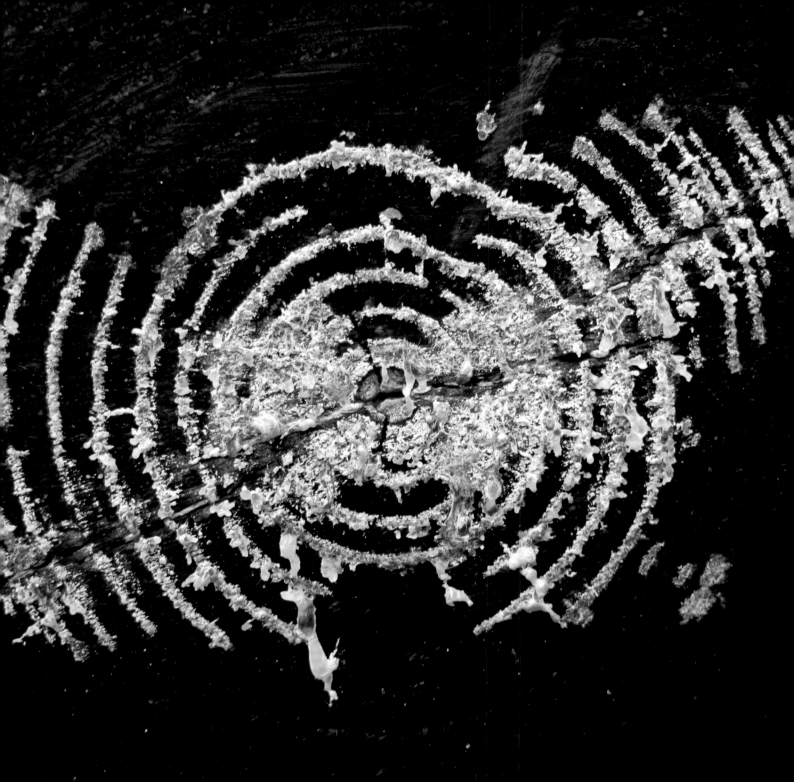

Cycle of Life

Death in the forest is complicated. Trees fall, stumps rot, leaves decompose, fires smolder. Animals die; their bodies drop and decompose. And then a different population of creatures goes to work, turning the stuff of death into the stuff of life, making of detritus the rich humus that feeds a future forest.

We may see fallen leaves or a rotting log in the forest as the epitome of tissue breakdown and decay—but in fact, they host a world of life and activity. Just scratch under the leaf mold or lift up a fallen log and you will see the swarm of activity: creatures hard at work, finding sustenance in the decay and leaving behind matter that builds the soil. Bacterial and fungal species sufficient in the enzymes that break down the tough stuff of wood work away as well.

Decomposing fungi may have already moved in on the dying tree before it fell, and now the fungal threads dive deep into the punky wood, finding spaces to establish and develop the fruiting bodies we call mushrooms. Plants germinate on the forest floor, thirsty rootlets burrowing through the decomposing matter.

Invertebrates galore—insects, spiders, worms, grubs, centipedes, mites, and others—transform the rotting wood. Some burrow in to feed on fungi or establish nests. Some can actually digest wood—termites the best known of those. Passalid species, also called bess beetles, consume so much decaying wood tissue in a week that they produce five times their body weight in frass—

Fungal mycelia invade a rotting log, synergies
contributing to the natural process of decay and regeneration.

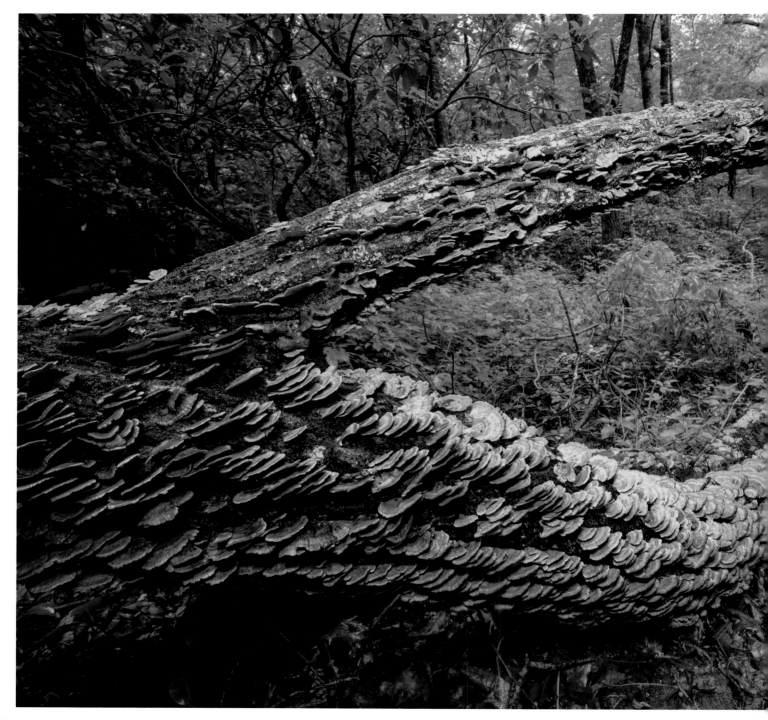

the word used by entomologists for their powdery excrement. They eat the frass and nest their young in it, replenishing their guts with the bacteria needed to digest wood. Insect-eating forest dwellers—frogs, lizards, moles, and possums, for example—rummage through, tearing up the rotting wood even further.

All this activity benefits the forest. Elements locked into the cells of the wood—in particular, nitrogen—are released, making them more available to nearby tree rootlets seeking nourishment underground.

Plunge your hand down, grab a handful of forest soil, and feel the soft tilth of that rich, dark humus. In a healthy forest it comes naturally: the result of interactions among all the creatures contributing to the cycle of life and death and life again. ■

A tree falls in the forest; bacteria, fungi, and invertebrates
move in, transforming it to soil-enriching humus.

FAMOUS TREES

TREES THAT LIVE THROUGH TRAUMA

Many a tree persists through storms and seasons; most transcend the winds of political change. Some trees, miraculously, survive the traumas of war and terror. The Japanese have a name for these trees: *hibakujumoku*—from *jumoku,* trees or shrubs, and *hibaku,* atomic bomb survivor.

A single elm tree survived the blast of the 1995 terrorist bombing of a federal building in Oklahoma City; after the blast, little was left but the stumps of branches. Now, it spreads its leafy limbs to provide memories, hope, and shade. A single pear tree remained standing after the 2001 terrorist bombing of New York's World Trade Center. Removed and tended for years, in 2010 it was replanted: a centerpiece of the 9/11 Memorial Plaza.

In Hiroshima, Japan, trees still stand today that lived through the devastating atomic bomb blast of August 6, 1945. The people of Hiroshima tend these 170 hibakujumoku—among them ginkgo, camphor, willow, cherry, and eucalyptus trees. One survivor ginkgo grows through the gate of a Buddhist temple; another is now encircled by the entryway of a temple rebuilt a little more than a mile from the blast's epicenter. At a closer look, its trunk tells the story, tilting slightly toward the blast site, bark scarred on that side only.

For those with personal memories of that day, the trees have the deepest meaning. "When people around me died of the atomic bomb sickness, and I also wondered whether I would survive," said one woman, "I saw this tree putting out shoots and thought I could somehow go on living." ■

The Callery pear tree that survived the 9/11 attack blossoms each spring, surrounded by new construction—including the 1,776-foot-tall One World Trade Center.

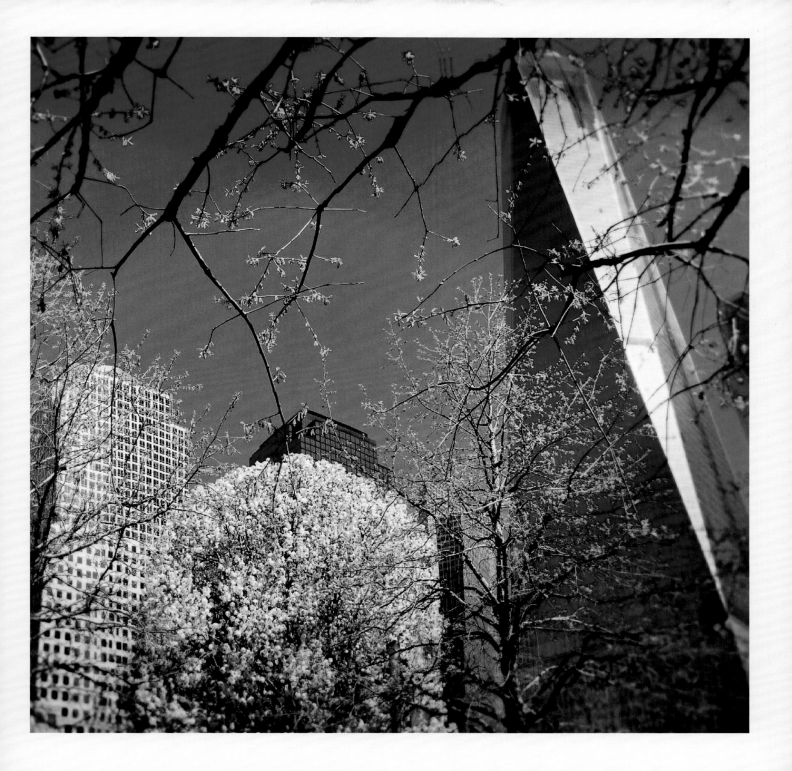

CHAPTER SIX

FOREST

Come into the forest: refreshed, enriched,
at peace with the world that surrounds you.

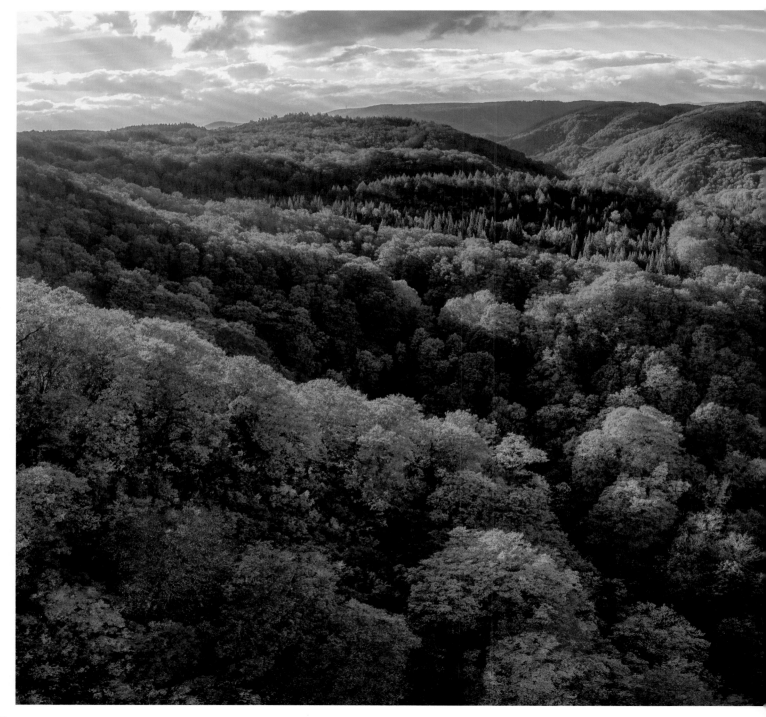

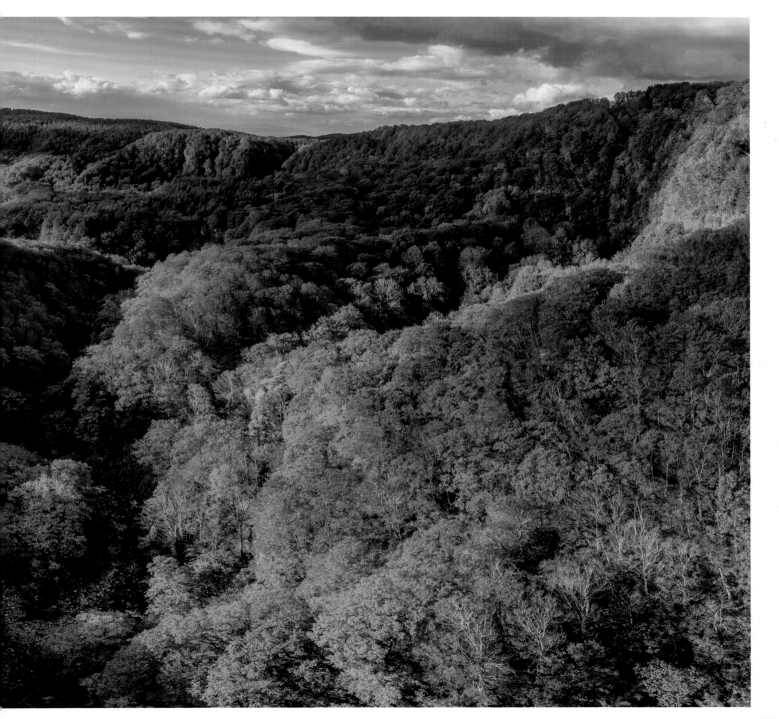

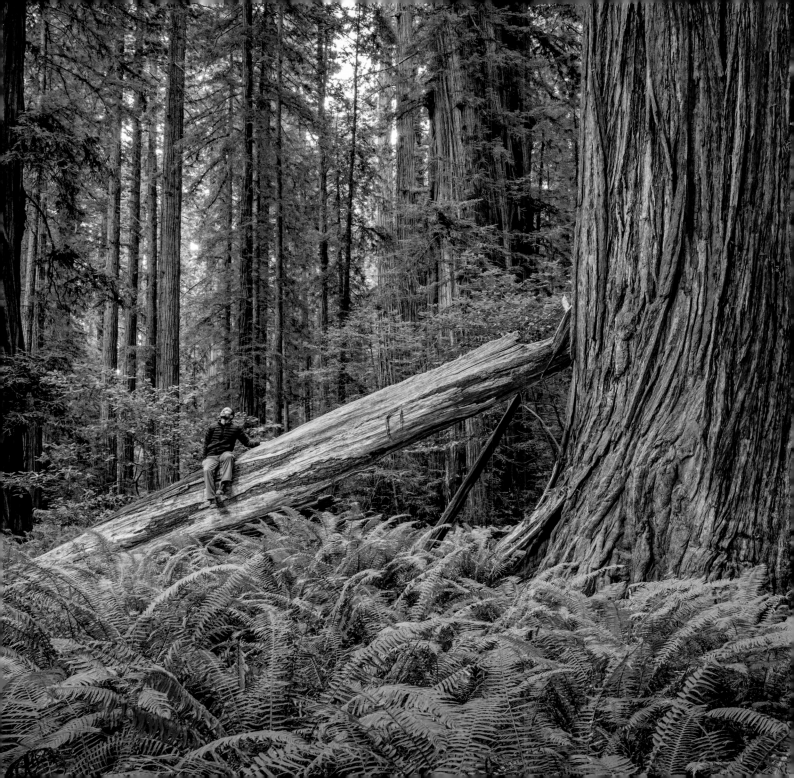

Forest Bathing

In 1982, creative thinkers in Japan's Ministry of Agriculture, Forestry, and Fisheries came up with a new way to relieve the anxieties of an increasingly urban culture and return attention to the beautiful forests across the land. Tomohide Akiyama, director general of the ministry, called the idea *shinrin-yoku,* a new word combining the Japanese characters for forest, trees, and the sense of being engulfed in abundance. Another translation is "forest bathing," a practice now embraced worldwide.

With spiritual roots in Shinto, a faith that envisions spirits throughout nature, the concept was embraced by the Japanese people and has since developed into a thriving network of locations, guided experiences, and therapeutic techniques. Scientific analyses followed, confirming the healthful impact of the plan.

In his seminal book *Forest Bathing*, Dr. Qing Li describes the concept this way: "Simply being in nature, [and] connecting with it through our sense of sight, hearing, taste, smell and touch." Walking is an essential factor, but it's possible to participate by either taking an hour-long stroll or spending several days and nights in the woods. The goal is to unplug from phones and laptops, leave behind streaming services and social media. The practice can be experienced alone, with like-minded friends, or with a trained adviser.

Even a fallen limb from a California redwood tree dwarfs the human form, evoking awe and refreshing the spirit.

PREVIOUS PAGES: Awash with autumnal color, the landscape around Aomori, Japan, hints at why forest bathing originated in that country.

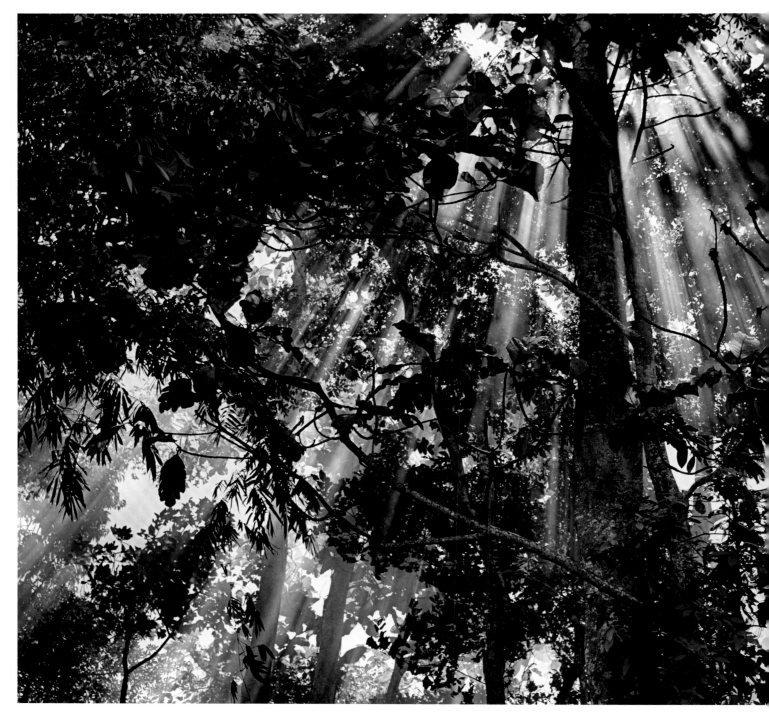

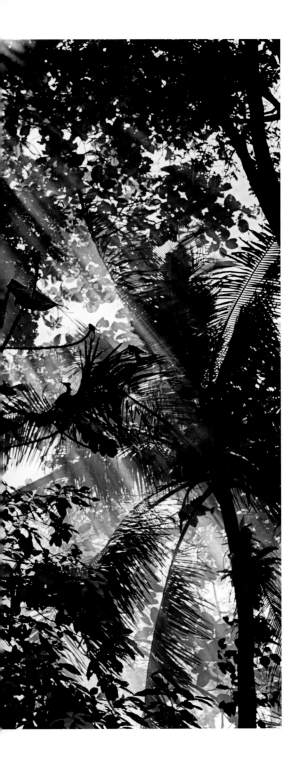

A plethora of new studies have offered remarkable proof that forest bathing is good for overall health. Heart rate and blood pressure drop to healthier levels; those suffering from depression, anxiety, sleep disorders, and even addiction respond positively. Levels of cortisol—the stress hormone—drop. In participants with diabetes, blood glucose levels decrease. Some studies even suggest that forest bathing can heighten the immune system's natural killer cells, fortifying resistance to cancer.

In Japan, at least 62 forests are certified for shinrin-yoku; worldwide, hundreds of therapists have gained certification in the practice. But as good as the idea is, forest bathing has become a big business—a sign, perhaps, of how far our daily lives have taken us from nature.

Going for a simple walk in the park or woods, every day, for as long as possible: That's forest bathing at its finest. ◼

Sunlight sifts through the canopy of trees in Bali: a moment of inspiration, no matter one's faith.

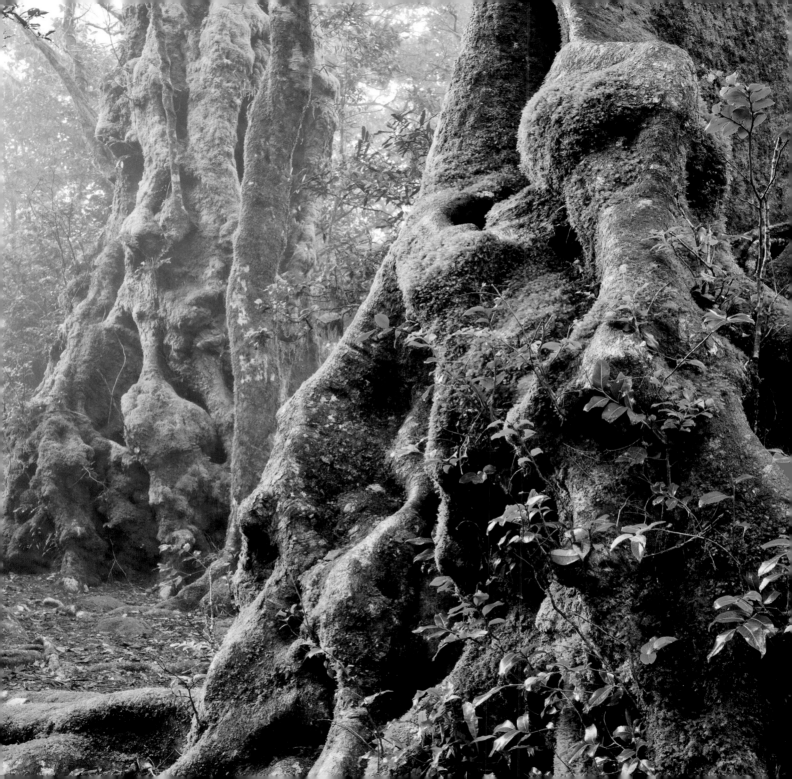

Old Forests

The forest of fairy tales is always old. Majestic trees of complementary species share the space and shade the woodland floor. Old and young, thriving and declining—even dead stumps and rotting logs have a beauty all their own. Wildflowers strew the path more often trod by deer than by humans. Squirrels and salamanders, woodpeckers and turtles: Kindly animals go about their business.

This is the forest primeval, as Henry Wadsworth Longfellow wrote—a poetic ideal. But such places do exist in the world. Known as old-growth or primary forests, they tend to evade a precise scientific definition, as the criteria are subject to debate. Age of the trees? Prevailing species? Level of human development? All these factors combined?

The United Nations' 2020 Global Forest Resources Assessment defines a primary forest as a "naturally regenerated forest of native tree species, where there are no clearly visible indications of human activities and the ecological processes are not significantly disturbed," including "forests where indigenous peoples engage in traditional forest stewardship activities."

But few of the world's forests meet that definition. According to the report, forests cover 31 percent of our planet's land surface: 4.06 billion hectares, or 15.7 million square miles. Fully half that total is found in just five countries: Russia, Brazil, Canada, the United States, and China. Seven percent of Earth's forests— just over a million square miles—were deliberately planted. Of those, nearly half

These trees—Antarctic beeches in an Australian subtropical rainforest—
have likely weathered through centuries.

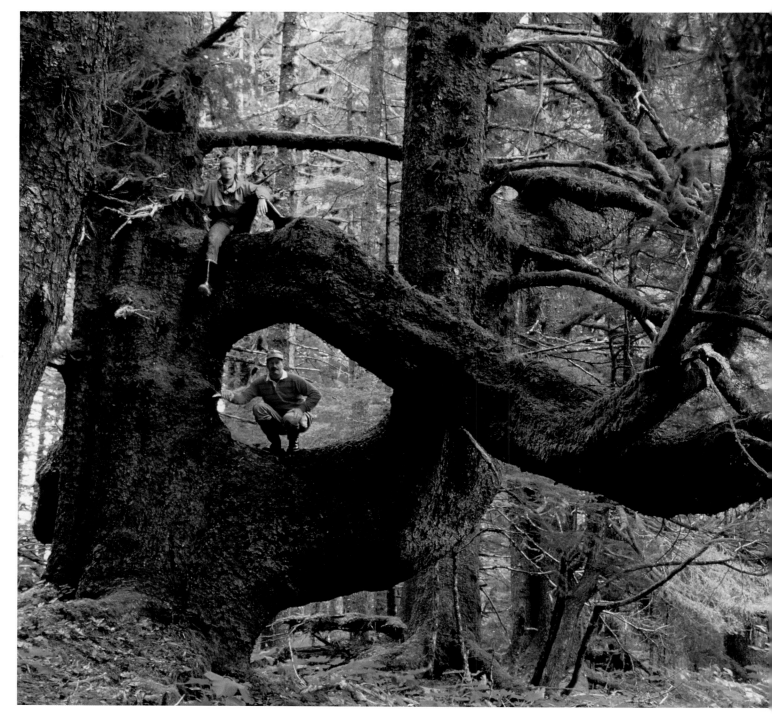

are tree plantations, one or two species planted simultaneously, ultimately to be harvested.

That certainly does not match the fairy-tale archetype. In fact, according to the UN report, only a bit more than a quarter of Earth's total forest area is primary forest. Some is temperate hardwood forest, like the Białowieża Forest of Belarus and Poland, the only remaining home of the European bison. Some is temperate rainforest, like Alaska's Tongass National Forest, with its fjords and streams where salmons spawn. Australia's Gondwana Rainforests, a system of subtropical rainforest reserves, represents the last vestiges of an ancient primary forest; here, plant and animal species reveal the ages in Earth's evolution.

Every one of these beloved expanses is threatened in some way: by logging, legal and illegal, in Białowieża and Tongass; wildfire in Gondwana; changing climate in all three. Indeed, it is hard to find an old-growth forest around the world that does not call out for protection. Without them, we lose both biodiversity and beauty, says Joan Maloof, founder of the Old-Growth Forest Network. The goal, she says, is to prevent them from disappearing entirely—becoming nothing but the stuff of fairy tales. ∎

Humans come and humans go; grand spruce trees prevail in Alaska's Tongass National Forest, one of North America's old-growth realms.

THE INVERTED TREE OF WISDOM

The *Bhagavad Gita,* an ancient Hindu scripture, envisions the world as a tree turned upside down, boughs below and roots above. Brahma, the Creator, dwells in its roots. Shiva, the Destroyer, dwells in its trunk. Vishnu, the Preserver, dwells in its branches, which grow out in all directions and reach down to the ground, just as we humans anchor our lives in the material realm. The great tree's leaves shimmer in the wind, each a verse of wisdom that speaks the truth, offering the path upward to the divine consciousness at the center of its roots.

As we look up, roots stretch down,
anchoring banyan trees in Makawao, Maui, Hawaii.

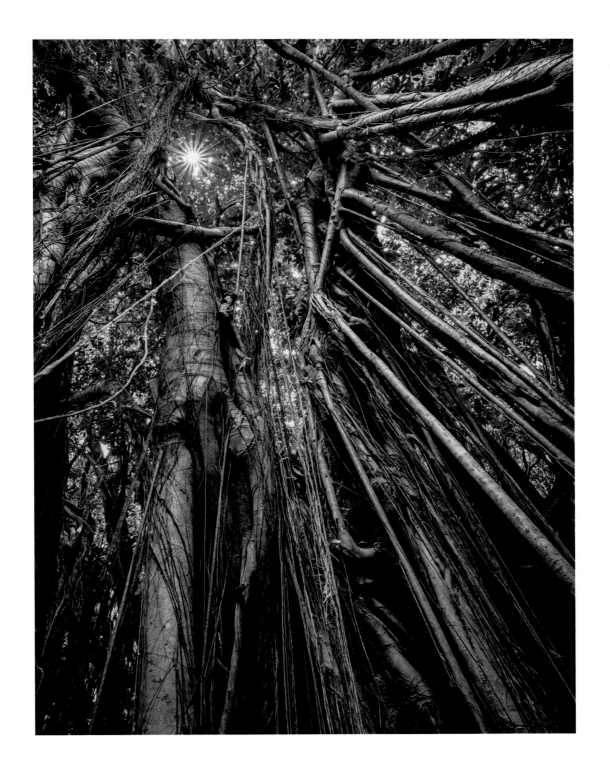

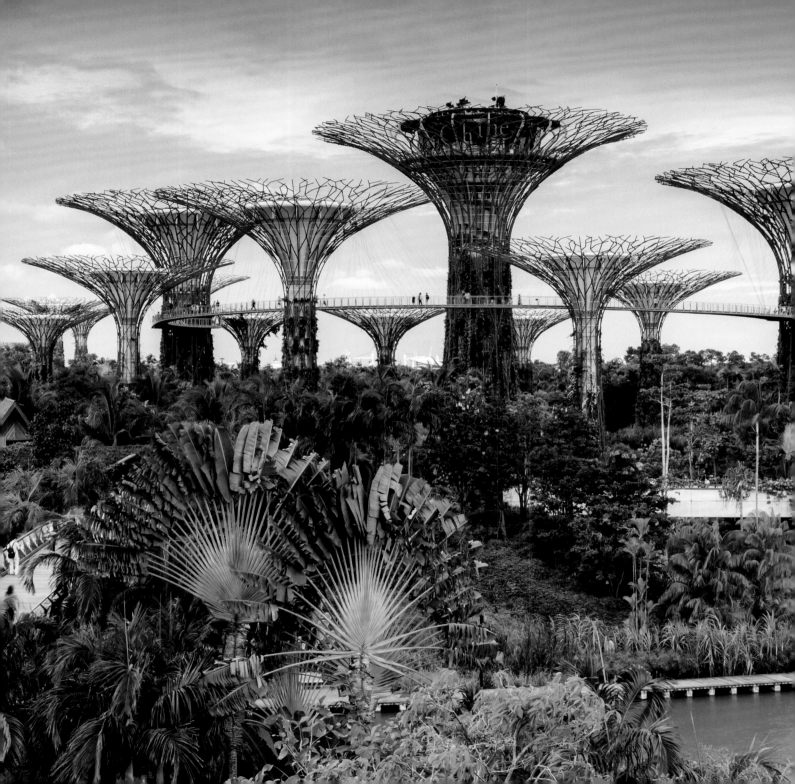

Forests in the City

As economists phrase it, city trees represent natural capital. They work hard for us: They clean the air; they cool in summer and moderate windchill in winter; they dampen noise from traffic and construction; they soak up rain and reduce stormwater runoff; and they contribute to human health, both physical and mental. In short, trees improve the quality of city life, and economists have the numbers to prove it.

The U.S. Forest Service calculates that a one-dollar investment in city tree planting could bring a return of $3.09 annually. Over 20 years, their analysis has shown, one red maple tree in Ohio removes 3,100 pounds of carbon dioxide from the atmosphere, reduces carbon emissions by 5,500 pounds, saves 570 kilowatt-hours of electricity, and filters 15 pounds of harmful volatiles from the air. Studying 10 of the world's megacities—those with populations over 10 million—economists calculated the median benefit of their trees to total $482 million annually, quantifying their ability to filter harmful gases and particulate matter from the air. The Department of Agriculture estimates that if 100 million more mature trees grew in U.S. cities, it would reduce energy costs by two billion dollars annually.

Singapore provides a fascinating model and inspiration. In less than a century, this island republic evolved through a period of concrete-filled urbanization into the garden city that it has become today. In the 1970s and 1980s, the increasingly

Supertree structures mimic the shape of the many trees planted in Singapore over the past 50 years, making it a city full of green.

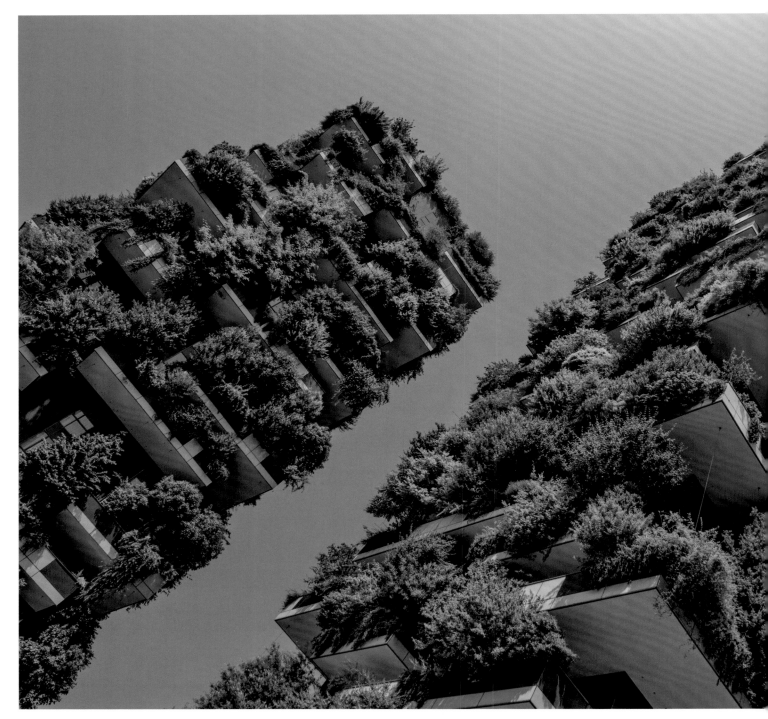

wealthy city established more greenery for the sake of leisure and recreation; by the early 2000s, regulations required that all new construction be counterbalanced with tree planting and park development. Singapore's 2020 One Million Trees initiative includes planting back lost native specimens, including mangroves.

Today, a redefinition of the green in our cities is not viewed as simply a recreational luxury, but an economic, environmental, and human health imperative. Increasing urban green means more trees for more people—an issue called tree equity. According to the nonprofit American Forests, "a map of tree cover is too often a map of income and race," with significantly fewer trees in the least advantaged neighborhoods. Study after study has found that nearby nature reduces vandalism and graffiti, even lowers crime rates. These are the neighborhoods that need more trees the most.

And the trees don't need to be planted on solid ground. Landscape architects are getting creative. Balconies, walls, and rooftops are becoming fields and gardens—all part of the growing urban forest. More than half the world's population lives in a city now. From Boston to Bangkok, Lima to Lagos, every city will benefit from more green. ■

Trees and shrubbery on each floor's terrace turn this city apartment dwelling in Milan, Italy, into a vertical green landscape.

Indoor Forests

Why do we gaze out the window? To daydream, waste time, stare into space, avoid work? Trapped inside, many yearn for the outside view. What do we gain from gazing?

A room with a window on nature makes a difference in people's lives, as evidenced by psychological research going back to the 1980s. A room with an outdoor view may not be the same as a walk in the woods, but it's better than nothing.

Early studies assessed the extremes. Prison inmates in cells with windows looking out at farmland made fewer sick calls than those whose windows faced into the prison yard. Surgery patients who could look out the window at a grove of trees enjoyed faster, easier recoveries than those who looked out at a brick wall.

Turns out that the same theory applies for people in offices and apartments. Gazing out at a scene of trees and greenery calms the mind and refreshes the attention. There's a reason why a window office is considered an executive perk. In an ideal world, everyone would have one, looking out at a park below.

Even indoor plants can make a difference. Studies have gone into remarkable detail on their value in the workplace: How many plants? How big? In front of the person sitting at a desk, or alongside? So far, the evidence shows that those with potted plants at work stay healthier and happier.

Plants indoors, from small to large, can bring
the salutary effects of the forest into daily life.

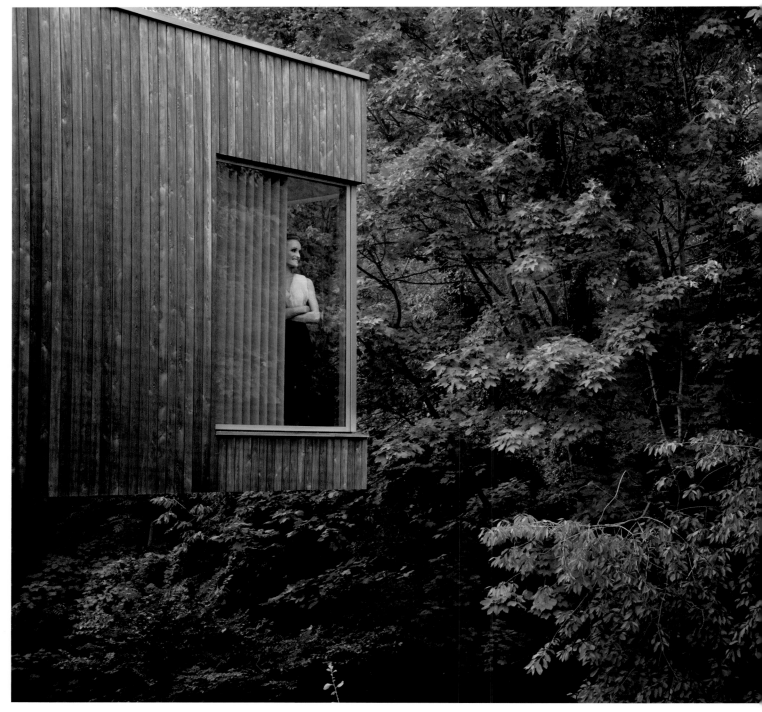

But the common assumption that indoor house plants clean the air may be unfounded. A NASA study started the rumor. With future space habitats in view, researchers asked if living plants filtered trace pollutants—benzene, trichloroethylene, formaldehyde—in tightly enclosed places. They grew plants in layers of activated carbon and potting soil, with an electric motor pulling air through the layers. Ironically, the pots without foliage trapped more pollutants than those with plants in full leaf, leading the researchers to recommend "maximizing air exposure to the plant root-soil area."

But back in the city, contact with indoor plants can make a difference. One study compared the physiological effects of working at a computer versus repotting a plant. No surprise: Research subjects felt jittery after working at a screen but soothed after interacting with the plant. It follows that those moments of working with soil indoors can re-create, in a small but significant way, the revitalizing experience of stepping into the forest. ▪

Studies have shown again and again that a natural view out the window reenergizes the mind.

The Advantage of Otherness

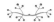

A walk in the woods promises a 360-degree, four-dimensional kaleidoscope of sensory experiences. The sights, the sounds, the smells. The feel of a breeze on your cheeks or soft mounds of moss and earth beneath your feet. Sometimes, you can even taste the forest air. Another world surrounds you—a key element of nature's power to refresh and heal.

We can feel it, we can experience it—and today, psychologists are fascinated by how these transcendent moments manifest themselves inside the human brain. Neuroscientists are working to characterize what some call the brain's default mode—the activity that occurs even when our eyes are closed and it seems we're not thinking about anything at all. In fact, some 90 percent of the energy expended by the human brain goes toward intrinsic operations rather than conscious mental effort.

But that default mode is not the same as self-absorption. Rumination and worry activate the subgenual or ventromedial cortex, a part of the brain deep in the frontal lobe that is involved with bipolar disorder and depression. One study found that those who took a walk through a park showed less activity in that brain region than those who took a walk through city streets. Being surrounded by nature, it turns out, can physically help take our minds off our troubles.

If the experience of nature helps us be kinder to ourselves, what effect does it have on our relationships with others? Psychologist John Zelenski

A walk in the park or forest redirects the attention.
Personal worries may fade, making way for a sense of well-being.

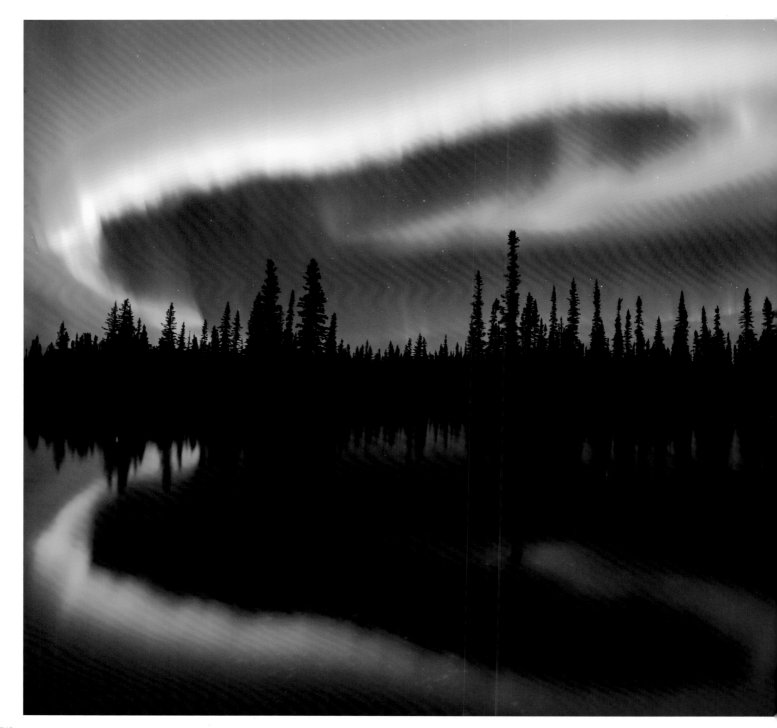

has conducted experiments asking just that. In one, he showed his subjects three different videos: a nature documentary, a documentary about architecture, and a sequence of geometric shapes paired with audio about writing. Then all played a fishing game, where the rules clearly stated that taking too many fish would leave the others without. The group that had witnessed nature took fewer fish than the other two, suggesting that an experience of nature actually increased the inclination to think and care about others.

Step into the forest experience—a walk in the woods, a stroll through the park, even a few minutes tending houseplants—and immerse yourself in a world of otherness. Poets, philosophers, and now psychologists are telling us: Nature imbues us with compassion—for others, and for ourselves. ▪

A horizon of Alaskan evergreens forms the demarcation between river and sky, both glowing with the eerie light of the aurora borealis.

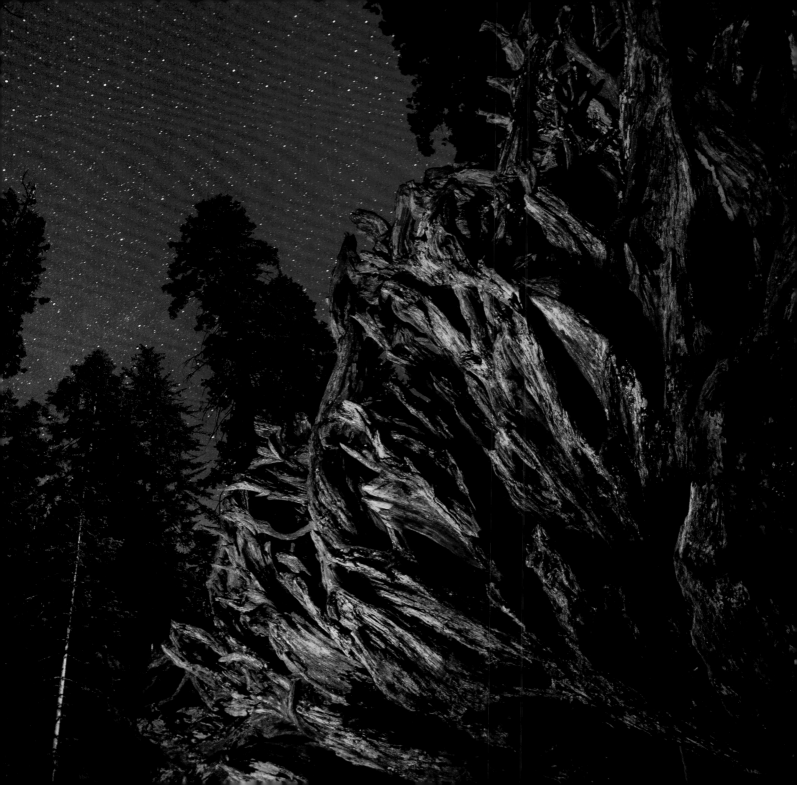

A Legacy of Healing

More than 150 years ago, the pioneering landscape architect Frederick Law Olmsted—best known for designing New York City's Central Park—championed the founding of a state-run nature preserve. It ultimately became Yosemite National Park, with its celebrated Mariposa Grove of giant sequoias. Olmsted's philosophy presages many of today's discoveries about the healthful influence of nature.

"It is a scientific fact that the occasional contemplation of natural scenes of an impressive character, particularly if this contemplation occurs in connection with relief from ordinary cares, change of air and change of habits, is favorable to the health and vigor of men and especially to the health and vigor of their intellect beyond any other conditions which can be offered them, that it not only gives pleasure for the time being but increases the subsequent capacity for happiness and the means of securing happiness," wrote Olmsted, in rhetoric almost too ponderous for us to absorb today. His words, though, are worth parsing.

Visits into natural settings like Yosemite can be "favorable" to "health and vigor"— especially the health and vigor of the intellect, Olmsted observed. It is particularly helpful that such visits provide "relief from ordinary cares" and a "change of habits." Not only do the moments in nature bring pleasure, but they build a "capacity for happiness" that lasts.

Giant sequoia trees have grown and fallen in California's Mariposa Grove, identified long ago by Frederick Law Olmsted as deserving of protection.

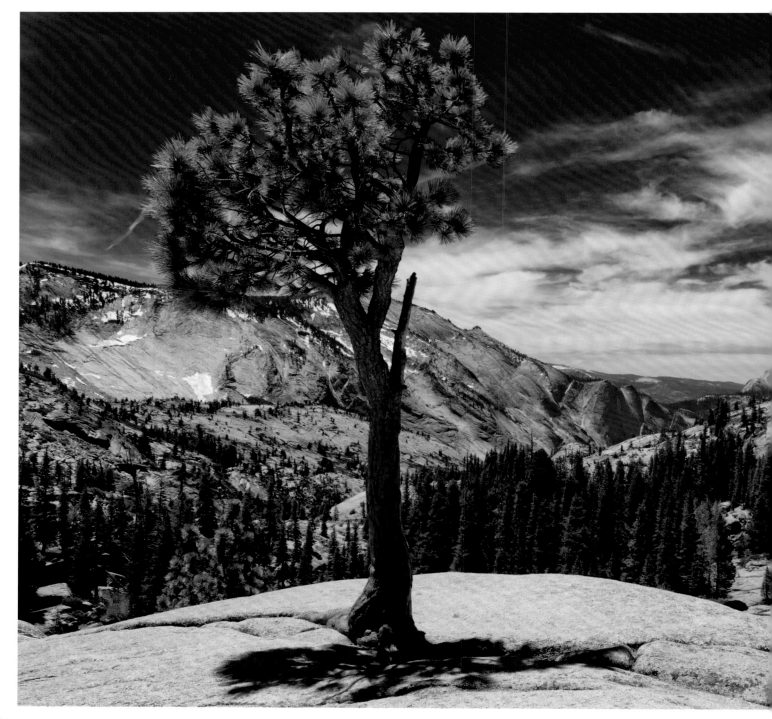

Later in the report, Olmsted contrasts "interests beyond those of the moment" with the immediacy of being in the forest. The pleasure of natural scenery "is for itself and at the moment it is enjoyed," he wrote. "The attention is aroused and the mind occupied without purpose, without . . . relating the present action, thought or perception to some future end."

The great landscape architect's eloquent statements did not convince fellow commissioners, and his report was never submitted to the California Legislature. A handwritten draft was typewritten only after his death. Composed in 1865—in the wake of the Civil War and the era of primitive medicine—his words may be arcane. But they convey the same discoveries modern psychologists and neuroscientists are making as they study the salutary impact of visits to the wild.

An immediacy, a sense of awe and beauty, a quieting of the mind, and physical refreshment: All add up to a forest that heals and an effect that lasts through time. ∎

A tree clings to a rocky foothold at the place now named Olmsted Point in California's Yosemite National Park.

FAMOUS TREES

THE TREES THAT WHISPER PRAYERS

As the Ute people tell it, they have lived on these lands forever. Once, long ago, they traversed the vast territory that is now Colorado and Utah. Until the 1600s, when the Spanish arrived, they walked these lands freely, recognizing spirit in all that surrounded them: the mountains and valleys, the plants and animals. They held the trees as sacred, especially the ponderosa pines. From those trees they gathered fiber and pitch for baskets, harvested medicine for healing, and foraged the sweet inner bark in early spring—long before nature provided any other sustenance.

The pines responded to the Ute people's care and respect by allowing them to bend the saplings into miraculous shapes: pointed at an angle, twisted into spirals, joined one with another as if in an embrace. For centuries these trees gave directions, marked graves, and whispered prophecies. When people had urgent prayers, they would bend a young tree, tie it down with yucca rope, and perform a ceremony—safe in the knowledge that the tree would contain their devotions for 800 years, to be renewed whenever the wind blew.

Since those days, the Ute people have shown the same resilience as the trees. Today, there are several Ute tribes and two Ute reservations, one in Colorado and one where Colorado, New Mexico, and Utah meet. And prayer trees still stand—including those in Fox Run Regional Park, south of Denver, where the breezes still lift the prayers of their ancestors. ∎

This prayer tree, a ponderosa pine, stands as a sacred signpost,
shaped long ago by Ute people near Colorado Springs, Colorado.

The Trees That Care for Their Own

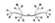

Some scientists today describe the interactions of trees as akin to communication, mutual concern, and family relations. It's easy to relegate trees to a category halfway to inanimate—after all, they don't move, they don't talk, and they seem passive in response to the abuses we inflict on them. But imaginative experiments are proving otherwise.

Acacia trees in the African savanna are among the earliest documented cases. When giraffes munch on their leaves, the trees propel alarm volatiles into the air, triggering their neighbors to exude offensive chemicals that fend off the grazers. Studies of other plant species have found that, similarly, a chemical response from clipped evergreen needles propagates a message to other trees nearby—and not only among the same species.

Signals move among trees underground as well, through the vast and intricate fungal system of mycorrhizae. Throughout the forest, tiny fungal roots develop in and among the roots of trees; stretched out, a square foot of soil might contain hundreds of miles of fungal threads. Weaving together into a complex underground mat, the trees and mycorrhizal fungi establish a symbiotic relationship. The trees share some of the sugars they produce through photosynthesis; the fungi collect and share mineral-rich moisture. Each thrives thanks to the other. Now, scientists are learning, these relationships connect not only fungi with trees, but also trees with other trees.

Lichens, moss, microbes, and invertebrates
turn a rotting log into a nursery for sprouting pine trees.

"There is a necessary wisdom in the give-and-take of nature—its quiet agreements and search for balance. There is an extraordinary generosity."

—SUZANNE SIMARD,
Finding the Mother Tree

To determine the extent of this kind of sylvan communication, forest ecologist Suzanne Simard and her graduate students bagged three-somes of disparate tree species seedlings, separated their root systems with mesh netting, and infused them with identifier isotopes. Indeed, the isotopes traveled from tree to tree—even species to species—among those that had lively relationships with the fungi near their root systems. The roots could not touch, but the fungal filaments between them could, revealing that

Evergreens grow side by side on Canada's Vancouver Island, amicably sharing the life force of a third, much bigger, rotting tree trunk.

signals, so to speak, traveled through the mycorrhizae into the separated seedlings. When the researchers pulled all the needles off the Douglas fir seedlings, the ponderosa pine seedlings got the message—and bulked up on defensive enzymes. News of distress traveled from sample tree to tree, species to species, through the elaborate underground communication system.

When you project these findings forest-wide, things get more complicated. The fungal mat connects many species of trees and interacts more productively with some than others. Plants coexist in part because the underlying mycorrhizal fungi balance resources among them. To understand the trees—which ones thrive and regenerate, which ones dwindle and die—researchers now realize they must understand the fungi connecting them.

Simard's work shows that a thriving forest includes what she calls mother trees: elders that represent sources of life for trees around them, even as they die. Her research team has analyzed the network among all the plants in a given section of forest. They found that certain elders serve as vibrant hubs, connected to the others: plants on the forest floor, saplings of diverse species, and neighboring trees as they mature. "Mother trees are the biggest, oldest trees in the forest," Simard says. "They are the glue that holds the forest together."

It's a model of cooperation as well as competition. Thanks to Simard's innovative research, we now know that a forest is not a stand of disconnected individuals. It's a network of living connections, a coexisting community with its own amazing ways of caring for one another. ∎

New research is finding that trees—perhaps these Michigan birches— can signal one another through the mycorrhizal network spreading beneath them.

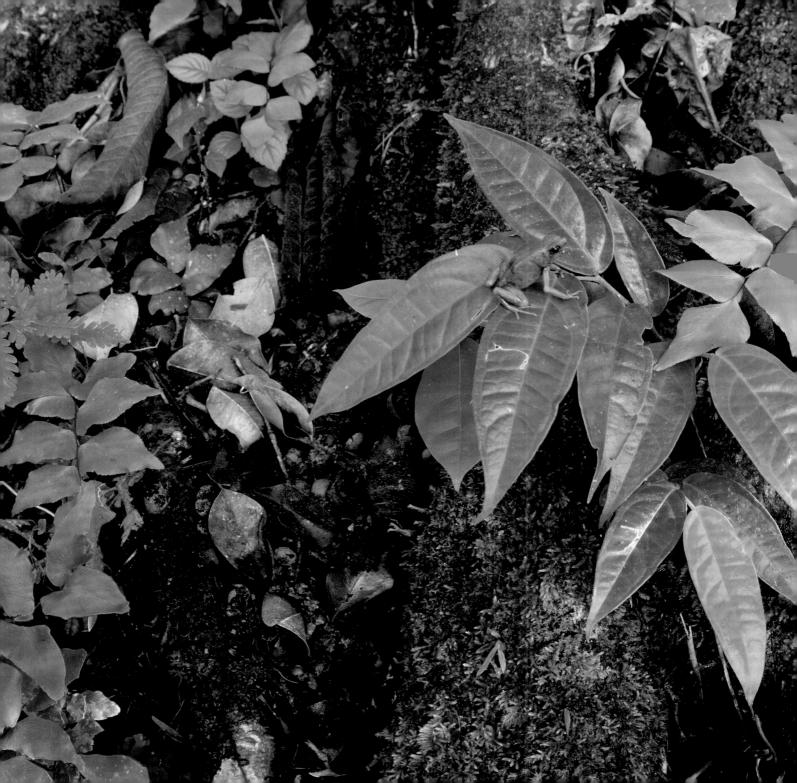

The Necessity of Biodiversity

You can't see the forest if all you look at is the trees. From microbes to monkeys, lichens to lemurs, ferns to frogs, a forest is the totality of all the life within it. There are intersections and relationships galore, and the whole forest, in all its biodiversity, is essential to the health of the planet—and thus important to human life, no matter where you live.

The Amazon rainforest, for instance, is home to millions of species, plant and animal. Estimates begin at three million and go up; the exact number is likely impossible to determine. First, there are the large, charismatic animals, including more than 400 species of mammal: monkeys, jaguars and pumas, capybaras (the world's biggest rodent, weighing up to 150 pounds), kinkajous and anteaters, and river mammals, including the otter and the pink river dolphin. Some 1,500 species of birds also live here, including toucans, macaws, and parrots; a number of others migrate to the region in winter. Next, the Amazon harbors as many as 1,000 species of amphibians, especially frogs, and hundreds of species of reptiles—iguanas, snakes, lizards, and such. And the insects! We have barely begun to count them, and their species likely number in the hundreds of thousands, if not millions.

Plant species in the Amazon number in the tens of thousands: fungi, mosses, shrubs, trees (species count estimated at 16,000), along with the plants that sprout in their branches and the vines that entwine them. There could be a

Frog, vine, moss, tree: These only hint at the multitude of life-forms in the Canandé Reserve, a protected area in Ecuador's Chocó rainforest, valued for its biodiversity.

thousand or more species of orchid alone—we just don't know. And these numbers do not even begin to include the species of microbes, both beneficial and destructive, that help the Amazon rainforest thrive.

Every plant and animal connects to others in an intricate web of life. We scope out one distinct interaction—for example, the Brazil nut tree, which depends on an orchid bee to pollinate its flowers and on agoutis, a rodent species, to crack into the husk of its fruit and disperse its seeds. Then we realize we must compound these interactions by millions to truly represent the complexity of this world.

Remove one piece, and you diminish the whole. The same could be said about every forest, from the taiga of Mongolia to the tropical shrubland of northern Australia, from the coastline mangroves of the Bahamas to the dry tropic forests of Madagascar. When a forest is flattened for the sake of timber, grazing cattle, or a monoculture plantation, it's not just the trees that disappear.

But let's rephrase the concept: Respect the forest, and you contribute to the whole. In biodiversity rests the preservation of the planet. ∎

A northern spotted owl swoops through California redwoods. The bands on its legs indicate researchers are tracking its behavior.

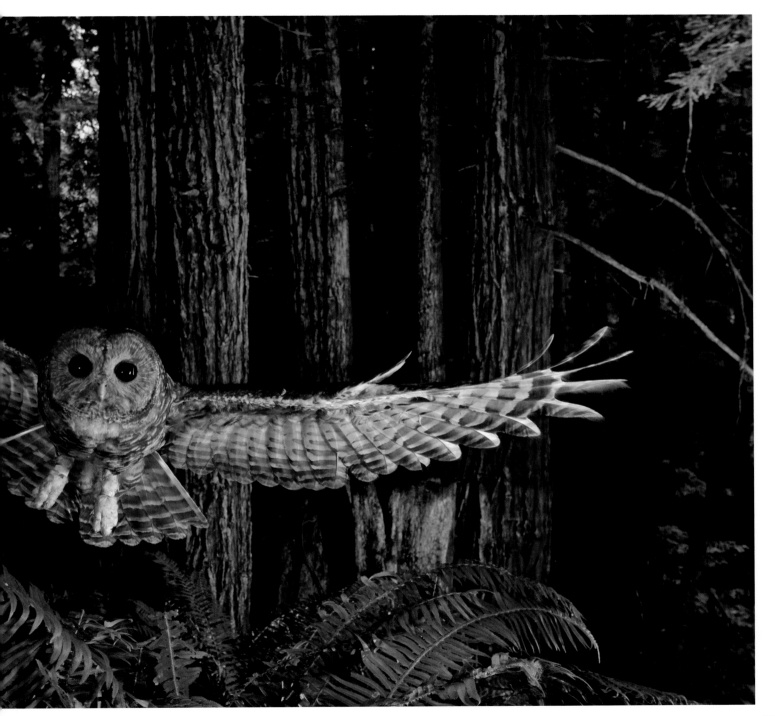

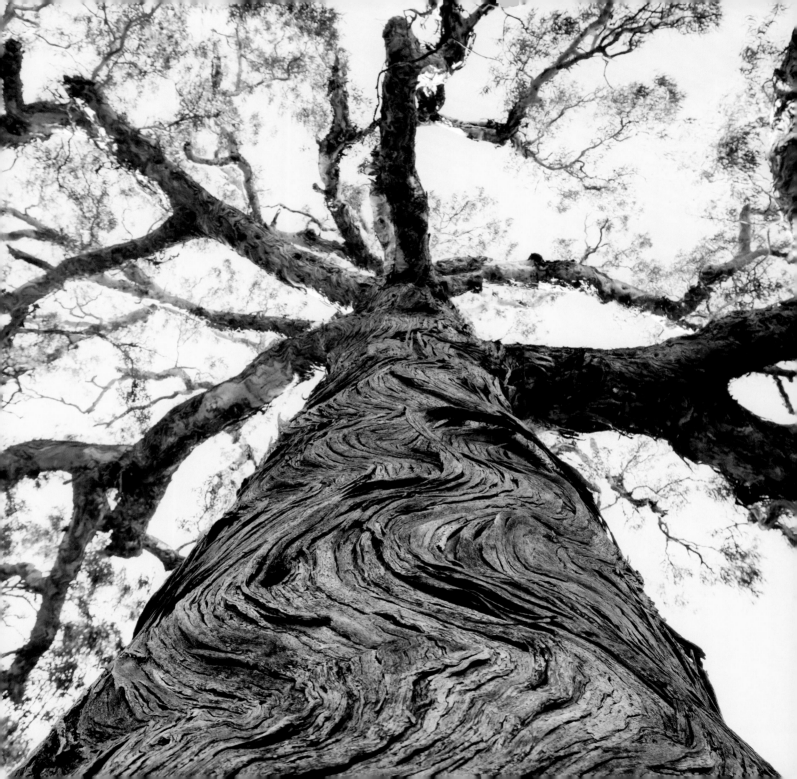

The Rights of the Forest

For the Djab Wurrung people of southeastern Australia, certain trees hold deep legacies of meaning. There are directions trees, from which a person can seek ancestral guidance, and birthing trees, which have given shelter to women as they have had their babies. One of these is believed to be 800 years old.

But to connect the cities of Melbourne and Adelaide, developers want to shoot a road straight through the region that is home to some of these precious specimens. Those trees, they feel, stand in the way of human progress.

Amid the battle, spokespeople for the Djab Wurrung have joined many others worldwide in a movement some have called "the new animism": a 21st-century legal philosophy that protects the rights of natural entities including lakes, rivers, forests, and trees.

The underlying principles of this movement were articulated in the early 1970s, with the announcement of plans to build an entertainment center in Mineral Springs Valley, part of California's Sequoia National Park. The Sierra Club objected, and the case went all the way to the U.S. Supreme Court. The majority decision ruled that the Sierra Club did not present evidence of personal harm. But Justice William O. Douglas wrote for the minority, arguing that it was the valley itself that should be protected—a concept articulated at the time in a landmark document, "Should Trees Have Standing?" by University of Southern California law professor Christopher D. Stone, and still referenced

Even the bark has character: a directions tree valued by
Australia's Djab Wurrung people, who listen here for the wisdom of the ages.

"The forest can bring you back to health and life, and you will want to conserve and protect it in turn."

—DR. QING LI,
Forest Bathing

today as more and more arguments are waged to protect the rights of nature.

The movement has gained steam ever since.

In the 1990s, 43 children in the Philippines sued the government over deforestation projects. Their lawyer, Antonio Oposa, argued that harm to the country's forests represented an affront to the rights of future generations to live in a healthy environment. The case met the same lower court response as that in California, but ultimately the Supreme Court in Manila upheld the rights of the children to protect themselves and future generations—a principle now called the Oposa Doctrine, with legal influence worldwide.

Can a tree claim legal standing? Laws around the world are changing, granting protections to natural wonders like this eucalyptus in Australia.

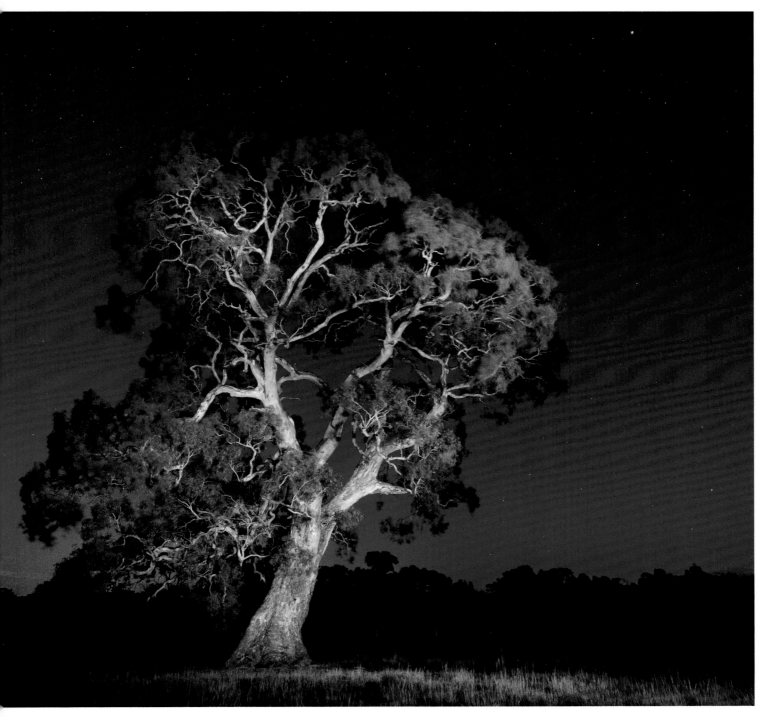

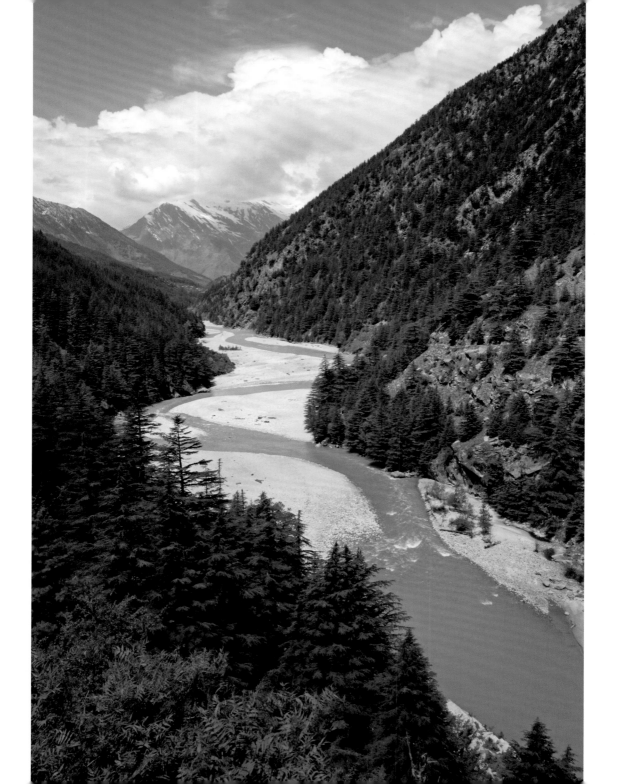

In 2014, New Zealand granted legal rights to a national park; in 2017 it granted legal rights to a river. In the wake of those decisions, conservationists in India sought legal protection for the Ganges and Yamuna Rivers, and ultimately all the natural entities of the Himalaya—mountains, glaciers, rivers, streams, lakes, forests, and trees.

A group of 25 children in Colombia, the youngest seven years old, followed the lead of the Philippines and sued to protect the Amazonian rainforest. The country's high court now asserts that it will "recognize the Colombian Amazon as an entity" whose rights should be protected and promises to put an end to commercial deforestation projects.

Does the forest have legal standing? It was a question from out of the blue in the 1970s. But in the last half century, awareness and concern for the threats to the nature of our planet—and recognition of the responsibility we hold—are inspiring more and more courts around the world to answer that question in the affirmative. ∎

The laws of India now protect the natural features of the Himalaya,
including this glacial flow in Gangotri, starting point for the mighty Ganges River.

Foresting the Planet

Stories of denuding landscapes ripple through human history. Today, some three trillion trees grow around the world, but it's estimated that nearly twice that many once covered the planet. We are cutting them down at a rate of 15 billion a year, according to one Yale University study. "Humans contend directly with natural forest ecosystems for space," as the researchers put it. But that trend is changing. People all over the world have started planting trees in numbers that could really make a difference.

First, localities took up the call. After the 2004 tsunami devastated Indonesia, residents started replanting wetland forests. Some 70 villages put in two million seedlings—both mangrove and other species—along the coastlines. In 2014, Pakistan initiated an ambitious replanting project, known as the Billion Tree Tsunami. They reached their goal early, in 2017—but they haven't stopped planting: In 2019, the mission was renewed with a 10-billion-tree goal. Ethiopia's prime minister challenged his people to plant 200 million trees in one day. China observes every March 12 as a national tree-planting day, working toward a goal of achieving 87 million acres of new trees by 2050.

Tree-planting efforts began to coalesce as nations joined in the Paris Agreement, a treaty on climate change that includes firm language about taking action "to conserve and enhance, as appropriate, sinks and reservoirs of greenhouse gases . . . including forests." Some countries, such as Costa Rica, enacted

Volunteers plant trees near the Badain Jaran Desert on March 12, 2021,
the 43rd annual tree-planting day in China.

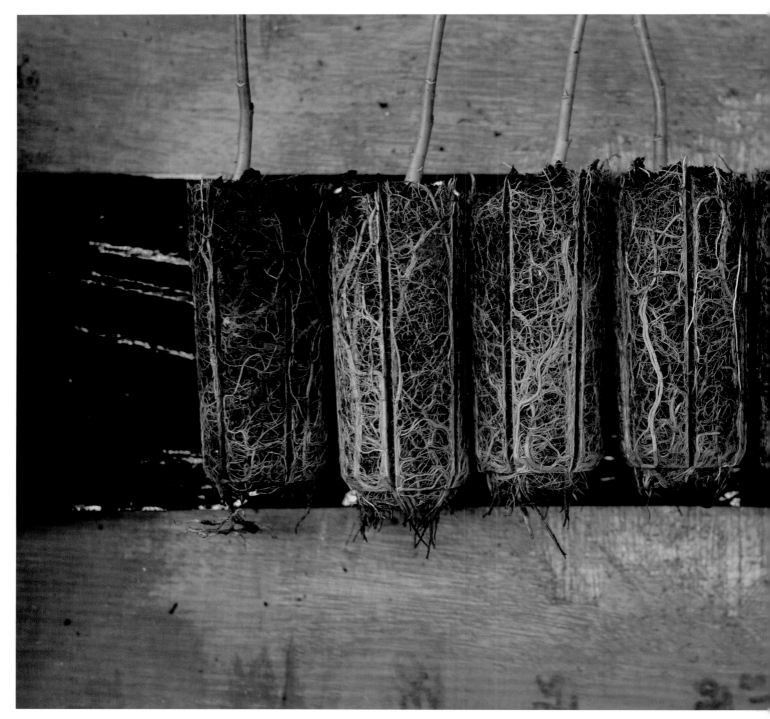

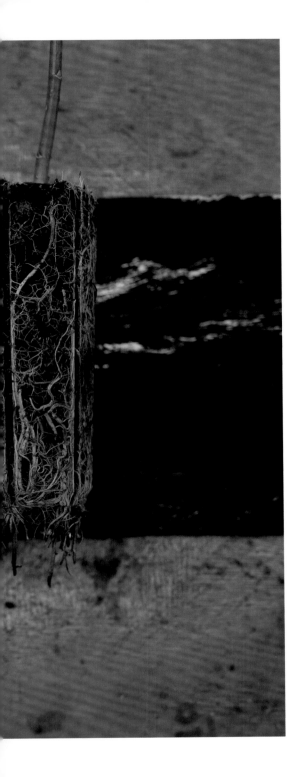

stronger forest protections, while others kept planting more trees. In 2020, two million citizens planted 250 million trees on a single day in India. In 2021, the United Kingdom pledged to triple its earlier replanting target.

Soon, international nonprofits began organizing for the cause. Germany joined the International Union for Conservation of Nature in the Bonn Challenge; BirdLife, the Wildlife Conservation Society, and the World Wildlife Fund started Trillion Trees. Each oversees multiple projects on every inhabited continent of the world. In fact, there are now so many nonprofit tree-planting ventures that there are even websites recommending the best among them.

Planting trees, whether in the dozens or the millions, is not a simple solution. Species selection and diversity, the need for long-term tending, even the vagaries of weather present challenges. But people around the world are pouring time, money, imagination, and sweat equity into the effort, trusting and believing that more trees will make for a better future. ■

Alder saplings, ready for planting, will put down roots in Doddington North Moor, Northumberland, one of Britain's largest forestation endeavors.

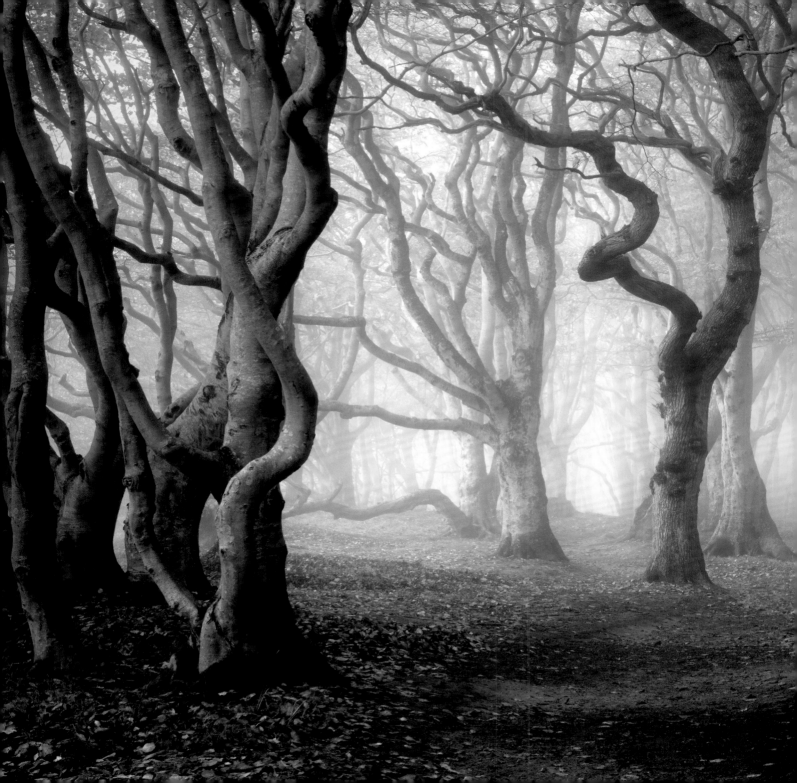

The Message of the Forest

Wherever you are, close your eyes and step into the forest. Feel the ancient presence that surrounds you. Even if you are not among tall trees, imagine that you are. This forest, any forest, every forest lives in our human imagination, as it has for millennia.

You are very small. Surrounding you stand sturdy beings that stretch toward the sun. Their roots sink down and weave their way through soil, past rocks and roots of neighboring trees, in and out and around, all unseen beneath your feet. Life force flows from underground, up old trunks, out strong branches, nourishing exquisite twigs and flowers, growing toward the open sky.

The air is crisp and clean. The light shimmers in the breeze. A squirrel springs from branch to branch overhead. A woodpecker thrums in perfect time. Leaves give gently beneath your step; a fallen twig snaps. The comforting smell of humus after rain engulfs your senses.

This forest knows the ways of nature: how earth and water, air and fire—timeworn archetypal elements—tell all the stories and ring out the warnings. Too much, too little, too dry, too wet. Trees have weathered extremes in centuries past; can they in times to come?

The forest gives so much: shade and solace, fruits and nuts aplenty. Examples of beauty, calm, cooperation. Pathways out of self-absorption and stress. Lessons of history, philosophy, and science. Moments of pleasure and reflection. Quiet. Peace. The meaning often lost in busy lives, found again in quietude.

Beech trees in Denmark's Kalø forest twist and turn invitingly.

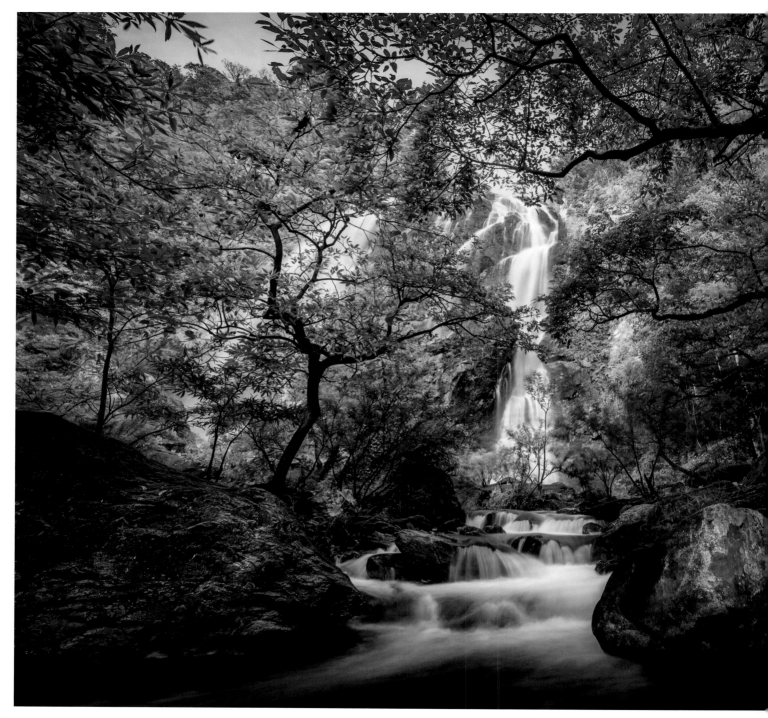

As we take, so should we give back. For millennia, humans have benefited from the forest: by gathering nourishment, burning tinder, carving tools, erecting buildings. And now, we risk overtaking. Our forests cannot always fend for themselves. By recognizing the complexity, the interconnections, the exquisite life of every tree in every forest, we learn to honor the world of nature as deeply as it deserves.

Step into the forest. This is a world that was here long before you; this is a world that will live on long after you die. Here the many are one, and one comprises many. Life and death, growth and decay. Breathe in, breathe out.

The forest is speaking. Let us listen. ∎

OPPOSITE: Waterfalls plunge, replenishing a woodland stream in the luxuriant forest of Thailand's Kamphaeng Phet Historical Park.

ABOVE: A maturing magnolia seed head, intricate in its symmetry and detail

FAMOUS TREES

THE TREE OF ENLIGHTENMENT

Sometime during the sixth century B.C., it is believed, the young prince Gautama Siddhartha's quest for meaning led him to a spreading fig tree on the banks of the Phalgu River, a tributary of the Ganges in northeastern India. There he sat, spine as strong as the tree trunk he leaned on, and there he attained enlightenment. There, at this splendid specimen of *Ficus religiosa,* Siddhartha became the Buddha.

A tree still grows at that spot—a shrine, a pilgrims' destination. More than a million people visit each year. Stone altars, railings, and plazas surround it. A temple towers over the tree. Sculptures inside depict the Buddha pointing his left hand up and his right hand down, connecting heaven and earth.

Called the *bodhi* tree, from the Sanskrit for "enlightenment," this icon has been the object of conflict and is a symbol of endurance. It was destroyed as early as the second century B.C., replanted, and destroyed again. Ashoka Maurya, the great Buddhist proselytizer of the third century B.C., revered it, and his daughter carried a twig from it to Sri Lanka. Called the Jaya Sri Maha Bodhi, that tree survives today, the focal point of another Buddhist shrine. It is considered the oldest tree planted by human hands.

Today's tree at Bodh Gaya was planted in 1881, a clone from the original. Warming temperatures, surrounding structures, and devotees clamoring to take home even one leaf put undue stress on it. Named a UNESCO World Heritage Site in 2002, it is now protected, ensuring that the bodhi tree—or its offspring—continues to thrive and inspire. ∎

Two monks sit in reverence under a sheltering tree in Bodh Gaya, India, where the Buddha found enlightenment.

FOLLOWING PAGES: Even this photograph of the forest in Lancashire, U.K., through which the River Roddlesworth flows, brings a sense of calm and completion.

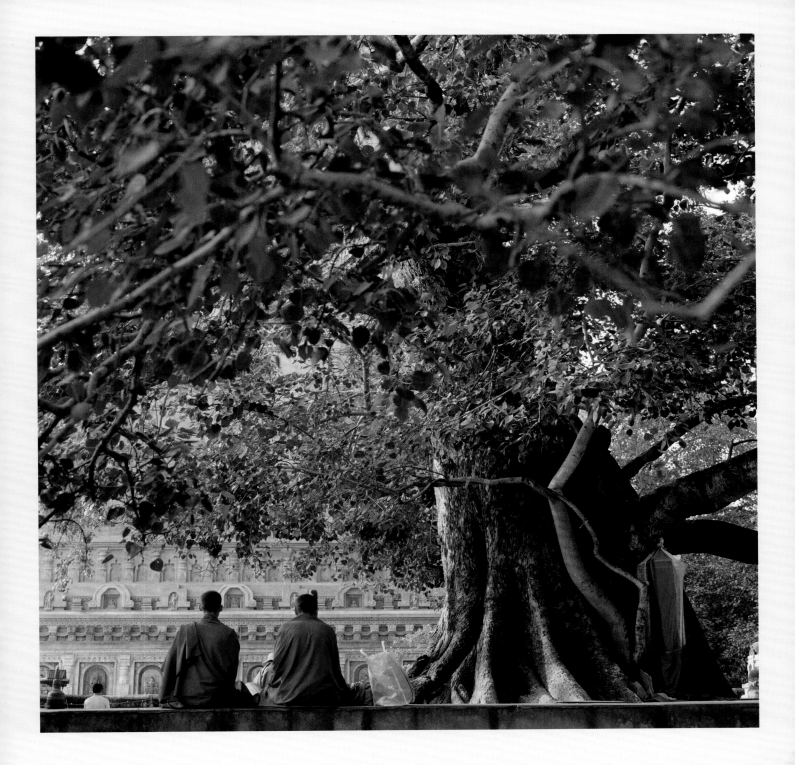

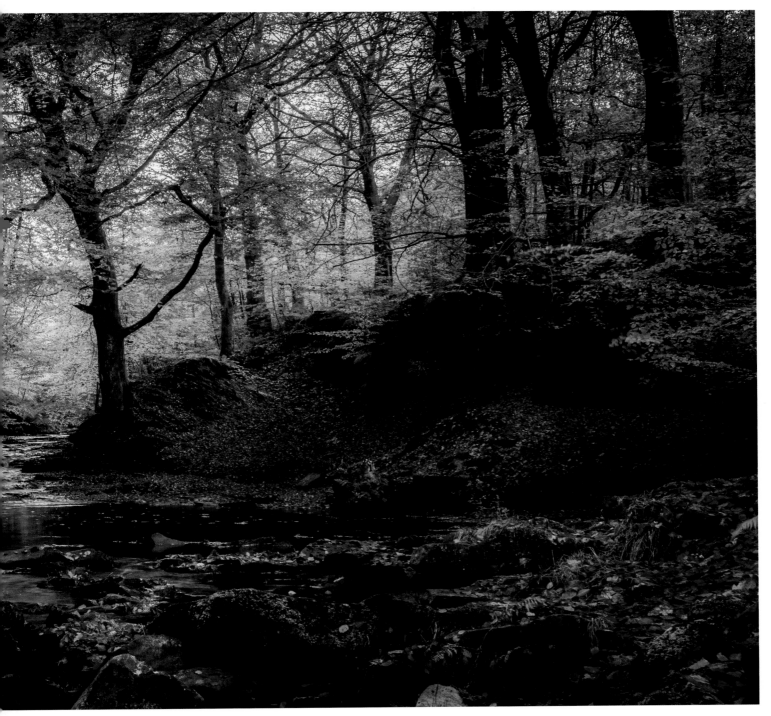

Illustrations Credits

Front cover, Nikada/Getty Images; back cover, Kim Jay Photography/Stocksy; 2-3, Inigo Cia/Getty Images; 4-5, Max Foster; 6, DTG Photography/Alamy Stock Photo; 14-15, Sjo/Getty Images; 16, Max Foster; 18, Dima Moroz/Shutterstock; 18-19, Sue Whiteman/Getty Images; 20, Geraint Rowland Photography/Getty Images; 22-3, Dean Fikar/Getty Images; 24, Dirk Wiersma/Science Source; 26-7, Power and Syred/Science Source; 29, David Wall/Alamy Stock Photo; 30-1, Greg Vaughn/Alamy Stock Photo; 32, Diane Cook and Len Jenshel/National Geographic Image Collection; 34-5, Michael Nichols/National Geographic Image Collection; 36, Greg Clure Photography; 38, Richard Jones/Science Source; 40-1, Patrick Aventurier/Gamma-Rapho via Getty Images; 41, De Agostini Picture Library/Getty Images; 43, Michael Duff/Getty Images; 44-5, Photon-Photos/Getty Images; 46, PjrStudio/Alamy Stock Photo; 48, De Agostini Picture Library/Getty Images; 48-9, R. McKellar, Royal Saskatchewan Museum; 50, Power and Syred/Science Source; 52-3, Baac3nes/Getty Images; 54, Jatuporn Chainiramitkul/Shutterstock; 55, DeAgostini Picture Library/Getty Images; 56, Richard Newstead/Getty Images; 58-9, Robert Llewellyn; 60, Thomas Winz/Getty Images; 62-3, Diptendu Dutta/AFP via Getty Images; 63, Richard Nazaretyan/Getty Images; 64, Supawit Srethbhakdi/Shutterstock; 66, Sven Zacek/Nature Picture Library/Alamy Stock Photo; 68-9, Neil Burnell; 70, Daniel J Barr/Getty Images; 73, Diane Cook and Len Jenshel/National Geographic Missions Program; 76-7, Artur Bogacki/Alamy Stock Photo; 78, Southern Lightscapes-Australia/Getty Images; 80-1, Johner Images/Getty Images; 82, David Scharf/Science Source; 84-5, Phil Degginger/Animals Animals/age fotostock; 86, Emmanuel Lattes/Alamy Stock Photo; 88, S. E. Cornelius/Science Source; 90-1, prill/Getty Images; 92, Dennis Frates/Alamy Stock Photo; 94-5, Gary Kavanagh/Getty Images; 97, Oleksiy Maksymenko Photography/Alamy Stock Photo; 98, Daniel Viñé Garcia/Getty Images; 100-1, blickwinkel/R. Bala/Alamy Stock Photo; 103, Pete Oxford/Nature Picture Library/Alamy Stock Photo; 104-5, Kevin Schafer/Minden Pictures; 106, Paul & Paveena Mckenzie/Getty Images; 108-9, zstockphotos/Getty Images; 110, Kim Jay Photography/Stocksy; 112-3, Robert Llewellyn; 114, Bill Swindaman/Getty Images; 116-7, Pete Oxford/Minden Pictures; 118, Max Foster; 120-1, Jack Dykinga/NPL/Minden Pictures; 121, AlasdairJames/Getty Images; 122, Roberto Moiola/robertharding; 124-5, fotopanorama360/Shutterstock; 126, ITAR-TASS News Agency/Alamy Stock Photo; 127, Natural History Museum, London/Alamy Stock Photo; 129, Avalon/Wolfgang Kaehler/Universal Images Group via Getty Images; 132-3, David Chrastek/Alamy Stock Photo; 134, Morley Read/Alamy Stock Photo; 136-7, D. Kucharski K. Kucharska/Shutterstock; 138, Jerry and Marcy Monkman/EcoPhotography/Alamy Stock Photo; 140-1, Nick Beer/Shutterstock; 142, Brian Skerry/National Geographic Image Collection; 144-5, Ketkarn Sakultap/Getty Images; 146, Avalon.red/Alamy Stock Photo; 148, © Arno Gasteiger, 2021; 150-1, Arnaud De Grave/Le Pictorium/Alamy Stock Photo; 153, Nazar Abbas Photography/Getty

About the Authors

Susan Tyler Hitchcock is a writer and editor specializing in science, nature, and history. She has a Ph.D. in English and is the author of 13 books, including *Gather Ye Wild Things: A Forager's Year, Frankenstein: A Cultural History,* and National Geographic's *Geography of Religion.* She has written the text for numerous National Geographic photography books and edited many more, including field guides, atlases, and illustrated references. She lives in a mountainside forest near Charlottesville, Virginia.

Suzanne Simard is a professor of forest ecology at the University of British Columbia and the author of the *New York Times* best seller *Finding the Mother Tree: Discovering the Wisdom of the Forest.* A pioneer in the study of plant communication and intelligence, she has published more than 200 peer-reviewed articles, and her July 2016 TED talk, "How Trees Talk to Each Other," has garnered nearly five million views. She lives in Nelson, British Columbia, surrounded by temperate inland rainforests.

Since 1888, the National Geographic Society has funded more than 14,000 research, conservation, education, and storytelling projects around the world. National Geographic Partners distributes a portion of the funds it receives from your purchase to National Geographic Society to support programs including the conservation of animals and their habitats.

Get closer to National Geographic Explorers and photographers, and connect with our global community. Join us today at nationalgeographic.org/joinus

For rights or permissions inquiries, please contact National Geographic Books Subsidiary Rights: bookrights@natgeo.com

ISBN: 978-1-4262-1890-3

Printed in China

21/RRDH/1

CELEBRATE NATURE